MW00439158

Car Design

Paolo Tumminelli

teNeues

Editor in chief: Paolo Tumminelli
Editorial coordination: Robin Baum
Art Director: Heike Sieber
Translations: SWB Communications
English: Dr. Suzanne Kirkbright
French: Sylvie Péjac
Spanish: Gemma Correa-Buján

Published by teNeues Publishing Group

teNeues Publishing Company
16 West 22nd Street, New York, NY 100010, USA
Tel.: 001-212-627-9090, Fax: 001-212-627-9511

teNeues Book Division
Kaistraße 18
40221 Düsseldorf, Germany
Tel.: 0049-(0)211-994597-0, Fax: 0049-(0)211-994597-40

teNeues Publishing UK Ltd.
P.O. Box 402
West Byfleet
KT14 7ZF, Great Britain
Tel.: 0044-1932-403509, Fax: 0044-1932-403514

teNeues France S.A.R.L.
4, rue de Valence, 75005 Paris, France
Tel.: 0033-1-55766205, Fax: 0033-1-55766419

www.teneues.com

ISBN: 3-8238-4561-6

© 2004 teNeues Verlag GmbH + Co. KG, Kempen

Editorial Project: © 2003 goodbrands GmbH

Weissenburgstraße 35
50670 Cologne, Germany
Tel.: 0049-(0)221-17933-775
Fax: 0049-(0)221-17933-776
e-mail: mail@goodbrands.de
www.goodbrands.de

Printed in Italy
Cover photo © 12

Picture and text rights reserved for all countries. No part of this publication my be reproduced in any manner whatsoever.

All rights reserved.

While we strive for utmost precision in every detail, we cannot be held responsible for any inaccuracies, neither for any subsequent loss or damage arising.

Bibliographic information published by Die Deutsche Bibliothek. Die Deutsche Bibliothek lists this publication in the Deutsche Nationalbibliografie; detailed bibliographic data is available in the Internet at http://dnb.dbb.de

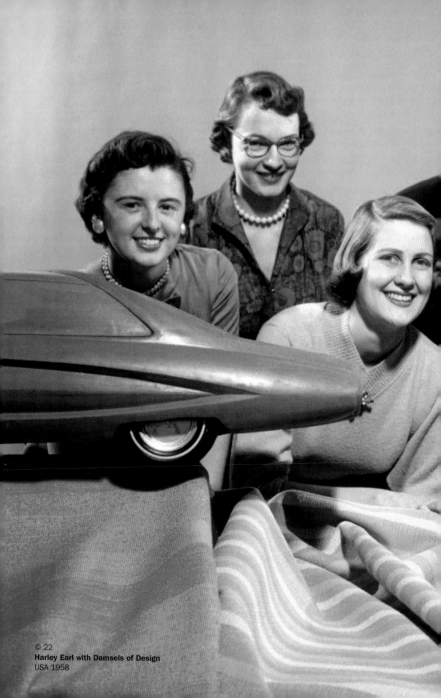

© 22

Harley Earl with Damsels of Design
USA 1958

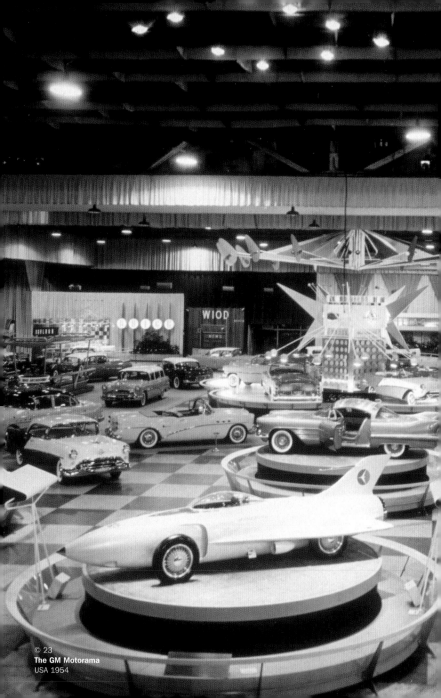

© 23
The GM Motorama
USA 1954

Introduction

Car design is not so much about creating an industrial style as fulfilling
dreams. In the first half of the twentieth century, cars were a luxury item
and available to society's élite. In the post-war era, cars became a popu-
lar consumer good.

No product has had such a strong influence on society as the automo-
bile. Its importance is not only a result of its economic significance, but
rather its social function. Cars connect people and places, they define
how our world looks, they link private and public spheres: Anyone who
drives a car likes being on show, and he cannot—or perhaps does not
want?—to be ignored. Cars boost the personality: I drive therefore I am.
Cars also come in as many different shapes as people. The variety of car
design proves it. This book reflects these designs, which will not only
delight car fans. The focus is not so much on technology as on relations
between people and cars, fashion and trends, cultures and design
languages. For that reason, pictures fulfil an important role. The photo-
graphs are exclusively selected from original, historical material. In some
cases, the pictures are shown here for the first time. The reason is banal:
frequently, a beautiful woman or special architecture steal the show from
the car—the point lies elsewhere, as Roland Barthes would say. That is
precisely the subject of this book: it is not about a portrait of the car as
a fetish object, but as part of our society, with all its colours and nuances.
Design critique can take a scientific form. However, more often than not
it is our feelings that either enable or prevent us from giving an objective
opinion about the design of a product, as for example, with brand pre-
ference. This book is scientifically researched, at least, to the extent that
it explains the development of modern automobile design by a pre-
selection and ordering of 1,222 models dating from 1947 to 2004. 370
of these models are pictured here, but they are by no means all, nor the
most attractive, or best models to have been created in the post-war era.
They either represent a particular style, or else they show a design
innovation, or a unique design feature. All of them are interesting and
many are worth rediscovering. Ultimately, deciding which models are
attractive or ugly—basically, no model is—is all about that special feeling.

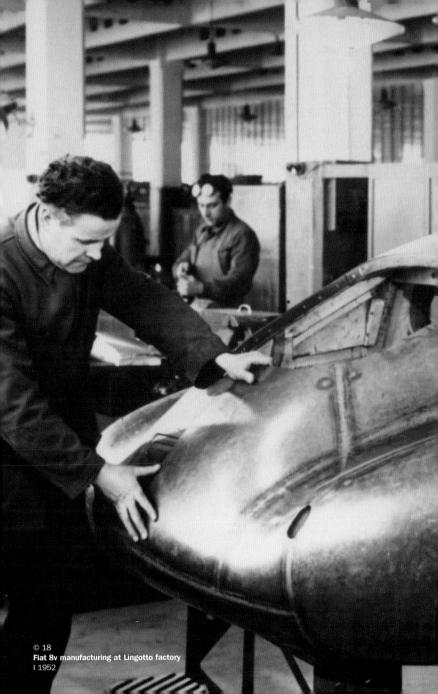

© 18
Fiat 8v manufacturing at Lingotto factory
I 1952

Einleitung

Automobildesign hat weniger mit industrieller Formgebung zu tun als mit der Erfüllung von Träumen. Ein Luxusobjekt, das in der ersten Hälfte des 20. Jahrhunderts einer Bevölkerungselite vorbehalten war, wurde in der Nachkriegszeit zu einem populären Konsumgut.

Kein Produkt hat die Gesellschaft so geprägt wie das Automobil. Dieser Stellenwert erschließt sich nicht nur aus seiner wirtschaftlichen Bedeutung, sondern hängt vielmehr mit seiner sozialen Funktion zusammen. Autos verbinden Menschen und Orte; sie bestimmen das Erscheinungsbild unserer Welt mit; sie verknüpfen die Privatsphäre mit der Öffentlichkeit: Wer Auto fährt, stellt sich zur Schau und kann – oder will? – nicht ignoriert werden. Autos dienen als Persönlichkeitsverstärker: Ich fahre also bin ich.

So verschieden wie die Menschen sind auch die Autos. Die Vielfältigkeit des Designs ist ein Beweis dafür. Sie spiegelt sich in diesem Buch wider, das nicht allein Autofans erfreuen soll. Es geht hier weniger um Technik als um Beziehungen zwischen Menschen und Autos, Mode und Zeitgeist, Kulturen und Formsprachen. Deswegen spielen Bilder eine wichtige Rolle. Es wurde ausschließlich originales, historisches Fotomaterial ausgewählt; zum Teil handelt es sich um Bilder, die noch nie veröffentlicht wurden. Der Grund dafür ist banal: oft stiehlt eine schöne Frau oder eine besondere Architektur dem Auto die Schau – der Punkt liegt woanders, wie Roland Barthes sagen würde. Aber gerade darum geht es: nicht um die Porträtierung des Autos als Fetischobjekt, sondern als Mitglied unserer Gesellschaft, mit all seinen Farben und Nuancen.

Designkritik kann wissenschaftlich sein. Oft sind es aber die Gefühle, zum Beispiel die Vorliebe für eine Marke, die es uns ermöglichen oder verbieten, das Design eines Produkts objektiv zu bewerten. Dieses Buch ist mindestens halbwissenschaftlich: Es erklärt die Entwicklung des modernen Automobildesigns basierend auf der Vorauswahl und Zuordnung von 1222 Modellen zwischen 1947 und 2004. Von diesen werden hier 370 abgebildet: nicht alle und auch nicht nur unbedingt die schönsten oder besten Autos der Nachkriegszeit. Sie sind entweder repräsentativ für eine bestimmte Stilrichtung, oder sie stellen eine Designinnovation bzw. Designbesonderheit dar. Alle sind interessant, viele sind eine Wiederentdeckung wert. Welche davon hübsch oder hässlich sind – im Prinzip keine – ist letztendlich Gefühlssache.

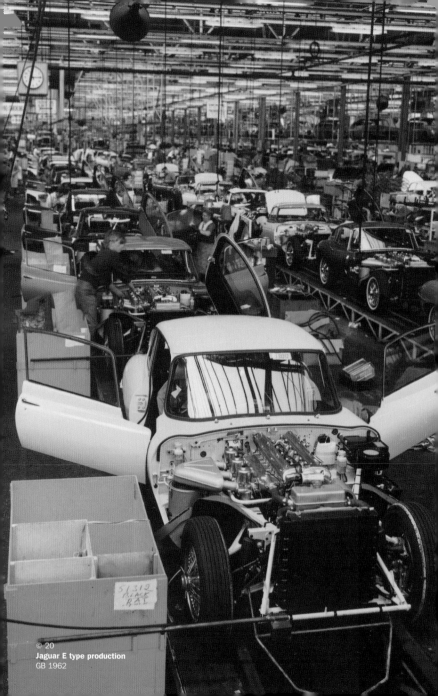

© 20
Jaguar E type production
GB 1962

Introduction

Dans le domaine du design automobile, la concrétisation des rêves a la
priorité sur le façonnage industriel. D'objet de luxe réservé à une élite au
milieu du 20ème siècle, la voiture devint un objet de consommation
populaire dans la période d'après-guerre.

Aucun produit n'a autant influencé la société. Cette place importante ne
s'explique pas que du point de vue économique mais aussi par sa
fonction sociale. Les voitures relient les gens et les endroits, elles déter-
minent l'aspect de notre monde, elles connectent la sphère privée et la
sphère publique : un conducteur de voiture s'expose, qu'il souhaite ou
pas se faire remarquer. La voiture sert d'amplificateur de la personnalité :
je conduis donc je suis.

Chaque individu est différent, tout comme une voiture. La variété du
design en est la preuve. Elle se reflète dans ce livre qui n'est pas seule-
ment conçu pour les fans de voiture. Il s'agit plus ici des relations entre
individus et voitures, mode et esprit du temps, culture et langage des
formes, que de technique.

C'est pourquoi les images jouent un rôle important. Les photographies
historiques sélectionnées sont toutes des originaux, certaines n'ont en-
core jamais été publiées. La raison est banale : souvent c'est une jolie
femme ou un élément architectural particulier qui détourne l'attention de
la voiture. Le point important est situé ailleurs, comme dirait Roland
Barthes. Mais c'est justement ce qui est intéressant : il ne s'agit pas de
la représentation de la voiture en tant qu'objet-fétiche mais en tant
qu'élément faisant partie de notre société avec ses caractéristiques et
nuances propres.

La critique du design peut être scientifique. Souvent ce sont des senti-
ments, comme la préférence pour une marque, qui nous permettent ou
nous empêchent d'évaluer objectivement le design d'un produit. Ce livre
est au moins à demi-scientifique : il explique le développement du design
automobile moderne sur la base d'une sélection et classification de 370
modèles créés entre 1947 et 2004. Pas toutes les voitures, ni unique-
ment les plus belles ou les plus réussies de l'après-guerre. Elles sont
représentatives d'un style particulier ou elles illustrent une innovation ou
un design spécial. Elles sont toutes intéressantes, et nombreuses sont
celles qui valent la peine d'être redécouvertes. Quelles sont les plus
belles ou les plus laides ? En principe, aucune. C'est une question de
sentiment.

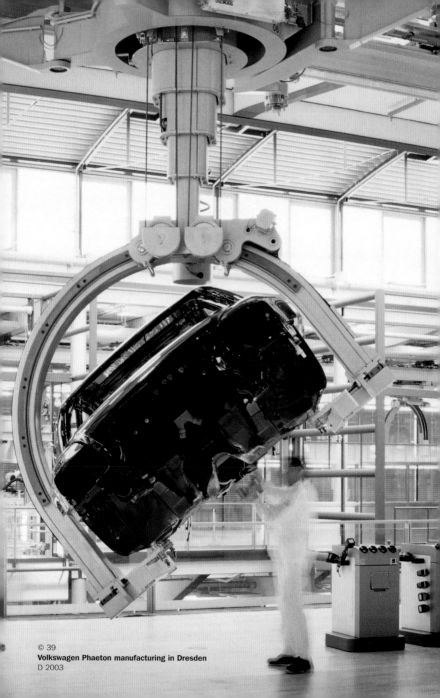

© 39
Volkswagen Phaeton manufacturing in Dresden
D 2003

Introducción

El diseño del automóvil tiene menos que ver con el modelado indus-
trial que con la realización de sueños. Un objeto de lujo, que en la pri-
mera mitad del siglo XX. estuvo reservado a las elites, se convirtió en la
posguerra en un bien de consumo popular.
Ningún producto ha marcado tanto a la sociedad como el automóvil. Este
valor es la consecuencia no sólo de su importancia económica sino que
está mucho más unido a su función social. Los automóviles unen a per-
sonas y lugares; contribuyen a condicionar el aspecto de nuestro mundo;
enlazan la esfera privada con la pública: Quien conduce un automóvil se
expone a la vista y no puede –¿o no quiere?– ser ignorado. Los automó-
viles sirven para fortalecer la personalidad: Conduzco, luego existo.
Los automóviles son tan distintos como las personas. La variedad del
diseño es una prueba de ello. Esto se refleja en este libro que no sola-
mente quiere alegrar a los fans del automóvil. Se trata aquí menos de la
técnica que de las relaciones entre las personas y los automóviles, la
moda y el espíritu de la época, las culturas y los lenguajes de formas. Por
eso, las imágenes juegan un papel importante. Fue escogido material
fotográfico histórico original exclusivamente; En parte, se trata de imáge-
nes que nunca fueron publicadas. El motivo de ello es banal: A menudo,
una mujer hermosa o una arquitectura especial le roban la escena al
automóvil –el punto decisivo está en otra parte, como diría Roland Barthes.
Pero de ello se trata precisamente: del retrato del automóvil, no como un
fetiche, sino como un miembro de nuestra sociedad con todos sus colo-
res y matices.
La crítica del diseño puede ser científica. Sin embargo, con frecuencia
son los sentimientos, por ejemplo la predilección por una marca, los que
hacen posible o nos impiden valorar objetivamente el diseño de un pro-
ducto. Este libro es, al menos, semicientífico: Explica la evolución del
diseño moderno del automóvil en base a la preselección y clasificación
de 1222 modelos entre 1947 y 2004. De éstos se reproducen aquí 370:
No son todos ni son tampoco necesariamente sólo los más bellos o los
mejores automóviles de la posguerra. Son, o bien representativos de una
corriente estilística concreta, o bien muestran una innovación o una par-
ticularidad del diseño respectivamente. Todos son interesantes, muchos
son dignos de redescubrirse. Cuáles de ellos son bellos o feos –en prin-
cipio ninguno– es, al fin y al cabo, una cuestión de sensaciones.

- ROCKET -

CLASSIC

NEW

PRE MODERN

BAROQUE

EDGE LINE

NEW LINE

EDG

SOFT

SHELL

FLOW LINE

FLOW

WEDGE LINE

GRAPH

1950 1960 1970

© 24
Trends in modern car design
2004

design

BAROQUE

RETRO

NEW CLASSIC

EDGE BODY

BOX

NEW EDGE BOX

CARVED BODY

FLOW BOX

SMOOTH BODY

1980 1990 2000

Design

18 **Automobile design** does not follow strict rules. Instead, a fluid confrontation of continuity and innovation, simplicity and extravagance determines its scope. There are dream cars, concept cars and car series. No matter whether they are successful or not, many cars have faded into obscurity, others have started short-lived trends, and some became legends. Design themes can be organized into 20 groups, which are connected to each other. Their individual complexity often results from the combination of global trends and regional cultures. By comparison to pre-war models, cars from the post-war era were modest and respectable in their basic design, like all things made when times are hard and materials scarce. However, after the shock of war was over, cars were made into a baroque extravaganza with pastel colors, chrome and tail-wings. In the sixties, the new and predominant lines were slim, flat, dynamic and purist. In the seventies, models were angular and graphic: at that time, the new trend was called wedge form; the front was often radically cut off, colours were more bright, and a matt-black look sparked off a new fashion. In the eighties, box-shaped cars were characterized by function and common sense: in the search for maximum rationality, the body became higher and the wheels smaller; at the same time, the goal was aerodynamics and the finest possible integration of all component parts. In the nineties, emotions were rediscovered, so that forms became more expressive, softer and rounder: a wave of retro styling began. Around the turn of the century, an age of eclecticism emerged, which was meant to satisfy the need for greater individuality. Nostalgia joins forces with experiments: on the one hand, new design languages are developed; on the other hand, a neo-classical style comes to the forefront. Brand features are rediscovered and emphasized. Heritage alone plays an increasingly important role. But the myth remains: cars made in the USA? They are self-confident in the extreme, ridiculously large and often eccentric. More strict and consistent design is made in Germany, where concept and function take priority over style and appearance. Whether traditional or avant-garde, this country's cars are always aristocratic and uncompromising: Great Britain's models are unmistakeably styled on the Buckingham Palace look. The French enjoy surprising everyone, they always design in a revolutionary, non-conformist style, even if this is at the expense of true beauty. It can be classical and elegant, radical and chic, or rational and beautiful, the characteristic obsession with a good figure has made Italy a reliable design school. Japan's art, on the other hand, is often to borrow something from everything and still to remain undeniably Japanese.

Design

Automobildesign folgt keinem geraden Weg, vielmehr bestimmt die fließen-
de Auseinandersetzung zwischen Kontinuität und Innovation, Einfachheit und
Extravaganz das Panorama. Es gibt Dream Cars, Concept Cars und Serien-
fahrzeuge. Egal ob erfolgreich oder nicht: manche sind in Vergessenheit gera-
ten, andere haben kurzlebige Trends gesetzt, einige wurden zur Legende. Eine
mögliche Ordnung der Designthemen führt zu 20 miteinander verbundenen
Gruppen. Ihre jeweilige Komplexität resultiert oft aus der Kombination von glo-
balen Trends und regionalen Kulturen. Im Vergleich zu den Modellen der Vor-
kriegszeit sind die Nachkriegsautos in ihrem organischen Design so beschei-
den und seriös wie jene zu Zeiten knapper Ressourcen. Sobald der Kriegs-
schock jedoch vorbei war, machten Pastellfarben, Chrom und Heckflossen die
Autos zur barocken Extravaganza. In den 60ern dominieren neue Linien:
schlank, flach, dynamisch und puristisch. Kantig und graphisch präsentieren
sich dagegen die 70er: Die neue Mode hieß damals Keilform; die Frontpartie
wurde oft radikal abgeschnitten, die Farben wurden schriller, mattschwarz setz-
te einen neuen Trend. Funktion und Vernunft prägten hingegen die schachtel-
förmigen Autos der 80er: Auf der Suche nach maximaler Rationalität wurden
die Karosserien höher und die Räder kleiner, gleichzeitig strebte man nach
Aerodynamik und der bestmöglichen Integration aller Teile. In den 90ern wurde
die Emotionalität wieder entdeckt, so dass die Formen expressiver, weicher
und runder wurden; eine Retrowelle nahm ihren Anfang. Um die Jahr-
tausendwende begann eine Zeit des Eklektizismus, die dem Bedürfnis nach
mehr Individualität entsprechen soll. Nostalgie mischt sich mit Experimenten:
einerseits werden neue Designsprachen entwickelt, andererseits kommt ein
Neoklassizismus zum Zuge. Markencharakteristika werden wieder entdeckt
und betont. Nur die Herkunft spielt immer weniger eine Rolle. Aber es bleibt
der Mythos: Autos aus den USA? Selbstbewusst bis zum Exzess, unvernünftig
groß und oft skurril. Aus Deutschland kommt eine strenge gestalterische
Konsistenz, bei der Konzept und Funktion Vorrang vor Form und Aussehen
haben. Entweder traditionsreich oder avantgardistisch, aber immer aristokra-
tisch und kompromisslos: die Autos aus Großbritannien sind in ihrem Stil à la
Buckingham Palace unverwechselbar. Die Franzosen überraschen gerne, sie
gestalten immer revolutionär und antikonformistisch, wenn auch auf Kosten
wahrer Schönheit. Egal ob klassisch-elegant, radikal-chic oder rational-schön,
die landestypische Obsession für die gute Figur hat Italien zur bewährten
Schule gemacht. Japans Kunst wiederum lag oft darin, von allem etwas zu
übernehmen und dabei doch unverkennbar japanisch zu bleiben.

Design

Le design automobile ne suit pas un chemin direct mais il rebondit entre des tendances contraires aux limites fluides : la continuité et l'innovation, la simplicité et l'extravagance. On découvre des voitures de rêve, des voitures conceptuelles et des voitures de série. Succès ou pas : certaines tombent dans l'oubli, d'autres ont lancé des modes de courte durée et d'autres encore sont devenues des mythes. Un classement des thèmes de design fait apparaître 20 groupes liés entre eux. Leur complexité respective résulte souvent de la combinaison des tendances globales et des cultures régionales. Comparées aux modèles d'avant-guerre, les voitures d'après-guerre ont un design simple et sérieux comme celles de l'époque où les ressources manquaient. Dès que le choc de la guerre fut passé, les couleurs pastel, le chrome et les ailettes arrière donnèrent le jour à des voitures à l'extravagance baroque. Dans les années 60, de nouvelles formes dominent : minces, plates, dynamiques et puristes. Au contraire, les années 70 se présentent plus graphiques et carrées : le cunéiforme était à la mode ; l'avant fut souvent brutalement coupé, les couleurs devinrent plus vives, le noir mat fut lancé. Par contre, le fonctionnel et la raison dominaient les voitures en forme de boîtes des années 80 : la recherche de la rationalité maximale conduisit à des carrosseries plus hautes et plus petites ; simultanément, on recherchait l'aérodynamique et la meilleure intégration possible de toutes les pièces. Dans les années 90, l'émotivité fut redécouverte et rendit les formes plus expressives, plus douces et plus rondes ; ce fut le début de la vague Rétro. La nostalgie s'associe aux expériences : d'une part, sont créés de nouveaux langages du design, d'autre part le néoclassicisme prend de l'importance. Les caractéristiques d'une marque sont redécouvertes et soulignées. Le pays d'origine compte de moins en moins. Mais un mythe demeure : les voitures des Etats-Unis ? De l'assurance jusqu'à l'excès, déraisonnablement grandes et souvent bizarres. L'Allemagne offre une consistance créatrice sévère dans laquelle le concept et la fonctionnalité dominent sur la forme et l'apparence. Soit traditionnelles, soit à l'avant-garde mais toujours aristocratiques et sans compromis : les voitures de Grande-Bretagne sont uniques dans leur style à la « Buckingham Palace ». Les Français étonnent volontiers, ils créent de manière révolutionnaire et anticonformiste, quelquefois aux dépens de la véritable beauté. L'obsession de la beauté sous une forme classique-élégante, radicale-chic, rationnelle-belle a fait école en Italie. Par contre, l'art du Japon a consisté à reprendre partout quelque chose mais en restant manifestement japonais.

Design

El diseño del automóvil no sigue un camino recto; El panorama lo condiciona
na más bien la contraposición entre la continuidad y la innovación, la sencillez y la extravagancia. Hay Dream Cars, Concept Cars y automóviles en serie. No importa si tienen éxito o no: Algunos cayeron en el olvido, otros marcaron tendencias efímeras, algunos se convirtieron en una leyenda. Un posible orden de los temas de diseño lleva a 20 grupos unidos entre ellos. Su respectiva complejidad resulta a menudo de la combinación de tendencias globales y culturas regionales. En comparación con los modelos de la época de la preguerra, los automóviles de la posguerra son tan modestos como aquellos en tiempos de escasos recursos. Sin embargo, tan pronto como el trauma de la guerra hubo pasado, los tonos pastel, el cromo y los alerones traseros convirtieron los automóviles en la extravagancia barroca. En los 60 dominan nuevas líneas: delgadas, planas, dinámicas y puristas. Por el contrario, los 70 se presentan angulosos y gráficos: La nueva moda se llamó por entonces cuneiforme; a menudo la parte frontal se cortó de forma radical. En cambio, la función y la lógica caracterizan los automóviles de los 80 en forma de caja: En busca de la máxima racionalidad, las carrocerías se volvieron más altas y las ruedas más pequeñas, al mismo tiempo se tendió a la aerodinámica. En los 90 se redescubrió la emotividad, de manera que las formas se hicieron más expresivas, más suaves y más redondas; Se inició una oleada Retro. Alrededor del cambio de milenio comenzó un período de eclecticismo que había de corresponder a la necesidad de una mayor individualidad. La nostalgia se mezcla con los experimentos: Por un lado se desarollan nuevos lenguajes de diseño, por otro lado entra en acción un neoclasicismo. Se redescubren y acentúan las características de las marcas. Solamente el origen juega cada vez menos un papel. Pero el mito permanece: ¿Automóviles de los EEUU? Seguros de sí mismos hasta el exceso, insensatamente grandes, a menudo extravagantes. De Alemania llega una severa consistencia creadora, en la cual la concepción y la función tienen prioridad sobre la forma y la apariencia. O con mucha tradición o vanguardistas: Los automóviles de Gran Bretaña resultan inconfundibles en su estilo à la Buckingham Palace. A los franceses les gusta sorprender, crean siempre de forma revolucionaria y anticonformista, aunque también a costa de la verdadera belleza. Tanto clásico-elegante, radical-chic o racional-bello, la típica obsesión por la buena figura ha hecho de Italia la escuela acreditada. Por otra parte, el arte de Japón consistió con frecuencia en asumir algo de todos pero permaneciendo al mismo tiempo inconfundiblemente japonés.

PreModern

Basically, automobiles in the pre-war period were a combination of different functional and clearly identifiable parts: engine space, headlights, fenders and passenger-seating. Space for a trunk was even uncommon; and generally, loading a single suitcase was enough. Today, it is still surprising to see the very vertically modeled proportions; fairly long, high and slender. Above all, research in areodynamics led to this type of design being abandoned. Numerous victories in motor-racing confirmed the importance of an airstream body shape, based on theories by Paul Jaray, Reinhard Koenig-Fachsenfeld and Wunibald Kamm. However, early attempts to sell streamline cars, like the Chrysler Airflow, the Fiat 1500 and the Tatra V8, were doomed to failure. They were simply too innovative. But the idea of building a body 'designed in one piece', by integrating each element of the vehicle into a smooth and single flow, continued to influence car design. The VW Beetle and the Citroen 2CV followed this trend. Although these cars were successful after the war, their designs were already finished towards the end of the 1930s.

Im Grunde genommen sind die Autos der Vorkriegszeit eine Kombination aus unterschiedlichen, deutlich erkennbaren Funktionsteilen: Motorraum, Scheinwerfer, Kotflügel und Fahrgastraum. Selbst der Kofferraum ist eine Seltenheit; meistens reichte ein bloß aufgehängter Koffer aus. Die sehr vertikal angelegten Proportionen überraschen heute noch; länglich, hoch und schmal. Vor allem die Forschung im Bereich der Aerodynamik trug dazu bei, sich schließlich von diesem Designkonzept zu entfernen. Die Bedeutung einer strömungsgünstigen Karosserie nach den Theorien von Paul Jaray, Reinhard Koenig-Fachsenfeld und Wunibald Kamm wurde durch viele Erfolge im Rennsport bestätigt. Die ersten Versuche, Streamline-Autos wie den Chrysler Airflow, den Fiat 1500 und den Tatra V8 zu verkaufen, waren aber zum Scheitern verurteilt. Sie waren einfach zu innovativ. Dennoch begleitet die Idee einer Karosserie „wie aus einem Guss", bei der alle Elemente ineinander fließend integriert sind, das Automobildesign weiterhin. In diese Richtung gingen der VW Käfer und der Citroen 2CV. Obwohl wir diese als erfolgreiche Nachkriegsautos kennen, war deren Design bereits gegen Ende der 30er Jahre entstanden.

© 9
Citroën 11CV Traction Avant, F 1934
(photo 1952)

© 21
Lincoln Zephyr, USA 1935

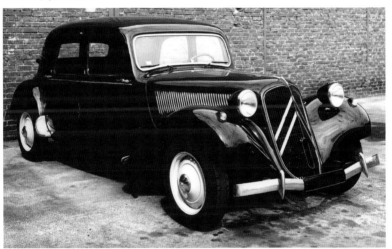

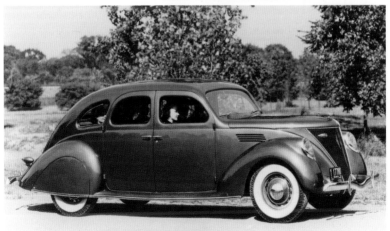

© 9
Citroën 2CV, F 1949
(photo 1955)

© 40
Volkswagen P2 Export, D 1949

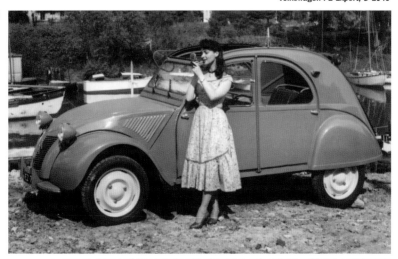

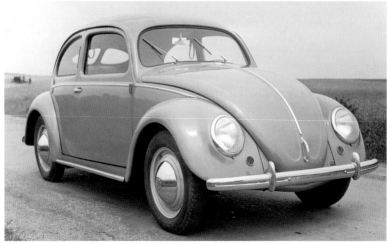

PreModern

Les voitures d'avant-guerre sont une combinaison de diverses parties
fonctionnelles clairement reconnaissables : compartiment moteur, phare,
aile et habitacle. Même le coffre à bagages est une rareté ; la plupart du
temps une valise accrochée suffit. Les proportions en dominante verticale
surprennent encore aujourd'hui ; le design est allongé, haut et étroit. C'est
surtout la recherche dans le domaine aérodynamique qui a contribué à s'é-
carter de ce concept de design. L'importance d'une carrosserie aéro-
dynamique, selon la théorie de Paul Jaray, Reinhard Koenig-Fachsenfeld et
Wunibald Kamm, a été confirmée par les nombreux succès rencontrés dans
le sport automobile. Mais les premières tentatives de vente de voitures
Streamline telles que la Chrysler Airflow, la Fiat 1500 et la Tatra V8 ont
mené à l'échec. Ces voitures étaient trop porteuses d'innovation. Cepen-
dant, l'idée d'une carrosserie fondue en un seul morceau, où tous les élé-
ments s'intègrent les uns aux autres, continue de guider la conception
automobile. C'est la direction qu'a prise la coccinelle de Volkswagen et la
2 CV de Citroën. Bien que ces voitures soient connues comme des modè-
les d'après-guerre, leur design était déjà né à la fin des années 30.

Bien mirado, los automóviles de la época de la preguerra son una combi-
nación de diferentes partes funcionales claramente reconocibles: compar-
timiento del motor, faros, guardabarros y habitáculo para el pasajero.
Incluso el guarda-equipajes es una rareza; La mayoría de las veces era
suficiente con una maleta sólo colgada. Las proporciones, trazadas muy
verticalmente, sorprenden todavía hoy; alargadas, altas y delgadas. Es-
pecialmente la investigación en el terreno de la aerodinámica contribuyó a
alejarse finalmente de este concepto del diseño. La importancia de una
carrocería favorable a la aerodinámica según las teorías de Paul Jaray,
Reinhard Koenig-Fachsenfeld y Wunibald Kamm fue confirmada por los
muchos éxitos en las carreras automovilísticas. Los primeros intentos de
vender automóviles Streamline como el Chrysler Airflow, el Fiat 1500 y el
Tatra V8 estuvieron condenados al fracaso. Simplemente eran demasiado
innovadores. Sin embargo, la idea de una carrocería "como de una pieza",
en la cual todos los elementos están integrados fluyendo unos en los otros,
continúa acompañando al diseño del automóvil. El Escarabajo (VW Käfer) y
el Citroen 2CV fueron en esta dirección: Aunque los conocemos como exi-
tosos automóviles de la posguerra, su diseño ya había surgido hacia finales
de los años 30.

Classic

The classical ideal of beauty represents a typical problem for car design. What is better: evolution or revolution? For many car manufacturers, post-war design experiments offered no viable alternative to a classical and attractive way of modeling. Ultimately, new cars were introduced in Shell Design as a mass product and therefore as a counter-example to models offered by the automobile establishment. Above all, brand names with a longer tradition were cautious about introducing innovations: Technically, their cars were brought up to latest performance standards, but in design terms, they were a mixture of new with tried and tested qualities. Features: the curve of the fenders was visibly retained, a vertical radiator grill shares the engine hood, which is built higher, and the tail is hardly developed. The general proportions are reminiscent of pre-war cars: long, slender and high. Now and in the past, this very expressive design was seen as an example of timeless elegance, whether in a sedan or sports car. It was not until the 1960s that classic car design made way the generally more modern approach of society. But this design is enjoying a comeback, just in time for the turn of the twentieth century.

Das Ideal der klassischen Schönheit stellt ein typisches Problem des Automobildesigns dar. Was ist besser: Evolution oder Revolution? Für viele Hersteller boten die Designexperimente der Nachkriegszeit keine wahren Alternativen zur klassisch-schönen Gestaltung. Letztendlich präsentierten sich die neuen Autos im Shell Design als Massenprodukt und somit als Gegenentwurf zum Automobilestablishment. Vor allem Marken mit größerer Tradition führten Neuerungen nur mit Vorsicht ein: Zwar wurden deren Autos technisch auf den neuesten Leistungsstand gebracht, gestalterisch jedoch mischte man Neues mit Bewährtem. Merkmale: der Schwung der Kotflügel bleibt sichtbar erhalten, ein vertikaler Kühlergrill teilt die höher gesetzte Motorhaube, das Heck ist kaum entwickelt. Die allgemeinen Proportionen erinnern an Vorkriegsautos: lang, schmal, hoch. Egal ob Limousine oder Sportwagen, dieses sehr expressive Design wurde gestern wie heute als Beispiel zeitloser automobiler Eleganz betrachtet. Erst in den 60er Jahren lässt das Classic Design im Zuge der allgemeinen Erneuerungen der Gesellschaft nach. Aber pünktlich zur Jahrtausendwende macht es sich wieder bemerkbar.

© 22
Cadillac Sixty-One Sedanet (Club Coupe), USA 1948

© 14
BMW 502 Coupé, D 1954

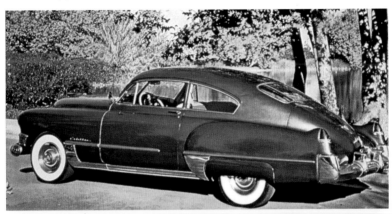

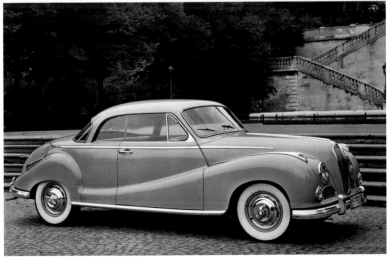

© 20
Jaguar XK 120, GB 1948

© 5
Bentley Type R, GB 1950

28

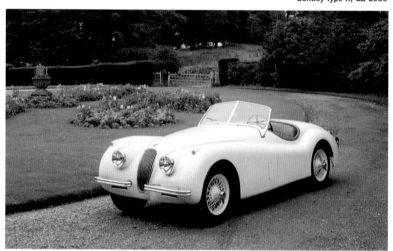

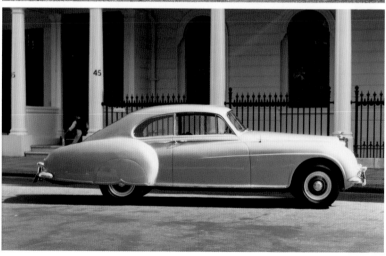

Classic

L'idéal de la beauté classique pose un problème typique au design auto-
mobile. Que choisir : évolution ou révolution? Pour de nombreux fabricants,
les expériences du design d'après-guerre n'apportaient pas de véritables
alternatives au beau design classique. En outre, les nouvelles voitures au
design Shell se présentaient comme un produit de masse et étaient donc en
opposition au monde automobile traditionnel. En particulier, les marques
symboles de grande tradition n'apportaient des changements qu'avec pré-
caution : leurs voitures étaient innovatrices sur le plan des performances
techniques mais pour la conception, elles offraient un mélange de nouveau-
té et de bon vieux temps. Caractéristiques : la ligne élancée de l'aile est visi-
blement conservée, la calandre verticale divise le capot du moteur qui
monte plus haut, l'arrière est à peine développée. Les proportions géné-
rales rappellent celles des voitures d'avant-guerre : la silhouette est allon-
gée, étroite, haute. Qu'il s'agisse d'une berline ou d'une voiture de sport, ce
design très expressif reste, hier comme aujourd'hui, un exemple d'élégance
automobile intemporelle. Le design Classic perd seulement de son impor-
tance dans les années 60, dans la fougue du renouveau général de la socié-
té. Mais il revient ponctuellement en force au changement de millénaire.

El ideal de la belleza clásica representa un problema típico del diseño del
automóvil. ¿Qué es mejor: evolución o revolución? Para muchos fabricantes,
los experimentos del diseño de la época de la posguerra no ofrecían alter-
nativas verdaderas a la configuración clásicamente bella. A fin de cuentas,
los nuevos automóviles se presentaron en diseño Shell como un producto
de masas y, con ello, como contra-diseño al establishment del automóvil.
Especialmente las marcas de mayor tradición sólo introdujeron las innova-
ciones con precaución: Aunque sus automóviles fueron puestos al nivel de
rendimiento más moderno, en el diseño se combinó lo nuevo con lo experi-
mentado. Características: La curva del guardabarros se conserva visible, una
parrilla del radiador delantera divide el capó colocado a más altura, la parte
trasera apenas está desarrollada. Las proporciones generales recuerdan a
los automóviles de la preguerra: alargadas, altas y delgadas. Tanto en una
limusina como en un vehículo deportivo, este diseño muy expresivo fue con-
siderado, ayer y hoy, como el ejemplo de una elegancia automovilística inde-
pendiente de la moda de la época. No fue hasta los años 60 que el diseño
Classic disminuyó como consecuencia de las innovaciones generales de la
sociedad. Pero puntualmente al cambio de milenio se hace notar de nuevo.

Soft Shell

The integration of all parts led to the early 1950s Soft Shell Design. In 1947, Raymond Loewy invented the Studebaker Champion and the series of modern sedans. The innovative tail section that functioned as trunk space surprised Americans who smiled and asked: which way is it going? But the idea of rounded, flowing forms was a success. Horizontal lines that were unbroken between the fenders became a global trend. Ford and General Motors followed the fashion by creating a similar design in 1949; and the so-called Ponton Side Design was the new fashion in Europe: Rover, Alfa Romeo and Fiat were among the first to offer this design. Simplicity of form was admirably suited to the technology of a self-supporting body and it was easy to produce. Above all, when the new design was transferred to the modest scale of a European car, it was combined with high versatility and wonderful proportions. In small vehicles, the construction principle was to build the engine at the rear and put the trunk in front. The result was a high-quality family car.

Die Integration aller Formteile führte zum Soft Shell Design der frühen 50er Jahre. Mit dem Studebaker Champion erfand Raymond Loewy 1947 die Typologie der modernen Stufenhecklimousine. Die innovative Heckpartie mit Kofferraumfunktion überraschte die Amerikaner, die lächelnd fragten: which way is it going? Aber das Konzept der abgerundeten, fließenden Formen wurde ein Erfolg. Horizontale Linien ohne Unterbrechung zwischen den Kotflügeln wurden zum weltweiten Trend. Ford und General Motors folgten 1949 mit einem ähnlichen Design; in Europa machte das so genannte Ponton Side Design schnell Schule: Rover, Alfa Romeo und Fiat waren unter den ersten Anbietern. Die Einfachheit der Form eignete sich hervorragend für die Technologie der selbsttragenden Karosserie und ist einfach zu produzieren. Vor allem aber war das neue Design, übertragen auf die bescheidenen Maße eines europäischen Autos, mit einem hohen Nutzwert und wunderbaren Proportionen gekoppelt. Bei Kleinautos drehte sich das konstruktive Prinzip: Der Motor saß hinten, der Kofferraum vorne, so dass daraus ein vollwertiges Familienauto wurde.

© 14
Studebaker Champion, USA 1947

© 11
Chrysler Newport Town & Country, USA 1950

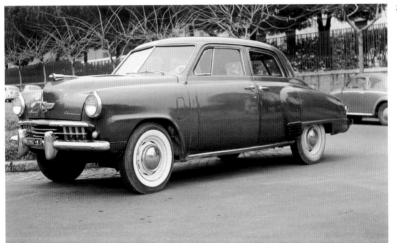

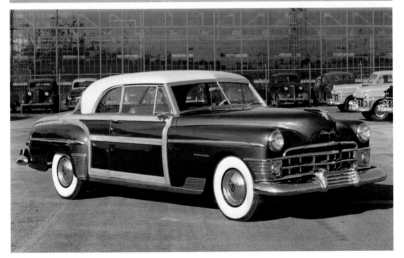

© 19
Alfa Romeo 1900, I 1950

© 18
Fiat 600, I 1955

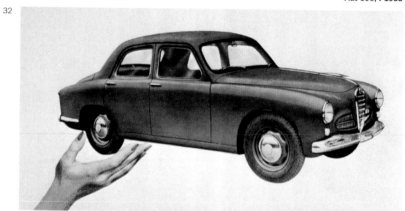

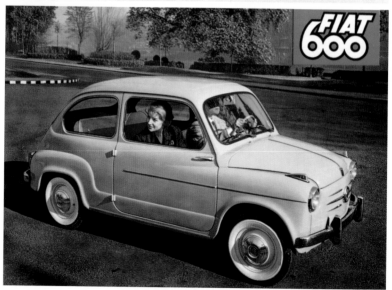

Soft Shell

L'intégration de toutes les pièces moulées donna naissance au design Soft Shell du début des années 50. En 1947, Raymond Loewy créa la typologie de la berline moderne à coffre avec le modèle Studebaker Champion. La partie arrière innovatrice faisant fonction de compartiment à bagages surprit les Américains qui demandèrent en souriant : which way is it going? Mais le concept des formes arrondies et fluides fut couronné de succès. Les lignes horizontales non interrompues entre les ailes remportèrent un succès mondial. Ford et General Motors ont suivi, en 1949, avec un design identique ; en Europe, le design Ponton Side s'est rapidement fait connaître : Rover, Alfa Romeo et Fiat furent les premiers producteurs à l'offrir. La simplicité de la forme est parfaitement adaptée à la technologie de la carrosserie autoporteuse et elle est facile à produire. Mais surtout, le nouveau design adapté aux dimensions modestes d'une voiture européenne était associé à une valeur utile élevée et à des proportions merveilleuses. Pour les petites voitures, le principe de construction s'inversait : le moteur à l'arrière et le coffre à bagages à l'avant en faisait une bonne voiture familiale.

La integración de todas las partes modeladas llevó al diseño Soft Shell de los tempranos años 50. Con el Studebaker Champion, Raymond Loewy inventó en 1947 la tipología de la moderna limusina con la parte trasera escalonada. La innovadora parte trasera con función de portaequipajes sorprendió a los americanos que se preguntaron sonriendo: which way is it going? Pero el concepto de las formas redondeadas y fluidas se convirtió en un éxito. Las líneas horizontales sin interrupción entre los guardabarros se convirtieron en la tendencia mundial. Ford y General Motors siguieron en 1949 con un diseño similar; en Europa, el llamado diseño Ponton Side creó escuela rápidamente: Rover, Alfa Romeo y Fiat estuvieron entre los primeros que lo ofrecieron. La sencillez de las formas se prestó excelentemente para la tecnología de la carrocería autoportante y es fácil de producir. Pero el nuevo diseño, trasladado a las medidas modestas de un automóvil europeo, estaba vinculado sobre todo a un alto valor útil y a unas magníficas proporciones. En el caso de los automóviles pequeños se dio la vuelta al principio constructivo: El motor estaba detrás, el portaequipajes delante, de modo que de él surgió un automóvil familiar perfectamente válido.

Flow Shell

In the 1950s, there was still no clear distinction between ordinary vehicles and racing cars: in the Mille Miglia, you were even allowed to celebrate the victory in your own family sedan. This situation led to a search for higher performance vehicles by improved aerodynamics and weight reduction, a fascinating area of research for European automobile manufacturers after the war. Of course, racing performance had to be linked to optimal everyday usage: The Berlinetta Granturismo was created, inspired by Pininfarina's Cisitalia 202. Design perfection was achieved by compact volume, modern proportions and clean lines. Key features: the hood for the engine is positioned flat and low between the fenders, generous glazing provides good visibility in all directions, the tail flows. The name Flow Shell is also inspired by these features. This design concept dominated European sports cars after the war until the 1970s. It was well suited to cars with a rear engine: the form of the first Porsche 356 was built in this style.

In den 50er Jahren gab es noch keine eindeutige Trennung zwischen Straßen- und Rennfahrzeugen: Sogar mit der familieneigenen Limousine durfte man um den Sieg bei der Mille Miglia fahren. Vor diesem Hintergrund wurde das Streben nach höheren Leistungen durch verbesserte Aerodynamik und Gewichtsreduktion zum faszinierenden Forschungsfeld für die europäischen Automobilkonstrukteure der Nachkriegszeit. Natürlich musste die sportliche Leistung mit optimaler Alltagstauglichkeit verbunden sein: Die Berlinetta Granturismo wurde geboren. Als Vorbild gilt Pininfarinas Cisitalia 202. Gestalterische Perfektion wurde durch kompaktes Volumen, moderne Proportionen und puristische Linien erreicht. Wichtige Merkmale: Die Motorhaube liegt flach und tief zwischen den Kotflügeln, die großzügige Verglasung bietet eine gute Aussicht in alle Richtungen, das Heck fließt. Hiervon inspiriert ist auch der Name Flow Shell. Dieses Designkonzept blieb typisch für europäische Sportautos der Nachkriegszeit bis in die 70er Jahre hinein, und eignete sich auch hervorragend für Autos mit Heckmotor: die Form des ersten Porsche 356 wurde in diesem Stil realisiert.

© 33
Cisitalia Tipo 202 berlinetta, I 1947
design: Pininfarina

© 13
Porsche 356, D 1951

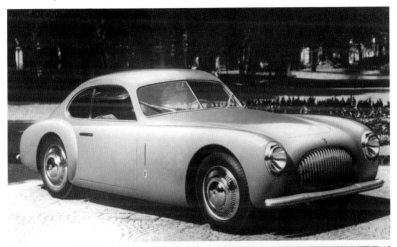

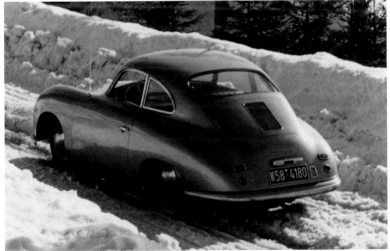

© 17
Alfa Romeo Giulietta sprint, I 1954
design: Bertone

© 17
Lancia Aurelia GT B20, I 1951
design: Boano
production: Pininfarina

36

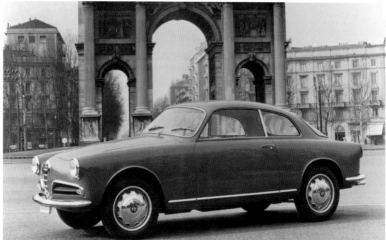

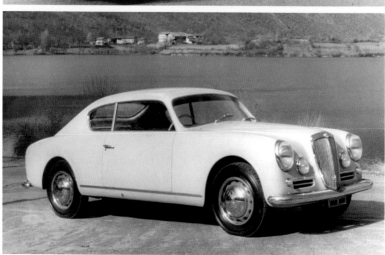

Flow Shell

Dans les années 50, il n'y avait pas de séparation nette entre les véhi-
cules de rue et les véhicules de course. On pouvait même participer à la
course Mille Miglia avec la berline familiale. Avec ce concept en arrière-
plan, le fascinant champ de recherche exploré par les constructeurs auto-
mobiles européens de l'après-guerre était voué à l'amélioration de
l'aérodynamique et à la réduction du poids pour augmenter les perfor-
mances. Naturellement, les performances sportives devaient être asso-
ciées à une qualité optimale pour l'utilisation de tous les jours. Cela
donna naissance à la Berlinetta Granturismo. Le résultat idéal est la Cis-
italia 202 de Pininfarina. La perfection de la conception a été atteinte
grâce à un volume compact, des proportions modernes et des lignes
pures. Caractéristiques essentielles : le capot du moteur est logé à plat
et en profondeur entre les ailes, le vitrage généreux offre une meilleure
vue dans toutes les directions, l'arrière est fluide. Le nom Flow Shell s'ins-
pire de ce concept. Ce design resta typique pour les voitures de sport
européennes d'après-guerre même dans les années 70, et il s'adaptait
également très bien aux voitures avec le moteur à l'arrière : la forme de
la première Porsche 356 fut conçue dans ce style.

En los años 50 todavía no existía una división clara entre vehículos de
carreras y vehículos para la carretera: Incluso con la propia limusina fami-
liar estaba permitido correr por la victoria en la Mille Miglia. Ante este tras-
fondo, el afán por rendimientos más elevados mediante una aerodinámica
mejorada y una reducción del peso se convirtió en el campo de investiga-
ción de los constructores europeos de automóviles de la posguerra.
Naturalmente, el rendimiento deportivo tenía que estar ligado a una apti-
tud óptima para la vida cotidiana: El Berlinetta Granturismo había nacido.
El Cisitalia 202 de Pininfarina está considerado como el ejemplo de esto.
La perfección en el diseño se consiguió mediante un volumen compacto,
unas proporciones modernas y líneas puristas. Características importan-
tes: El capó se encuentra plano y bajo entre los guardabarros, el genero-
so acristalamiento ofrece una buena visibilidad en todas las direcciones,
la parte trasera fluye. En esto está también inspirado el nombre Flow
Shell. Este concepto del diseño permaneció típico de los automóviles
deportivos de la posguerra hasta entrados los años 70 y sirvió también de
manera excelente para los automóviles con motor trasero: La forma del
primer Porsche 356 fue realizada en este estilo.

Rocket

During the war, the aircraft industry developed at lightning speed. Many engineers were occupied at that time with developing even faster aeroplanes and ultimate fighting machines. In the process, they fell in love with the look. Designers like Harley Earl, the mighty Vice President of GM who was in charge of styling, was even obsessed with the idea of combining cars and aircraft: despite the war, the Rocket became a style icon. While Eisenhower was pushing through total mobility and building gigantic highways, designers, not only in the US, flirted with the idea of building a car with a rocket-propelled jet look. The design elements produced a direct relationship between road and outer space: a projectile-like front, panoramic, dome-shaped roof, wings, fins and jet-pipes (they were originally intended for real jet engines). This is how fantastic dream cars were created that were naturally never built as a finished product. But they showed traces of the original design in other ways: the occasional fin, projectile-like bumper, nose like a rocket, or jet-stream tail light. Of course, chrome and acrylic glass were used everywhere. Although you can hardly take this automobile dream seriously, the child-like optimism and revolutionary vision even seems impressive today.

Während des Krieges entwickelte sich die Flugzeugindustrie rasant. Viele Ingenieure waren zu jener Zeit damit beschäftigt, schnellere Flugzeuge und ultimative Kriegsmaschinen zu entwickeln, und verliebten sich währenddessen in deren Ästhetik. Designer wie Harley Earl, der mächtige GM Vizepräsident für Styling, war sogar von der Idee besessen, Autos mit Flugzeugen zu kombinieren: Dem Krieg zum Trotz wurde die Rakete zu einer Ikone. Während Eisenhower das Projekt der totalen Mobilität einfädelte und gigantische Autobahnen baute, liebäugelten Designer – und das nicht nur in den USA – mit der Idee eines Autos im Jetraketenlook. Die gestalterischen Elemente stellen eine direkte Parallele zwischen Straße und Weltall her: Projektil-Front, Panorama-Kuppeldach, Flügel, Flossen und Jet-Röhren (die ursprünglich für echte Jet-Motoren vorgesehen waren). So entstanden wunderbare Traumautos, die selbstverständlich nie als Ganzes produziert wurden, aber dennoch anderorts viele Spuren hinterließen: mal eine Flosse, mal eine Projektil-Stoßstange, mal eine Raketennase, mal eine Jet-Strom-Rückleuchte. Überall war natürlich viel Chrom und Acrylglas zu finden. Auch wenn man diese Autovision nicht ganz ernst nehmen kann, beeindruckt ihre optimistische, revolutionäre Naivität noch heute.

© 23
Buick le Sabre, concept USA 1951

© 30
Chrysler 300 S Dart, concept I 1955
design: Ghia

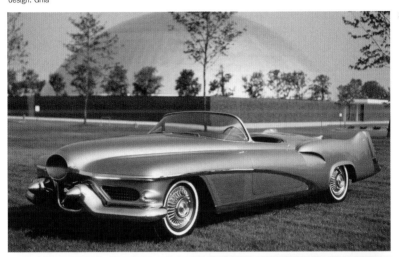

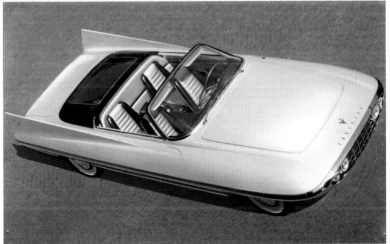

© 37
Alfa Romeo 1900 BAT 5, concept I 1953
design: Bertone

© 20
Ford La Tosca, concept USA 1955

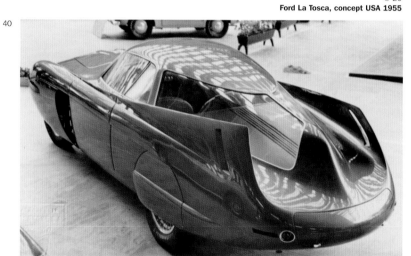

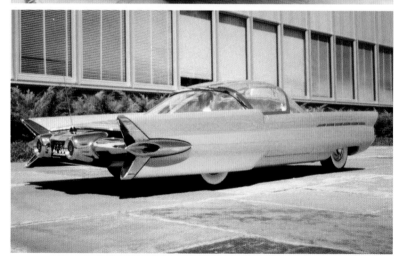

Rocket

Pendant la guerre, l'industrie aéronautique s'est développée extrême-
ment vite. De nombreux ingénieurs étaient occupés à développer des
avions plus rapides et des machines de guerre dont l'esthétique les fasci-
nait. Des concepteurs comme Harley Earl ou le puissant vice-président du
stylisme de GM étaient obnubilés par l'idée de combiner une voiture et un
avion : en dépit de la guerre, la fusée devint une icône. Pendant que
Eisenhower développait le projet de la mobilité totale et construisait des
autoroutes énormes, les concepteurs – et pas seulement aux Etats-Unis –
travaillaient à l'idée d'une voiture ressemblant à une fusée. Les éléments
conceptuels mettaient en parallèle direct la rue et le cosmos : avant pro-
jectile, toit panoramique en coupole, aileron, ailettes et tuyaux jet (conçus
à l'origine pour de vrais moteurs jet). Ainsi naquirent de merveilleuses voi-
tures de rêve, qui bien sûr ne furent pas produites en tant que tel mais lais-
sèrent de nombreuses traces dans d'autres domaines: soit une ailette, soit
un pare-chocs projectile, soit une pointe de fusée, soit un feu arrière de
fusée. Naturellement, on voyait partout beaucoup de chrome et de plexi-
glas. Même si cette vision automobile ne peut pas vraiment être prise au
sérieux, sa naïveté optimiste et révolutionnaire nous influence encore
aujourd'hui.

Durante la guerra, la industria aeronáutica se desarrolló muy rápidamen-
te. Por aquella época, muchos ingenieros se dedicaban a desarrollar avio-
nes más rápidos y la maquinaria de guerra más moderna y, mientras tanto,
se prendaron de su estética. Diseñadores como Harley Earl, el poderoso
vicepresidente de diseño de GM, estaba incluso obsesionado con la idea
de combinar automóviles con aviones: A pesar de la guerra, el cohete se
convirtió en un icono. Los elementos creativos producen un paralelo entre
la carretera y el cosmos: el frontal de un proyectil, la cúpula panorámica,
los alerones, los estabilizadores y los tubos de jet (inicialmente previstos
para los auténticos motores de los jet). Así surgieron maravillosos automó-
viles de ensueño que evidentemente nunca fueron producidos como un
conjunto pero, sin embargo, dejaron muchas huellas en otro lugar: aquí un
estabilizador, allí el parachoques de un proyectil, aquí el morro de un cohe-
te, allí las luces traseras de un jet-stream. Naturalmente, por todas partes
se podía encontrar mucho cromo y vidrio acrílico. Aunque esta visión de un
automóvil no puede tomarse totalmente en serio, su ingenuidad optimista
y revolucionaria todavía impresiona actualmente.

New Line

In the mid-1950s, a new aesthetic ideal established itself for the modern car. A flatter and wider body with a lower center of gravity promised to be more dynamic in a way that was supposed to have an effect not only optically, but also in car performance. All metal surfaces were kept flat and straight: cars gradually became more horizontal and geometrical. To emphasize this dynamic movement, for the first time, the trim marking the car on the side profile from one fender to another was clearly marked on a level with the windows. Often a second, matching line was added and centrally positioned to cut the side into two parts on a horizontal profile. In particular, Pininfarina's special V-angle, introduced almost simultaneously in the Nash Ambassador and Lancia Flaminia, made the cars look flatter and more slender than ever. The essence of the New Line was discovered. However, since there was still no sensible alternative to the large, round headlights, it was still not possible yet to say a final farewell to the past.

Mitte der 50er Jahre etablierte sich ein neues Schönheitsideal für das moderne Automobil. Eine flachere und breitere Karosserie mit niedrigerem Schwerpunkt versprach eine größere Dynamik, die sich nicht nur optisch, sondern auch in der Fahrleistung bemerkbar machen sollte. Alle Blechflächen blieben flach und gerade gehalten: Autos wurden allmählich horizontaler und geometrischer. Um den dynamischen Schwung zu betonen, wurde zum ersten Mal jene Gürtellinie deutlich erkennbar gemacht, die das Auto seitlich von Kotflügel zu Kotflügel auf Höhe der Fenster markiert. Mit dieser Linie korrespondierte oft eine zweite Linie, die mittig angebracht wurde, um die Seite horizontal zweizuteilen. Vor allem Pininfarinas besondere V-Winkel, nahezu gleichzeitig im Nash Ambassador und Lancia Flaminia eingeführt, ließ die Autos optisch flacher und schlanker denn je wirken. Das Fundament der New Line war gefunden: Wegen der großen, runden Scheinwerfer, zu denen es noch keine vernünftige Alternative gab, konnte man sich aber vom Gesicht der Vergangenheit noch nicht endgültig trennen.

© 11
Chrysler New Yorker Deluxe, USA 1955

© 33
Nash Ambassador, concept I 1955
design: Pininfarina

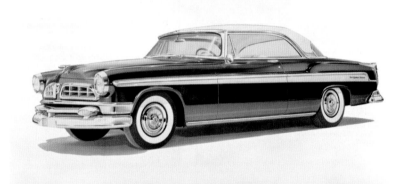

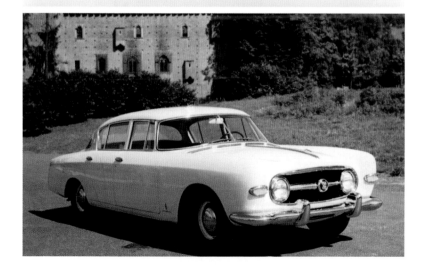

© 21
Continental MK II hardtop coupe, USA 1956

© 18
Lancia Flaminia berlina prototipo, I 1956
design: Pininfarina

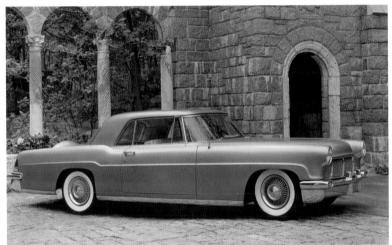

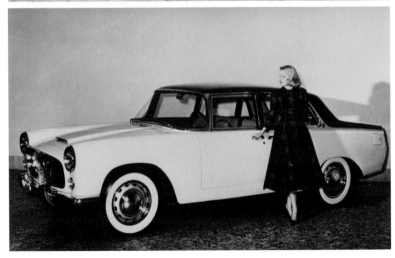

New Line

En pleines années 50, un nouvel idéal de beauté de la voiture moder-
ne s'établit. Une carrosserie plus plate et plus large avec un centre de
gravité plus bas promettait une plus grande dynamique qui devait se faire
remarquer dans l'optique mais aussi dans les performances de la voitu-
re. Toutes les surfaces en tôle étaient plates et droites : les voitures
devinrent progressivement plus horizontales et géométriques. Pour
accentuer la ligne dynamique, la ligne de ceinture fut clairement souli-
gnée, pour la première fois, d'une aile à l'autre à la hauteur de la fenê-
tre. A cette ligne correspondait souvent une seconde ligne qui, au milieu,
divisait horizontalement le flanc en deux parties. Surtout l'angle en V de
Pininfarina, presque simultanément utilisé pour la Nash Ambassador et la
Lancia Flaminia firent apparaître les voitures plus plates et plus minces
que jamais. La base de la New Line avait été découverte mais à cause
des gros phares ronds pour lesquels aucune solution de remplacement
n'existait encore, on ne pouvait pas encore se séparer définitivement du
visage du passé.

A mediados de los años 50 se estableció un nuevo ideal de belleza
para el automóvil moderno. Una carrocería más plana y más ancha con
el centro de gravedad más bajo prometía una mayor dinámica que habría
de hacerse notar no sólo en la óptica sino también en el rendimiento.
Todas las superficies de metal se mantuvieron planas y rectas: Los auto-
móviles se volvieron progresivamente más horizontales y geométricos.
Para acentuar el impulso dinámico se hicieron visibles por primera vez
aquellos bajos que marcan el automóvil lateralmente de guardabarros a
guardabarros a la altura de las ventanas. Con esta línea se correspondió
a menudo una segunda línea colocada centralmente para dividir los lados
horizontalmente en dos. Sobre todo el especial ángulo V de Pininfarina,
introducido casi al mismo tiempo en el Nash Ambassador y el Lancia
Flaminia, hizo que los automóviles parecieran visualmente más planos y
delgados que nunca. El fundamento de New Line había sido hallado: Pero
a causa de los grandes faros redondos, para los que todavía no había
alternativa, uno todavía no podía separarse definitivamente de la cara del
pasado.

Baroque

By 1948, the Cadillac already included small tail-fins, which in terms of their look were reminisicent of the Lockhheed P 38 fighter aircraft. These even appear elegant today. Additionally, in the early 1950s, tail-fins on sports cars were also a sign of aerodynamic perfection, which was a favourite European experimental project. The fact that this rocket design feature turned into an icon of an arbitrary era of Detroit Baroque is a phenomenon that is only to be explained by a collective design euphoria, which lasted exactly five years. Between 1955 and 1959, cars in the USA became bigger, brighter, shinier and more eccentric than ever. There were no design rules, only an obsession with building bigger and better and a certain showmanship. This was precisely the right thing for a society full of stars who were caught up in a permanent class conflict among themselves, as described by Vance Packard in his 1959 "The Status Seekers". The trend lasted for a fairly long time and so reached Europe as well. Nevertheless, from 1960, the fins suddenly grew smaller and the chrome and colours became more modest: even the designers had obviously seen enough.

Bereits 1948 trug der Cadillac als ästhetische Reminiszenz an das Kampfflugzeug Lockheed P38 kleine Heckflossen, die aus heutiger Perspektive sogar elegant aussehen. Darüber hinaus waren Anfang der 50er Jahre Heckflossen auf Sportautos ein Zeichen aerodynamischer Perfektion, mit dem man auch in Europa gerne experimentierte. Dass dieses Gestaltungselement im Rocket Design zur Ikone der willkürlichen Zeit der Detroiter Baroque wurde, ist ein Phänomen, das sich nur mit einer kollektiven Designeuphorie erklären lässt, die genau 5 Jahre dauerte. Zwischen 1955 und 1959 wurden Autos aus den USA größer, bunter, glänzender und skurriler denn je. Gestalterische Regeln gab es keine, nur eine Obsession für das Mehr und den gewissen Showeffekt: genau das Richtige für eine Gesellschaft, deren Prominenz sich in einem ständigen Klassenkampf untereinander befand, wie von Vance Packard in „The Status Seekers" von 1959 beschrieben. Der Trend dauerte länger an und erreichte so auch Europa, dennoch wurden ab 1960 die Flossen plötzlich kleiner, der Chrom und die Farben dezenter: selbst die Designer waren offensichtlich übersättigt.

© 21
Ford Fairlane 500 4dr Victoria, USA 1957

© 11
Chrysler New Yorker hardtop coupe, USA 1957

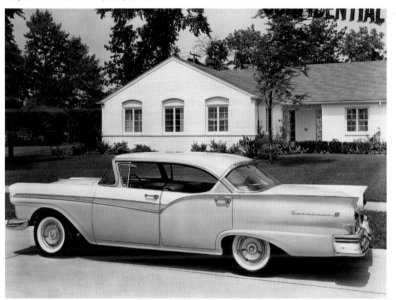

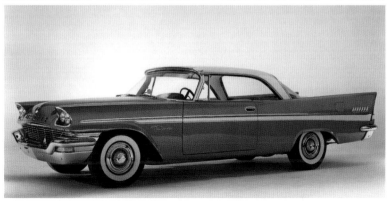

© 21
Cadillac Eldorado Brougham, USA 1957

© 21
Cadillac Eldorado Biarritz, USA 1959

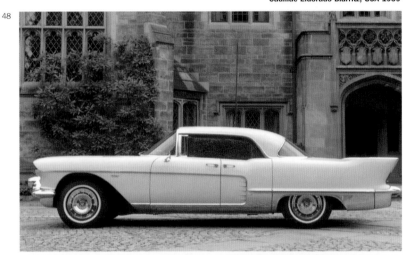

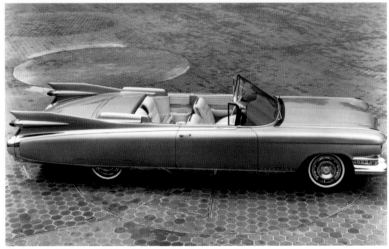

Baroque

Dès 1948, la Cadillac disposait d'ailettes arrière, une réminiscence
esthétique de l'avion de combat Lockheed P38, qui dans une perspecti-
ve actuelle fait encore preuve d'élégance. Au début des années 50, les
ailettes arrière sur les voitures de sport étaient synonymes de perfection
aérodynamique, avec laquelle on expérimentait aussi volontiers en
Europe. Que cet élément conceptuel devienne l'icône du design Rocket
au temps arbitraire du Baroque de Detroit est un phénomème qui ne peut
s'expliquer que par l'euphorie collective du design qui dura exactement 5
ans. Entre 1955 et 1959, les voitures aux Etats-Unis devinrent plus gran-
des, plus colorées, plus brillantes et plus bizarres que jamais. Il n'existait
pas de règles de conception mais seulement une obsession pour l'excès
et l'effet de show : c'était exactement ce dont avait besoin la société,
dont les célébrités se livraient à un combat incessant de classes, comme
le décrit Vance Packard dans « The Status Seekers » en 1959. Cette
mode dura longtemps et atteint aussi l'Europe, mais à partir de 1960, les
ailettes devinrent soudain plus petites, le chrome et les couleurs plus
décentes : même les concepteurs étaient apparemment saturés.

Ya en 1948 el Cadillac llevaba pequeños estabilizadores traseros como
una reminiscencia estética del avión de combate Lockheed P38 que,
desde una perspectiva actual, aparecen incluso elegantes. Más allá, a
principios de los años 50, los estabilizadores traseros en los automóviles
deportivos fueron un signo de perfección aerodinámica con el que tam-
bién gustó experimentar en Europa. Que este elemento creador en el
diseño Rocket se convirtiera en el icono de la época arbitraria del
Baroque de Detroit es un fenómeno que sólo puede explicarse con la
euforia colectiva por el diseño que duró justamente 5 años. Entre 1955
y 1959 los automóviles de los EEUU se volvieron más grandes, con más
colorido, más brillantes y extravagantes que nunca. No existían reglas de
diseño, solamente una obsesión por el "más" y un cierto efecto de show:
Justo lo apropiado para una sociedad cuyas celebridades se encontraban
en una continua lucha de clases entre ellas, como lo describió Vance
Packard en "The Status Seekers" de 1959. La moda duró más tiempo y
así llegó también a Europa; sin embargo, a partir de 1960 los estabiliza-
dores se volvieron más pequeños, el cromo y los colores más discretos:
incluso los diseñadores estaban claramente sobresaturados.

Edge Line

After the Baroque period, there is a noticeable need for more design clarity. The principles of New Line were adopted once again, but in a more radical way: the Lancia Flaminia with special body-work by Boneschi seems almost minimalist in comparison to contemporary cars. The trend is for edge—orthogonal surfaces, sharp lines. It hardly matters whether they are spartan or sophisticated, cars in Edge Line Design are meant to project precision and functionality. Smaller, double headlights, which were verticially and horizontally aligned, later even rectangular lights, made it possible for greater freedom in the process of modeling the front part; and a more accentuated V-angle was often the way of modeling the side. At the same time, an effort was made for greater efficiency of form: functionality turned into a design theme. The wheels became smaller to make more space for the interior. This also contributed to a more modern appearance. These measures also met the needs of new consumers: the 1964 Renault 16 was an invention of the flexible, dual capacity car with a large roof over the trunk and variable interior design. The trend showed potential and continued to be developed well into the 1980s.

Nach der Baroque-Zeit wird der Bedarf nach größerer gestalterischer Klarheit spürbar, die Prinzipien der New Line werden wieder aufgenommen und radikalisiert: Der Lancia Flaminia mit Spezial-Karosserie von Boneschi wirkt gegenüber zeitgenössischen Autos fast minimalistisch. Das Eckige – orthogonale Flächen, scharfe Kanten – wurde zur Mode. Egal ob spartanisch oder raffiniert, Autos im Edge Line Design sollten Präzision und Funktionalität ausstrahlen. Kleinere Doppelscheinwerfer, vertikal oder horizontal angeordnet, später sogar rechteckige Leuchten ermöglichten mehr Freiheit in der Gestaltung der Frontpartie; ein starker V-Winkel modellierte oft die Seite. Gleichzeitig strebte man nach einer höheren Effizienz der Form: Funktionalität wurde zum gestalterischen Thema. Um mehr Platz für den Innenraum zu gewinnen, wurden die Räder kleiner, was zugleich zu einem moderneren Aussehen beitrug. Derart wurde auch den Bedürfnissen der neuen Konsumenten entsprochen: mit dem Renault 16 von 1964 wurde das flexible Zwei-Volumen Auto mit großer Heckklappe und variabler Innenausstattung erfunden. Der Trend bewies Potenzial und entwickelte sich weiter, bis in die 80er Jahre hinein.

© 18
Lancia Flaminia convertibile, concept I 1961
design: Carrozzeria Boneschi

© 22
Pontiac Grand Prix Sport Coupe, USA 1963

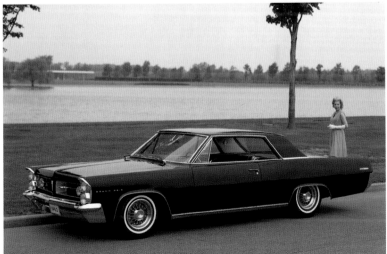

© 17
Fiat 130 berlina, I 1969

© 21
Ford Granada, D 1977

52

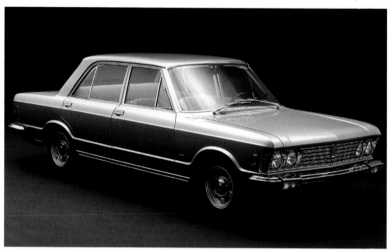

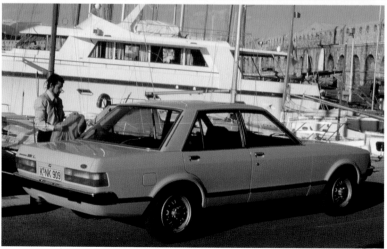

Edge line

Après le Baroque, un besoin de plus grande clarté de conception se fit sentir, les principes de la New Line furent repris et radicalisés : la Lancia Flaminia avec la carrosserie spéciale de Boneschi paraît presque réduite à un minimum par rapport aux voitures de l'époque. Les surfaces orthogonales, les arêtes vives deviennent à la mode. Spartiates ou raffinées, les voitures au design Edge Line devaient rayonner par leur précision et fonctionalité. Des phares doubles plus petits alignés à la verticale ou à l'horizontale et plus tard même rectangulaires, apportaient plus de liberté dans la conception de la partie avant ; un angle en V modelait souvent les flancs. Simultanément, on recherchait une plus grande efficacité des formes: la fonctionalité devint le thème conceptuel. Afin de gagner de l'espace pour l'habitacle, les roues devinrent plus petites, ce qui contribua à donner à la voiture une allure plus moderne. Ainsi furent satisfaits les besoins des nouveaux consommateurs: avec la Renault 16 de 1964 fut conçue une voiture flexible à deux volumes équipée d'un grand hayon arrière et d'une garniture intérieure variable. Cette tendance démontra son potentiel et se développa jusque dans les années 80.

Tras la época del Baroque se hace sentir la necesidad de una mayor claridad creadora, los principios de New Line se retoman y radicalizan: El Lancia Flaminia con la carrocería especial de Boneschi aparece casi minimalista frente a los automóviles coetáneos. Lo angular –superficies ortogonales, cantos agudos– se convirtió en moda. Igual si eran austeros o refinados, los automóviles en diseño Edge Line habían de irradiar precisión y funcionalidad. Los faros dobles más pequeños, colocados vertical u horizontalmente, más tarde incluso las luces rectangulares, hicieron posible más libertad en la configuración de la parte frontal; un intenso ángulo V modeló a menudo el lateral. Al mismo tiempo, se aspiró a una mayor eficiencia en la forma: La funcionalidad se convirtió en el tema del diseño. Para ganar más espacio en el habitáculo interior, las ruedas se volvieron más pequeñas lo que contribuyó al mismo tiempo a un aspecto más moderno. Tal cosa satisfizo también las necesidades de los nuevos consumidores: Con el Renault 16 de 1964 se inventó el flexible automóvil de dos volúmenes con un gran portón trasero y un equipamiento interior variable. La tendencia demostró potencial y continuó desarrollándose hasta entrados los 80.

Flow Line

At the beginning of the 1960s, Flow Line emerged as a contrast to Edge Line. In Flow Line, new formal elements were translated into a soft, flowing form. This meant that modern proportions were retained, but now they were modeled in slightly convex metal surfaces. The line in a side profile could still be made out, but no drastic interventions were carried out and any edges were rounded off. 1958 was the year of Giovanni Michelotti's Triumph Italia. In particular, the prototype model with plexiglass covers on the headlights was a forerunner of this design trend. Whether in the angular shape of the Lincoln Continental or the round Ford Taunus 17m (nick-named the "Bath"), the cars in Flow Line Design appear surprisingly clean and respectable, as though they had been caressed by the wind. The Flow Line Design of the late 1960s already went out of fashion, as it was more classical and less radical than the Edge Line Design. One exception was Pininfarina's BMC 1800. This represented a new type of Fastback sedan; and although it was never produced, it inspired many cars in the 1970s.

Flow Line stellte sich Anfang der 60er Jahre als Pendant zur Edge Line vor, wobei hier die neuen formalen Elemente in eine weiche, fließende Form übersetzt wurden. So blieben die modernen Proportionen erhalten, wurden aber nun mit leicht konvexen Blechflächen modelliert. Die Seitenlinie war zwar spürbar, aber auf markante Eingriffe wurde verzichtet; die Kanten wurden abgerundet. 1958 war Giovanni Michelottis Triumph Italia, vor allem in der Prototypversion mit Plexiglas-Scheinwerferabdeckung, ein Vorreiter dieser Designrichtung. Ob eckiger, wie der Lincoln Continental, oder runder, wie der Ford Taunus 17m (auch „Badewanne" genannt), wirken Autos im Flow Line Design erstaunlich pur und dezent, als ob sie vom Wind gestreichelt würden. Klassischer und weniger radikal als das Edge Line Design, war das Flow Line Design Ende der 60er Jahre bereits aus der Mode. Mit einer Ausnahme: Pininfarinas BMC 1800 stellte die neue Typologie der Fastback-Limousine vor; und obwohl sie nicht produziert wurde, hat sie doch viele Autos der 70er Jahre inspiriert.

© 14
Triumph TR3 Italia, concept I 1958
design: Michelotti

© 21
Lincoln Continental convertible sedan, USA 1962

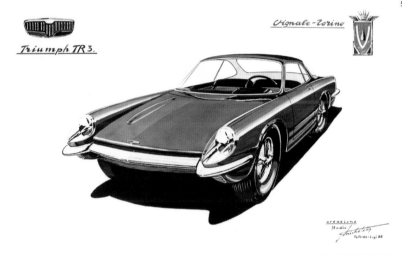

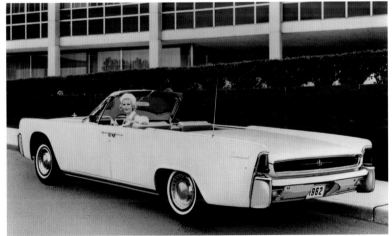

© 28
Rover P6 3500, GB 1963

© 33
BMC 1800, concept I 1967
design: Pininfarina

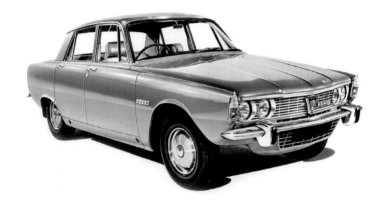

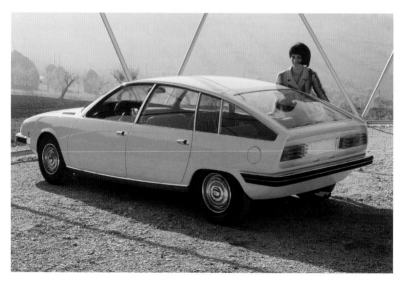

Flow Line

Au début des années 60, Flow Line apparut comme l'homologue de Edge Line mais n'en était qu'une interprétation, avec des nouveaux éléments aux formes plus fluides et plus souples. Les proportions modernes furent conservées mais les surfaces de tôle furent modelées de manière légèrement convexe. La ligne latérale était identifiable mais on évita des modifications trop prononcées et les arêtes s'arrondirent. En 1958, la Triumph Italia de Giovanni Michelotti était à l'avant-garde, surtout dans la version prototype avec la couverture des phares en plexiglas. Que le design soit anguleux comme pour la Lincoln Continental ou arrondi comme pour la Ford Taunus 17m (appelée également « baignoire »), les voitures de design Flow Line produisent un effet étonnamment pur et décent, comme si elles avaient été caressées par le vent. Le design Edge Line plus classique et moins radical que le Flow Line fut démodé à la fin des années 60. A une seule exception : la BMC 1800 de Pininfarina présentait la nouvelle typologie de la berline Fastback ; et bien qu'elle n'ait pas été produite, elle a inspiré de nombreuses voitures des années 70.

El diseño Flow Line se presentó a principios de los años 60 como una réplica del Edge Line a lo cual los nuevos elementos formales se tradujeron aquí en una forma suave y fluida. Así, se mantuvieron las proporciones modernas aunque ahora fueron modeladas con superficies de metal ligeramente convexas. Aunque la línea lateral era perceptible, se renunció a marcados engranajes; Los cantos se redondearon. En 1958, el Triumph Italia de Giovanni Michelotti, sobre todo en la versión prototipo con recubrimiento de los faros con plexiglás, fue un precursor de esta tendencia del diseño. Tanto los más angulosos, como el Lincoln Continental, como los más redondos, como el Ford Taunus 17 m (también llamado "Bañera"), los automóviles en diseño Flow Line aparecen sorprendentemente puros y discretos como si hubiesen sido acariciados por el viento. Más clásico y menos radical que el diseño Edge Line, el diseño Flow Line ya estaba pasado de moda a finales de los 60. Con una excepción: El BMC 1800 de Pininfarina representó la nueva tipología de la limusina Fastback; y aunque no fue producida, inspiró muchos automóviles de los años 70.

Wedge Line

The first radical break with the past occurred in 1968, the very same year as a cultural revolution hit society at large. The break could actually not have been more revolutionary: the front part of the Alfa Romeo 33, Carabo by Bertone and the Bizzarrina Manta by Italdesign, was basically scrapped because of the introduction of Wedge Line. This changed the face of what was up to then without doubt the most important identifying feature of any automobile. This undifferentiated look with folding headlights is the most democratic design feature ever to be produced: it meant the abolition of brand differentiation in terms of design. The arrow-shaped body, whose absolutely geometrical shape was responsible for a new design paradigm, was meant to suggest dynamics and wind resistance. It was not only essential for all sports cars with central or front engine, but it also became popular in family sedans. The Alfa Romeo Giulietta, which was criticized in 1977 due to its short and high tail, suddenly shifted the proportions of classical sedans. Since then, Wedge Line has been an important element of car design.

Der erste radikale Schnitt mit der Vergangenheit fand 1968 statt, genau jenem Jahr also, in dem die gesamte Gesellschaft eine Kulturrevolution durchlief. Revolutionärer hätte der Schnitt tatsächlich nicht sein können: beim Alfa Romeo 33 Carabo von Bertone und dem Bizzarrini Manta von Italdesign wurde die Frontpartie durch die Einführung der Wedge Line grundsätzlich abgeschafft. Somit wurde auch das Gesicht, ohne Zweifel bis dato das wichtigste Erkennungsmerkmal eines Automobils, abrasiert. Diese undifferenzierte Erscheinung mit Klappscheinwerfern ist das demokratischste Designelement, das je produziert wurde: sie bedeutete die Abschaffung der Markendifferenzierung in konzeptioneller Hinsicht. Die keilförmige Karosserie, deren absolute Geometrie für einen Paradigmenwechsel der Gestaltung verantwortlich war, sollte Dynamik und Windschnittigkeit suggerieren. Sie war nicht nur ein Muss für alle Sportautos mit Mittel- oder Frontmotor, sondern setzte sich auch im Bereich der Familienautos durch. Der Alfa Romeo Giulietta, 1977 wegen seines kurzen, hohen Hecks kritisiert, verschob auf einmal die Proportionen der klassischen Stufenhecklimousinen. Wedge Line ist seitdem ein wichtiges Element im Automobildesign.

© 25
Bizzarrini Manta, concept I 1968
design: Giugiaro

© 4
Lamborghini LP 500 Countach, I 1971
design: Bertone

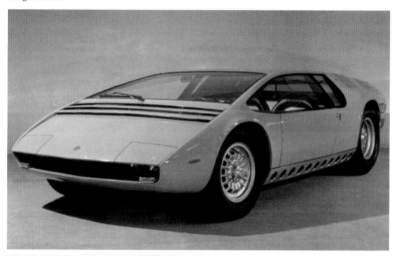

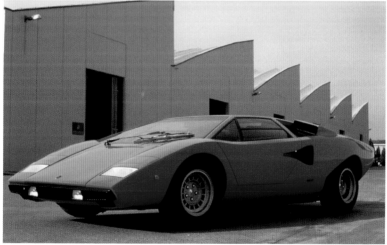

© 19
Alfa Romeo Giulietta, I 1977

© 15
Lotus Elite, GB 1974

60

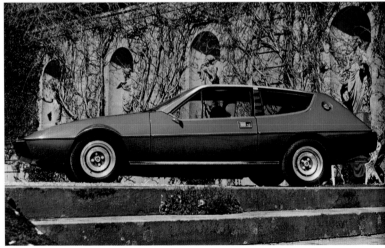

Wedge Line

La première coupure radicale avec le passé se produisit en 1968, exactement l'année où la société entière vécut une révolution culturelle. La coupure n'aurait pas pu être plus révolutionnaire : la partie frontale de l'Alfa Romeo 33 Carabo de Bertone et de la Bizzarrini Manta de Italdesign fut abolie lorsque la Wedge Line fut adoptée. La face, le signe distinctif le plus important de la voiture jusqu'à cette date, fut ainsi rasée. Cette vision neutre à phares rétractables est l'élément de design le plus démocratique qui fut jamais produit : elle annulait les différences entre les marques du point de vue de la conception. La carrosserie cunéiforme, dont la géométrie absolue était responsable d'un changement de paradigme dans la conception, devait suggérer la dynamique et l'aérodynamisme. Elle était non seulement une obligation pour les voitures de sport à moteur frontal ou central, mais s'établissait aussi dans le domaine des voitures familiales. L'Alfa Romeo Giulietta, critiquée en 1977 à cause de son arrière court et haut, modifia soudain les proportions de la berline classique à coffre. La Wedge Line est depuis lors un élément important du design automobile.

El primer corte radical con el pasado tuvo lugar en 1968, o sea, justamente aquel año en que toda la sociedad pasó por una revolución cultural. De hecho, el corte no podía haber sido más revolucionario: En el Alfa Romeo 33 Carabo de Bertone y el Bizzarrini Manta de Italdesign, la parte frontal fue eliminada básicamente mediante la introducción de Wedge Line. Con ello se afeitó también la cara, hasta ahora sin duda el distintivo más importante de un automóvil. Esta apariencia indiferenciada con faros abatibles es el elemento de diseño más democrático que se había producido nunca: En lo que se refiere a la concepción, esto significa la eliminación de la diferenciación de marcas. La carrocería cuneiforme, cuya geometría absoluta fue responsable de un cambio de paradigma del diseño, había de sugerir dinámica y aerodinámica. No fue solamente una obligación para todos los automóviles deportivos con motor frontal o central sino que también se impuso en el ámbito de los automóviles familiares. El Alfa Romeo Giulietta, criticado en 1977 por su parte trasera corta y alta, desplazó de pronto las proporciones de las clásicas limusinas con la parte trasera escalonada. Wedge Line constituye, desde entonces, un elemento importante en el diseño del automóvil.

New Baroque

In the USA, car design never really moved out of the 1950s. After Edge Line Design produced a few beautiful and many non-descript vehicles, car manufacturers in the late 1960s rediscovered old values. In a new way, cars once again turned baroque. Two modeling elements stayed in the memory. First, the prominent radiator grill, modeled to project outwards and given the nickname "Knudsen Nose" by the then President of Ford. Secondly, the bent shape set into the side profile, corresponding to the C-column, a novelty of the 1964 Ford Mustang. In design terms, this was reminiscient of the curvy line of classical fenders. In addition, eccentric new discoveries, like the vinal roof of the Cabrio and accentuating spokes on wheel caps. Ford and GM also introduced this fashion in Europe, but there is no doubt that New Baroque was much better suited to American dimensions. When US cars also had to be made much smaller in the 1980s, this style at first seemed ridiculous before finally fading into obscurity.

Das Automobildesign in den USA hatte die 50er Jahre nie richtig hinter sich gelassen. Nachdem das Edge Line Design wenige wunderschöne und viele undifferenzierte Fahrzeuge produziert hatte, fanden die Automobilhersteller in den späten 60ern zu alten Werten zurück. So wurden die Autos auf eine neue Art und Weise wieder barock. Zwei gestalterische Elemente bleiben in Erinnerung: der nach außen gezogene, prominente Kühlergrill, nach dem damaligen Präsidenten von Ford auch „Knudsen-Nase" genannt, und der mit der C-Säule korrespondierende Knick an der Seite, der eine Neuheit des 1964er Ford Mustang war und formal an den Schwung klassischer Kotflügel erinnerte. Dazu kamen skurrile Neuentdeckungen wie das Vinyldach im Cabrio- und die Radkappen im Speichenstil. Durch Ford und GM kam diese Mode auch nach Europa; zweifellos passte der New Baroque aber viel besser zu den amerikanischen Dimensionen. Als auch die US-Autos in den 80er Jahre kleiner werden mussten, rutschte der Stil zuerst ins Lächerliche und schließlich in die Vergessenheit.

© 22
Cadillac Fleetwood Eldorado, USA 1967

© 21
Ford LTD Brougham, USA 1971

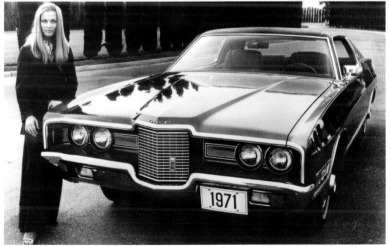

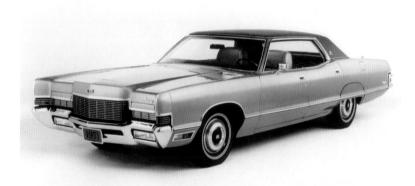

New Baroque

Aux Etats-Unis, le design automobile des années 50 n'avait jamais vraiment disparu. Après que le design Edge Line eut produit moins de voitures merveilleuses et plus de voitures indifférenciées, les fabricants d'automobiles de la fin des années 60 retrouvèrent les anciennes valeurs. Les voitures redevinrent baroques mais d'une nouvelle manière. Deux éléments de conception restaient en mémoire : la calandre extériorisée et proéminente, appelée «nez Knudsen» en hommage à l'ex-président de Ford, et le coude sur le flanc au niveau du support C qui était une nouveauté de la Ford Mustang de 1964 et qui rappelait l'élan de l'aile classique. En outre, des inventions bizarres comme le toit en vinyle pour les cabriolets et les enjoliveurs dans le style rayon firent leur apparition. Grâce à Ford et GM, cette mode arriva également en Europe mais le New Baroque correspondait mieux, sans aucun doute, aux dimensions américaines. Lorsque les voitures américaines durent aussi diminuer de taille dans les années 80, le style tourna d'abord au ridicule puis tomba finalement dans l'oubli.

El diseño del automóvil en los EEUU nunca había dejado los años 50 verdaderamente atrás. Después de que el diseño Edge Line hubiera producido pocos automóviles bellísimos y muchos vehículos indiferenciados, los fabricantes de automóviles encontraron en los tardíos años 60 el camino de regreso a viejos valores. Así, los automóviles volvieron a ser barrocos de una nueva manera. Dos elementos del diseño quedan en el recuerdo: La prominente parrilla del radiador estirada hacia fuera, llamada también "Nariz de Knudsen" por el entonces presidente de Ford, y el pliegue en el lado correspondiendo con el pilar C que fue una novedad del Ford Mustang de 1964 y formalmente recordaba a la curva de los guardabarros clásicos. A ello se añadieron nuevos descubrimientos extravagantes como el techo de vinilo en el estilo Cabrio y los tapacubos en el estilo de rayos. A través de Ford y GM esta moda llegó también a Europa; pero, sin duda, el New Baroque se adaptó mucho mejor a las dimensiones americanas. Cuando en los años 80 también los automóviles de los EEUU hubieron de volverse más pequeños, el estilo se deslizó primero en lo ridículo y, finalmente, en el olvido.

Edge Box

The 1973 Oil Crisis was a cold shower for the automobile industry, which catered for steady growth. It was even suggested that there was no future for the motor car. Adjustment plans were introduced which were so radical that even programms already running were delayed or completely stopped. When the crisis was finally over, it was time to bring in new cars. Compact, dual capacity vehicles with optimal use of space and economic appearance were preferred. At the same time, the industry began to use plastics. Wherever shiny chrome was the standard before, now grey or black plastic was used: the matt, black look that was reserved for rally and sports cars towards the end of the 1960s now became a mega hit. To save on development costs, the producers began to work on Global Cars—rationality was the order of the day. Giorgio Giugiaro started to experiment with a new kind of automobile architecture: a more compact and higher style for increased space and smaller exterior mass. The clean, smart Edge Box Design, naturally with rectangular headlights, became the new fashion. Giugiaro's prototype of the Lancia Megagamma was the inspiration for an entire generation of station wagons.

Die Ölkrise von 1973 bedeutete eine kalte Dusche für die Automobilindustrie, die auf ständiges Wachstum ausgerichtet war. Es wurde sogar behauptet, dass es keine Zukunft mehr für das Automobil gäbe. Es kam zu derart radikalen Veränderungsplänen, dass sogar laufende Programme verschoben oder ganz gestoppt wurden. Als die Krise schließlich vorbei war, wurde es auch Zeit für neue Autos. Kompakte Zwei-Volumen-Autos mit optimaler Raumnutzung und ökonomischem Aussehen wurden bevorzugt. Gleichzeitig begann die Industrie, Kunststoffe einzusetzen. Wo früher glänzender Chrom auftrat, stand nun graues oder schwarzes Plastik: Die mattschwarze Ästhetik, die gegen Ende der 60er Jahre Rallye- und Sportautos vorbehalten war, wurde zum Megatrend. Um Entwicklungskosten zu sparen, begannen die Hersteller an Global Cars zu arbeiten – Rationalität war angesagt. Giorgio Giugiaro fing an, mit einer neuen Automobil-Architektur zu experimentieren: kompakter und höher für mehr Raumangebot bei kleineren Außenmassen. Das saubere, vernünftige Edge Box Design – natürlich mit rechteckigen Scheinwerfern – wurde zum Trend, Giugiaros Prototyp des Lancia Megagamma zum Vorbild für eine ganze Generation von Großraumfahrzeugen.

© 40
Volkswagen Golf, D 1974
design: Giugiaro

© 11
Dodge Omni, USA 1978

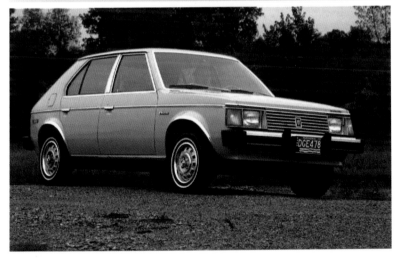

© 25
Lancia Megagamma, concept I 1978
design: Giugiaro

© 36
Renault Espace, F 1984

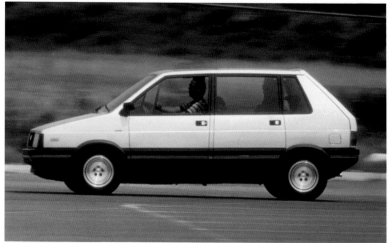

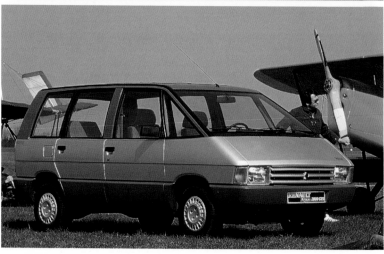

Edge Box

La crise pétrolière de 1973 fut une douche froide pour l'industrie auto-
mobile qui était programmée pour une croissance continue. Et même, on
prétendit qu'il n'y avait plus d'avenir pour les voitures. Il y eut des modifi-
cations radicales des plans et certains programmes en cours furent
repoussés ou interrompus. Quand la crise fut passée, on était prêt pour
de nouvelles voitures. Les voitures à deux volumes avec une utilisation
optimale de l'espace et un aspect économique eurent la préférence.
Simultanément, l'industrie commença à utiliser les matières synthétiques.
Là où le chrome brillait auparavant, on trouvait maintenant un plastique
gris ou noir : l'esthétique en noir mat qui était réservée aux voitures de ral-
lye ou de sport à la fin des années 60 devint la grande mode. Pour éco-
nomiser sur les coûts de développement, les constructeurs commencèrent
à travailler sur les voitures globales (Global Car). La rationalité était
demandée. Giorgio Giugiaro commença à expérimenter une nouvelle ar-
chitecture automobile : plus compacte et plus haute pour offrir plus d'es-
pace avec des dimensions extérieures réduites. Le design Edge Box pro-
pre et raisonnable – bien sûr avec des phares rectangulaires – devint la
nouvelle vogue ; le prototype Lancia Megagamma de Giugiaro devint un
modèle pour toute une génération de véhicules à grande capacité.

La crisis del petróleo de 1973 significó una ducha fría para la industria
automovilística que estaba orientada hacia un crecimiento constante.
Incluso se afirmó que no había futuro para el automóvil. Se llegó a seme-
jantes planes radicales de cambios que incluso programas en marcha se
aplazaron o detuvieron por completo. Cuando finalmente pasó la crisis,
llegó también el momento de los automóviles nuevos. Se prefirieron los
automóviles compactos de dos volúmenes con un aprovechamiento del
espacio óptimo y una apariencia económica. Al mismo tiempo, la industria
comenzó a utilizar materiales sintéticos. La estética del negro mate, que
hacia finales de los 60 se había reservado para los automóviles de rally y
deportivos, se convirtió en una súper-moda. La racionalidad hacía furor.
Giorgio Giugiaro empezó a experimentar con una nueva arquitectura del
automóvil: más compactos y más altos para una mayor oferta del espacio
en unas dimensiones exteriores más pequeñas. El diseño Edge Box, esme-
rado y racional, naturalmente con faros rectangulares, se convirtió en la
moda, el prototipo de Giugiaro del Lancia Megagamma en el modelo para
una generación entera de vehículos de gran capacidad.

Graph

In the 1970s, the use of unpainted, plastic components established itself. These had already been seen in the form of bumpers on the 1971 Ferrari 365 GTC4 and the 1972 Renault 5. The designers soon began to experiment with the possibilities of this material. For that reason, the body was often structured in an upper, attractive part out of lacquered metal and a lower, functional part out of grey plastic. Even Mercedes adapted this principle and applied it for the first time in its 1979 S-Class. Pininfarina even went so far as to separate both parts completely and in this way he discovered his characteristic side section in the style of Fontana. Plastic was also used as an integral part of the entire front and tail ends, as an additional spoiler or as a graphic element to emphasize the line of the side profile. This graphic game led to the Graph Design. After many 1970s cars underwent rejuvenation with a plastic makeover, frequently with ridiculous results, the matt, black look of the early 1990s was finally at an end.

In den 70er Jahren etablierte sich die Anwendung von unlackierten Kunststoffteilen, wie man sie schon in Form von Stoßstangen am 1971er Ferrari 365 GTC4 und im 1972er Renault 5 gesehen hatte. Die Designer fingen bald an, mit den Möglichkeiten dieses Materials zu experimentie-ren. So wurde die Karosserie oft in einen oberen, ästhetischen Teil aus lackiertem Metall und in einen unteren, funktionalen Teil aus grauem Kunststoff gegliedert. Auch Mercedes adaptierte dieses Prinzip, zum ersten Mal bei seiner S-Klasse von 1979. Pininfarina ging sogar so weit, beide Teile komplett voneinander zu trennen und fand auf diesem Wege seinen charakteristischen Seitenschnitt à la Fontana. Auch als integraler Teil der gesamten Front- und Heckpartie, als zusätzlicher Spoiler oder als graphisches Element zur Betonung der seitlichen Linie fand der Kunststoff Anwendung. Aus diesem graphischen Spiel heraus entstand das Graph Design. Nachdem viele Autos der 70er mit einer Kunststoffkur verjüngt worden waren – oft mit skurrilen Ergebnissen –, war die mattschwarze Ästhetik Anfang der 90er Jahre endgültig vorbei.

© 17
Fiat Ritmo, I 1978

© 33
Peugeot 104 Peugette, concept I 1976
design: Pininfarina

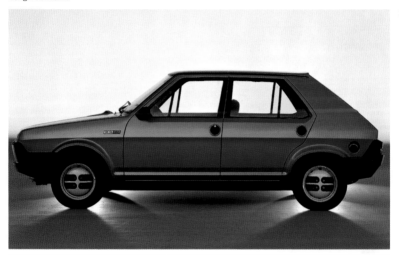

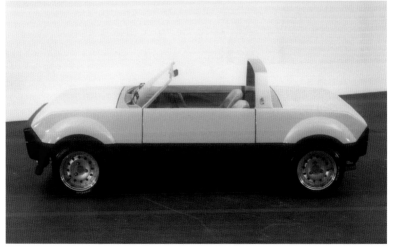

© 17
Alfa Romeo 33, I 1983

© 35
Renault R18 Turbo, F 1980

72

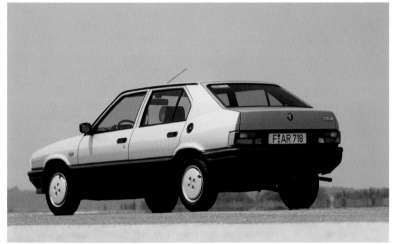

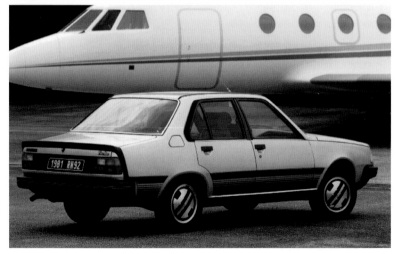

Graph

Dans les années 70, s'établit l'usage de pièces en matière synthétique
non laquée telles que le pare-chocs de la Ferrari 365 GTC4 en 1971 et
de la Renault 5 en 1972. Les concepteurs commencèrent bientôt à expé-
rimenter les possibilités offertes par ce matériau. Souvent la carrosserie
se composait d'une partie supérieure esthétique en métal laqué et d'une
partie inférieure fonctionnelle en synthétique gris. Mercedes adopta éga-
lement ce principe pour la première fois dans sa série classe S de 1979.
Pininfarina poussa jusqu'à séparer complètement les deux parties et
aboutit ainsi à sa coupe latérale typique à la Fontana. La matière syn-
thétique fut aussi utilisée comme partie intégrante de l'avant et de l'ar-
rière, comme becquet supplémentaire ou comme élément graphique pour
souligner la ligne latérale. Ce jeu graphique donna naissance au design
Graph. Après la cure de rajeunissement au synthétique que subirent de
nombreuses voitures des années 70 – avec des résultats souvent bizar-
res –, l'esthétique du noir mat disparut au début des années 90.

En los años 70 se estableció la aplicación de partes sintéticas no bar-
nizadas como ya se habían visto en forma de parachoques en el Ferrari
365 GTC4 de 1971 y en el Renault 5 de 1972. Pronto los diseñadores
comenzaron a experimentar con las posibilidades de este material. De
esta manera, la carrocería se dividió con frecuencia en una estética parte
superior de metal barnizado y en una parte inferior funcional de material
sintético gris. También Mercedes adaptó este principio por primera vez en
su clase S de 1979. Pininfarina fue incluso más lejos al separar por com-
pleto ambas partes una de la otra encontrando así su característico corte
lateral a la Fontana. El material sintético también encontró aplicación
como parte integral de la totalidad de las zonas frontal y trasera como
spoiler adicional o como elemento gráfico que acentuara la línea lateral.
De este juego gráfico surgió el Graph Design. Después de que muchos
automóviles de los años 70 hubieran sido rejuvenecidos con una cura de
material sintético –a menudo con resultados extravagantes–, la estética
del negro mate había terminado definitivamente a principios de los años
90.

Flow Box

In addition to rationality, aerodynamics once again became an important trend from the 1970s. This time, aerodynamics had less to do with speed than reducing consumption: without rockets and wings, an attempt was to make more economic vehicles for everyday usage. A renaissance followed of smooth, flowing forms with softer edges. The front of the vehicle and also the windshield were angled more steeply and all irregularities were resolved. Side windows, headlights and bumpers were integrated without any breaks in the body. This is how the new Flow Box style emerged: suddenly round and soft was in again; and at the end of the 1980s, cars in Edge Box Design were totally out. The newer Flow Box models differ in terms of their modeling origins from those of the Flow Shell period. In the early 1990s, three-dimensional computer modeling was quickly established and this enabled a much more complex structuring of surfaces. However, these were often exaggerated: bodies with a variable radius and multi-oval forms appeared so strange that today, without showing much emotion, we speak of an insignificant Vanilla Design.

Neben Rationalität wurde ab den 70er Jahren die Aerodynamik wieder zu einem wichtigen Trendfaktor. Diesmal hatte Aerodynamik weniger mit Geschwindigkeit als mit der Reduktion des Verbrauchs zu tun: Fernab von Raketen und Flügeln versuchte man, Alltagsautos ökonomischer zu machen. Dies bedeutete eine Renaissance für sauber fließende Formen mit weicheren Kanten. Die Front und auch die Windschutzscheibe wurden stärker geneigt, alle Unebenheiten gelöst. Seitenscheiben, Scheinwerfer und Stoßstangen wurden ohne Unterbrechung in die Karosserie integriert. So entstand der neue Flow Box Stil: plötzlich war rund und weich wieder Trend; Autos im Edge Box Design waren Ende der 80er Jahre völlig out. Die neueren Flow Box-Modelle unterscheiden sich in ihrer gestalterischen Herkunft von denen der Flow Shell-Zeit. Die 3D-Arbeit am Computer, die sich mit Beginn der 90er Jahre schnell etablierte, ermöglichte eine viel komplexere Gestaltung der Oberflächen. Diese wurde allerdings oft übertrieben: Karosserien mit variablen Radien und multiovalen Formen wirken so seltsam, dass man heute ohne große Emotion vom bedeutungslosen Vanilla-Design spricht.

© 36
Renault R14, F 1976

© 20
Ford Thunderbird, USA 1983

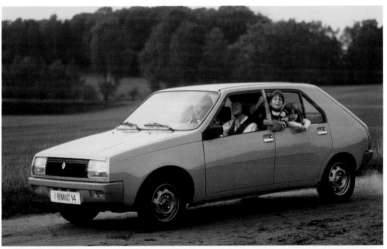

© 38
Toyota Previa, J 1990

© 20
Ford Taurus Wagon, USA 1996
(photo 1999)

Flow Box

En plus de la rationalité, l'aérodynamique redevint un facteur en vogue important. Cette fois l'aérodynamique s'attaquait davantage à la réduction de la consommation qu'à la vitesse : bien loin des fusées et des ailettes, on essayait de rendre les voitures du quotidien plus économiques. Cela signifiait la renaissance des formes nettes et fluides avec des arêtes plus douces. L'avant et le pare-brise devinrent beaucoup inclinés et toutes les irrégularités gommées. Les glaces latérales, les phares et les pare-chocs furent intégrés à la carrosserie, sans interruption. Ainsi naquit le style Flow Box : tout à coup, la mode du rond et du doux réapparut ; à la fin des années 80, les voitures de design Edge Box étaient totalement démodées. Les nouveaux modèles Flow Box se distinguent de ceux de l'époque Flow Shell par l'origine de la conception. Le travail à l'ordinateur en 3-D qui s'établit rapidement au début des années 90 permit une conception beaucoup plus complexe des surfaces. Cependant, ceci conduisit à une certaine exagération : les carrosseries à rayons variables et aux formes multi-ovales produisent un effet bizarre que l'on peut qualifier de design Vanille insignifiant, sans ressentir de grande émotion.

Junto a la racionalidad, a partir de los años 70 la aerodinámica se convirtió nuevamente en un importante factor de moda. Esta vez la aerodinámica tenía menos que ver con la velocidad que con la reducción del consumo: Lejos de los cohetes y los alerones se intentaron hacer automóviles cotidianos más económicos. Esto significó un renacimiento de las formas que fluyen limpiamente con cantos suaves. La parte frontal y también el parabrisas fueron inclinados más intensamente, todas las irregularidades se eliminaron. Las ventanas laterales, los faros y los parachoques fueron integrados sin interrupción en la carrocería. Así surgió el nuevo estilo Flow Box: de repente, lo redondo y lo suave estaban nuevamente de moda; los automóviles en diseño Edge Box estaban totalmente pasados de moda a finales de los años 80. Los modelos Flow Box más modernos se diferencian de los de la época del Flow Shell en la procedencia de su diseño. El trabajo en 3D con el ordenador, que a principios de los 90 se estableció rápidamente, hizo posible una configuración mucho más compleja de las superficies. Sin embargo, éstas se exageraron a menudo: Las carrocerías con radios variables y formas multiovales aparecen tan extrañas que hoy se habla, sin gran emoción, del insignificante diseño Vainilla.

Retro

The rational car certainly saved the industry's life, but it also made many customers unhappy. Trusty, cruel and economic: the customer can suffer as well due to so much efficiency. Indeed, the automobile industry in the 1980s was marked by two phenomena: the birth of the 'Tuner' that was to turn ordinary cars into something special; and the old timer cult. It was clear that more emotion was needed. Nostalgia seemed the best source for this. In 1989, Mazda unveiled the Miata, which was not only the first new Roadster worldwide for many years, but also seemed to be an imitation of a 1960s British Roadster. It became a cult vehicle and inspired a Retro wave in car design that continues to this very day. No matter whether it was the forties, fifties or sixties, the future was often inspired by an imaginary past. A special category of Retro is the Remake: if you have a brand, show it off. Past models were re-issued with an identical name and look, except that performance and construction were adapted to the new market. The New Beetle and Mini are the first in a long list.

Das rationale Auto hatte zwar der Industrie das Leben gerettet, aber viele Kunden unzufrieden gemacht. Seriosität, Grausamkeit, Ökonomie: unter so viel Effizienz kann man auch leiden. Tatsächlich wurde die Automobilszene der 80er Jahre durch zwei Phänomene geprägt: die Geburt der „Tuner", die gewöhnliche Autos zu Besonderheiten machen sollen, und der Kult um den Oldtimer. Klar war: man brauchte mehr Emotion. Die Wiederentdeckung der Vergangenheit schien die beste Quelle dafür zu sein. 1989 präsentierte Mazda den Miata, der nicht nur weltweit der erste neue Roadster seit vielen Jahren war, sondern auch noch einem britischen Roadster der 60er Jahre wie nachgemacht zu sein schien. Das Fahrzeug wurde zum Kult und löste eine Retrowelle im Automobildesign aus, die noch bis heute andauert. Egal ob 40er, 50er oder 60er, die Zukunft bezog ihre Inspiration oft aus einer imaginären Vergangenheit. Eine besondere Kategorie von Retro ist das Remake: wer eine Marke hat, der zeigt Sie. Modelle der Vergangenheit wurden mit identischem Namen und Look wieder editiert, nur die Leistungen und die Konstruktion passten sich dem neuen Markt an. Der New Beetle und der Mini sind die ersten in einer langen Reihe.

© 27
Mazda MX5 Miata, J 1989

© 10
Chrysler PT Cruiser, USA 1999

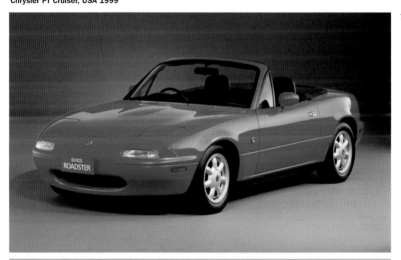

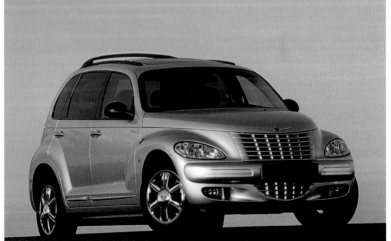

© 39
Volkswagen New Beetle, D 1998
(concept 1994)

© 7
Mini One, GB 2002
(concept 1997)

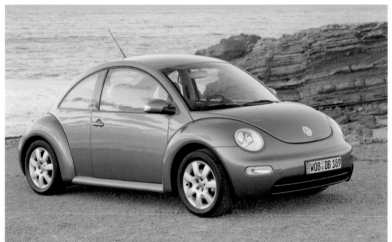

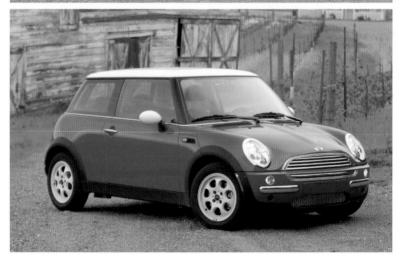

Retro

La voiture rationnelle a sauvé la vie de l'industrie mais a déçu de nom-
breux clients. Sérieux, cruauté, économie : autant d'efficacité peut aussi
faire souffrir. En effet, le monde automobile des années 80 a été façon-
né par deux phénomènes : la naissance des « Tuner » qui doivent trans-
former les voitures ordinaires en voitures spéciales et le culte des
anciennes voitures. Une chose était évidente : on avait besoin d'émotion.
La redécouverte du passé apparut comme la meilleure source. En 1989,
Mazda présenta la Miata qui était non seulement le premier Roadster
depuis longtemps mais qui semblait aussi être une copie du cabriolet
anglais des années 60. Le véhicule devint un mythe et déclencha une
vague Retro dans le design automobile, qui dure encore aujourd'hui. Que
ce soit les années 40, 50 ou 60, le futur prit souvent son inspiration dans
un passé imaginaire. Le remake est une catégorie particulière du Retro :
qui possède un objet de marque le montre. Les modèles du passé furent
de nouveau édités avec un nom et un aspect identique, seules les per-
formances et la construction s'adaptaient au nouveau marché. La New
Beetle et la Mini sont les premières d'une longue série.

Aunque el automóvil racional había salvado la vida a la industria, había
causado la insatisfacción de muchos clientes. Seriedad, crueldad, eco-
nomía: Bajo tanta eficiencia también se puede sufrir. De hecho, la esce-
na del automóvil de los años 80 fue caracterizada por dos fenómenos: El
nacimiento de los "Tuner", que habían de hacer especiales a los auto-
móviles normales, y el culto a los coches antiguos. Estaba claro: Se
necesitaba más emoción. El redescubrimiento del pasado parecía ser su
mejor fuente. En 1989 Mazda presentó el Miata, que no sólo fue el pri-
mer Roadster nuevo a nivel mundial desde hacía muchos años, sino que
incluso también parecía haber sido calcado de un Roadster británico de
los años 60. El automóvil se convirtió en un mito y desató una oleada
Retro en el diseño automovilístico que todavía perdura hasta hoy. Tanto
en los 40, como en los 50 o los 60, el futuro con frecuencia tomó su
inspiración de un pasado imaginario. Una categoría especial de lo Retro
es el remake: Quien tiene una marca, la muestra. Los modelos del pasa-
do fueron editados nuevamente con nombre y look idénticos, solamente
las prestaciones y la construcción se adaptaron al nuevo mercado. El
New Beetle y el Mini son los primeros de una larga serie.

New Edge Box

As a reaction to the ubiquitous, characterless Vanilla styles, in the late 1990s, a new repertoire of detail was the focus of experiment: New Edge. In principle, this is a fusion of Edge, Flow and Graph elements: rounded forms flow into sharp edges and pointed angles and this is how they become more interesting. As the side profile of the 1998 Mercedes A-Class shows, the glass-work was proportioned in a new way, often resulting in a quite extraordinary, deconstructivist appearance. At the same time, entirely new character expressions emerged from new and more complex forms of headlights that were created by plastic work. The early Ford models in New Edge Design set new trends that almost every other manufacturer followed: suddenly, nearly all cars in Flow Box Design had to be modernized. Flow Box had died and at the turn of the twentieth century the market was ripe for a new development.

Als Reaktion auf die allgemeingültigen, charakterlosen Vanilla-Formen wird Ende der 90er Jahre mit einer neuen Detailsprache experimentiert: die des New Edge. Im Prinzip geht es um eine Fusion von Edge-, Flow- und Graph-Elementen, wobei rundliche Formen mit scharfen Kanten und spitzen Winkeln ineinander fließen und so interessanter werden. Wie die Seite der Mercedes A-Klasse von 1998 beweist, wurde die Verglasung neuartig geteilt, woraus oft ein recht außergewöhnliches, dekonstruktivistisches Erscheinungsbild resultierte. Gleichzeitig entwickeln sich durch die neuen, komplexeren Scheinwerferformen, die die Kunststofftechnik ermöglicht, völlig neue Gesichtsausdrücke. Die ersten Ford-Modelle im New Edge Design setzten Trends, denen fast jeder folgte: nahezu alle Autos im Flow Box Design mussten plötzlich aktualisiert werden. Flow Box war gestorben, und zur Jahrtausendwende war der Markt reif für eine Neuentwicklung.

© 12
Mercedes Benz A-Klasse, D 1997

© 21
Ford Focus, D 1998

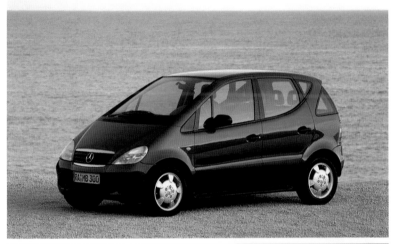

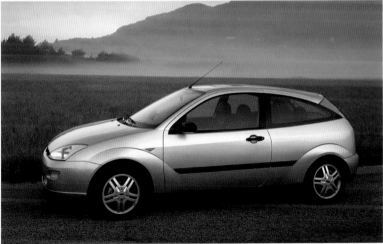

© 20
Mercury Cougar, USA 1999

© 1
Opel Corsa, D 2000

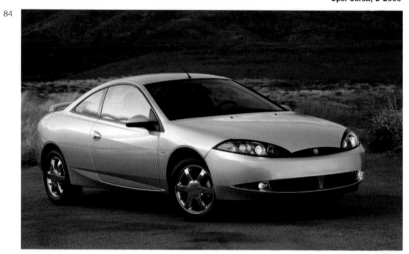

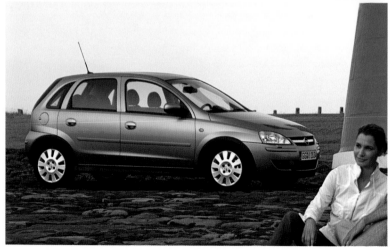

New Edge Box

Pour réagir aux formes Vanille banales, on expérimente un nouveau
langage des détails à la fin des années 90 : celui du New Edge. Il s'agit
d'une fusion des éléments Edge, Flow et Graph dans laquelle les formes
arrondies à arêtes vives et aux angles pointus se combinent et deviennent
ainsi plus intéressantes. Comme la partie latérale de la Mercedes de la
classe A de 1998 le prouve, le vitrage a été divisé d'une nouvelle ma-
nière aboutissant à un objet inhabituel et déconstructiviste. Simulta-
nément, les nouvelles formes complexes de phare issues de la technique
du synthétique permettent de façonner de toutes nouvelles faces. Les
premiers modèles de Ford en design New Edge lancent la mode que la
plupart suivent : presque toutes les voitures de design Flow Box doivent
soudain être actualisées. Le design Flow Box était mort, et au change-
ment de millénaire, le marché était prêt pour une nouvelle évolution.

Como reacción a las formas Vainilla, universales y sin carácter, se expe-
rimenta a finales de los años 90 con un nuevo lenguaje del detalle: el del
New Edge. En principio se trata de una fusión de elementos del Edge,
Flow y el Graph, a lo cual las formas redondeadas con cantos pronun-
ciados y ángulos agudos fluyen unas en las otras volviéndose así más
interesantes. Como lo muestra el lateral del Mercedes Clase-A de 1998,
el acristalamiento fue dividido de una manera moderna de lo cual resul-
tó a menudo un aspecto verdaderamente excepcional y deconstructivista.
Al mismo tiempo se desarrollan expresiones de la cara completamente
nuevas por medio de las nuevas formas más complejas de los faros que
hace posible la técnica del material sintético. Los primeros modelos de
Ford en diseño New Edge marcaron tendencias que casi todos siguieron:
Prácticamente todos los automóviles en diseño Flow Box hubieron de ser
actualizados de repente. Flow Box había muerto y, para el cambio de
milenio, el mercado estaba maduro para un nuevo desarrollo.

Trends

Smooth Body

Two factors are especially important to follow the development of to-day's car design: speed and brand names. Due to more intense global competition and market saturation, every type of model has a shorter and shorter lifespan. A higher pace of innovation is called for and design loses stability. Brand features are becoming increasingly important, since in-stead of assuming general trends, individual design languages are de-veloping, which attempt to link a brand's heritage with its future. Due to the necessity of market concentration, this phenomenon is the incentive for new design languages in the future: individuality plays the key role. This is especially important because new product niches—so-called Crossovers—are being discovered that basically require an entirely new design language.

The Smooth Body trend is the ideal successor of Flow Line and Flow Box: clean lines, elegant look and an aerodynmic feel.

Zwei Faktoren sind von besonderer Bedeutung, um die Entstehung des heutigen Automobildesigns nachzuvollziehen: Geschwindigkeit und Branding. Aufgrund des verstärkten globalen Wettbewerbs und der gesät-tigten Marksituation wird der Lebenszyklus eines jeden Automodells immer kürzer. Eine höhere Innovationsrate ist notwendig, und das Design verliert an Stabilität. Branding-Aspekte gewinnen immer mehr an Be-deutung, denn anstatt von allgemeinen Trends auszugehen, entwickeln sich individuelle Designsprachen, die Markenerbe und Markenzukunft zu verbinden versuchen. Aufgrund der Notwendigkeit der Markenkon-zentration wird dieses Phänomen zum Auslöser für neue Designsprachen der Zukunft: Individualität spielt die zentrale Rolle. Diese ist vor allem deswegen notwendig, weil neue Produktnischen – die so genannten Crossovers – entdeckt werden, die grundsätzlich eine neue Design-sprache erfordern.

Der Smooth Body Trend ist die ideelle Fortsetzung der Flow Line und Flow Box: saubere Linienführung, elegantes Aussehen, aerodynamisches Feeling.

© 20
Ford Thunderbird, USA 1989

© 2
Audi TT, D 1998
(concept 1995)

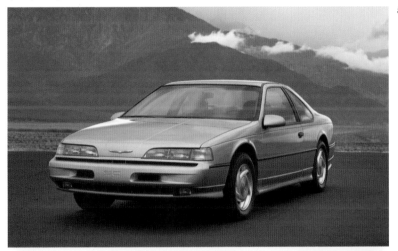

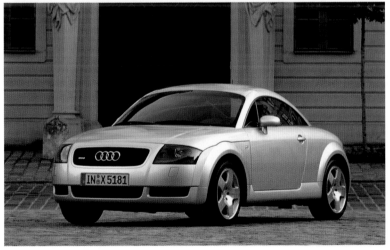

© 32
Peugeot 406 coupé, F 1997

© 10
Chrysler Concorde, USA 1998

88

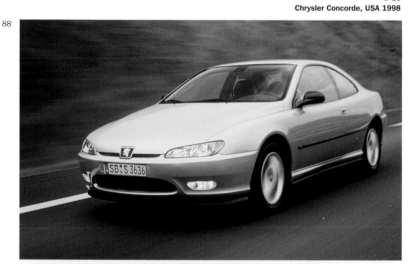

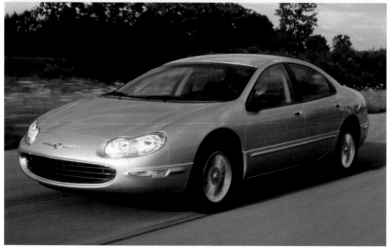

Smooth Body

Deux facteurs sont essentiels pour comprendre la naissance de la con-
ception automobile actuelle : la vitesse et la création de marque
(Branding). En raison de la concurrence globale accrue et de la satura-
tion du marché, le cycle de vie d'un modèle de voiture devient toujours
plus court. Il est nécessaire d'innover plus et le design perd de sa stabi-
lité. Les aspects du Branding gagnent de l'importance et au lieu de se
baser sur une mode générale, on développe des langages individuels de
design qui essaient de relier l'héritage de la marque et son avenir. Vu la
nécessité de la concentration des marques, ce phénomène sert de
déclencheur pour les nouveaux langages du design de l'avenir : l'indivi-
dualité joue le rôle principal. Ceci est surtout nécessaire parce que de
nouvelles niches de production (Crossovers) sont découvertes et qu'elles
nécessitent un nouveau langage du design.

La mode du Smooth Body est la suite idéale de Flow Line et Flow Box :
lignes nettes, aspect élégant, sensation aérodynamique.

Dos factores son de especial importancia para comprender el surgi-
miento del diseño automovilístico actual: velocidad y branding. A causa
de la creciente competencia global y de la saturada situación del merca-
do, el ciclo vital de cada modelo de automóvil es cada vez más corto. Una
tasa más elevada de innovación es necesaria y el diseño pierde estabili-
dad. Los aspectos del branding ganan cada vez más importancia pues, en
lugar de partir de tendencias generales, se desarrollan lenguajes indivi-
duales del diseño que intentan unir los herederos de las marcas y el futu-
ro de éstas. A causa de la necesidad de la concentración de marcas, este
fenómeno se convierte en el detonante de nuevos lenguajes de diseño
para el futuro: La individualidad juega el papel central y es especialmen-
te necesaria porque se descubren nuevas demandas de productos –los
llamados crossovers– que básicamente demandan un nuevo lenguaje del
diseño.

La tendencia Smooth Body es la continuación ideal de Flow Line y Flow
Box: un trazado de líneas limpio, una apariencia elegante, un feeling
aerodinámico.

Edge Body

Everything is in the detail: not only the external form, but also the interior of the head- and tail lights are now carefully designed.
The use of more plastic even for entire body parts meets new saftey standards and also means that a much more flexible form-language is possible. The body is basically strongly modeled, which guarantees more character. The disadvantage: nowadays cars are bigger, higher and fatter than they ever were before.

The Edge Body trend is a rediscovery and further development of Edge Line, Flow Line and New Baroque. These cars are characterized by a confrontation of straight surfaces and complete edges. A high trim and minimal glazing emphasize safety and solidity.

Alles im Detail: Nicht nur die äußere Form, sondern auch das Innenleben von Scheinwerfern und Rückleuchten wird nun sorgfältig designt. Der verstärkte Einsatz von Kunststoff auch für ganze Körperteile dient den neuen Sicherheitsvorschriften und ermöglicht zudem eine viel flexiblere Formensprache. Der Körper wird grundsätzlich stark modelliert, was für mehr Charakter sorgt. Der Nachteil: Autos sind heute größer, höher und fetter als sie es jemals waren.

Der Edge Body Trend ist eine Wiederentdeckung und Weiterentwicklung von Edge Line, Flow Line and New Baroque. Solche Autos charakterisiert eine Auseinandersetzung von geraden Flächen und vollen Kanten. Hohe Gürtellinie und kleine Verglasung betonen Sicherheit und Solidität.

© 20
Lincoln Sentinel, USA 1996

© 22
Cadillac XLR, USA 2002

© 10
Chrysler 300 C Touring, USA 2003

© 4
Lamborghini Gallardo, I 2003

Edge Body

Tout en détail: non seulement la forme extérieure mais aussi la vie inté-
rieure des phares et des feux arrière est soigneusement conçue.
L'utilisation poussée des matières synthétiques, même pour des parties
entières du corps, répond aux nouvelles règles de sécurité et permet éga-
lement un langage des formes beaucoup plus flexible. Le corps est pro-
fondément modelé, ce qui lui apporte plus de caractère. L'inconvénient :
les voitures sont plus grandes, plus hautes et plus grosses qu'elles ne
l'ont jamais été.

La mode Edge Body est à la fois une redécouverte et un perfectionne-
ment de l'esthétique Edge Line, Flow Line et New Baroque. Ces voitures
sont caractérisées par un contraste de surfaces plates et d'arêtes plei-
nes. Une ligne de ceinture élevée et un vitrage réduit soulignent la sécu-
rité et la solidité.

Todo con detalle: No solamente la forma externa, sino también la vida
interior de los faros y las luces traseras son diseñadas ahora cuidadosa-
mente. La utilización más intensa del material sintético también para par-
tes enteras del cuerpo es buena para las nuevas normas de seguridad y
a-demás hace posible un lenguaje de formas mucho más flexible.
Básicamente, el cuerpo es modelado con intensidad lo que proporciona
más carácter. La desventaja: Los automóviles son hoy más grandes, más
altos y más gruesos de lo que lo habían sido nunca.

La tendencia Edge Body es un redescubrimiento y un desarrollo de Edge
Line, Flow Line y New Baroque. Tales automóviles se caracterizan por un
contraste de las superficies rectas y los cantos redondeados. Los bajos
elevados y un pequeño acristalamiento acentúan la seguridad y la
solidez.

Carved Body

94 **Nowadays, cars** tend to be generally viewed as a body. The finished process of integration ensures an absolutely organic form. Glass surfaces are basically larger, panoramic windows are again in fashion as they were in the 1950s. With all additional elements already integrated into the body, the details are more important and become identifying features. To fulfil brand needs, modeling and marking the front part of the vehicle continues as the most important design theme.

The Carved Body trend is a continuation of New Edge with Graph influences. The car forms are very sculptured, to suggest dynamics and lightness.

Autos werden heutzutage gemeinhin als Körper betrachtet. Der vollendete Integrationsprozess sorgt für eine absolut organische Form. Glasflächen werden grundsätzliche größer, Panoramagläser wie in den 50er Jahren sind wieder im Trend. Da alle zusätzlichen Elemente bereits in die Karosserie integriert sind, gewinnen Details an Bedeutung und werden zum Erkennungsmerkmal. Um Branding-Aspekte zu erfüllen, bleibt die Gestaltung und Markierung der Frontpartie nach wie vor das wichtigste Thema beim Design.

Der Carved Body Trend ist eine Weiterentwicklung von New Edge mit Graph-Einflüssen. Autoformen werden sehr skulptural modelliert, um Dynamik und Leichtigkeit zu suggerieren.

© 35
Renault Avantime, F 1999

© 17
Fiat Stilo, I 2002

© 20
Volvo S80, S 1998

© 38
Lexus IS 200, J 1998

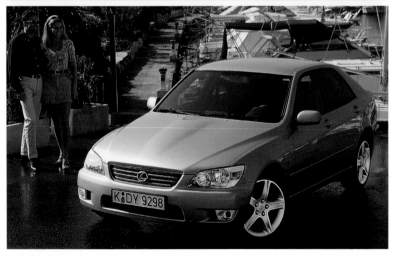

Carved Body

De nos jours, les voitures sont considérées d'ordinaire comme des corps. Le processus d'intégration complet crée une forme absolument organique. Les surfaces en verre sont plus grandes, les verres panoramiques comme dans les années 50 sont de nouveau à la mode.

Etant donné que tous les éléments sont déjà intégrés dans la carrosserie, les détails prennent de l'importance et deviennent des signes caractéristiques. Afin de satisfaire les aspects du Branding, la conception et le repérage de l'avant deviennent, comme auparavant, les sujets les plus importants.

La mode Carved Body est l'évolution du design New Edge avec des influences Graph. Les formes des voitures sont modelées comme des sculptures afin de suggérer dynamique et légèreté.

Los automóviles son considerados actualmente como cuerpos. El proceso de integración concluido proporciona una forma absolutamente orgánica. Las superficies de cristal se vuelven básicamente más grandes, los cristales panorámicos como en los 50 están nuevamente de moda.

Como todos los elementos adicionales ya están integrados en la carrocería, los detalles ganan importancia y se convierten en la característica distintiva. Para cumplir con los aspectos del branding, la configuración y la acentuación de la parte frontal siguen siendo igual que antes el tema más importante en el diseño.

La tendencia Carved Body es un desarrollo de New Edge con influencias de Graph. Las formas del automóvil son modeladas muy esculturalmente para sugerir dinamismo y ligereza.

New Classic

98 **There are no clear distinctions** among the four trends that are presented here. Rather, interpreting each of the trends in the respective brand language proves interesting, since this language is required persistently to evolve. Here, finding a relationship with the good old days is especially important. However, brands that lack this connection are not necessarily at a disadvantage: in the final analysis, the brand has greater freedom. Nevertheless, for the first time in its history, car design is preoccupied with its own past and future. Despite the mood of optimism in the industry, nobody is really courageous today as they were in the good old days. But the outlook is at least as creative and varied.

The development of Retro is called New Classic. This means that classical elements are interpreted in a new way, so that on the one hand they appear unmistakably traditional, and on the other hand prove very up-to-date due to totally new proportions and innovative details.

Innerhalb der vier Trends, die hier präsentiert werden, gibt es keine eindeutigen Unterscheidungen. Vielmehr ist die Interpretation eines jeden Trends in der jeweiligen Markensprache interessant, da diese sich selbst ständig weiterentwickeln muss. Hier ist vor allem die Beziehung zur guten, alten Zeit von besonderer Bedeutung. Wer diese nicht vorzuweisen hat, muss aber nicht unbedingt mit einem Nachteil leben: schließlich verfügt er über größere Freiheit. Dennoch: Zum ersten Mal in seiner Geschichte, beschäftigt sich das Automobildesign zugleich mit seiner Vergangenheit und seiner Zukunft. Trotz des Optimismus der Industrie: so mutig wie in den guten alten Zeiten ist man heute wirklich nicht mehr. Dafür aber mindestens genauso kreativ und vielfältig.

Die Weiterentwicklung von Retro heißt New Classic. Bei diesem Trend werden klassische Elemente neu interpretiert, so dass sie einerseits unverkennbar traditionell wirken, sich andererseits aber durch völlig neue Proportionen und innovative Details als sehr aktuell erweisen.

© 26
Maserati Quattroporte, I 2003
design: Pininfarina

© 17
Lancia Thesis, I 2002

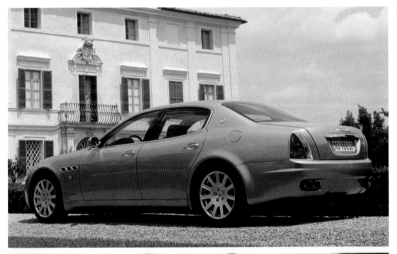

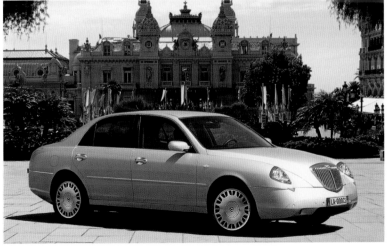

© 5
Bentley Continental GT, GB 2002

© 7
Rolls Royce Phantom, GB 2003

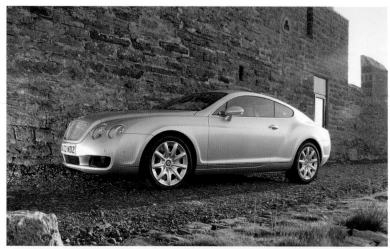

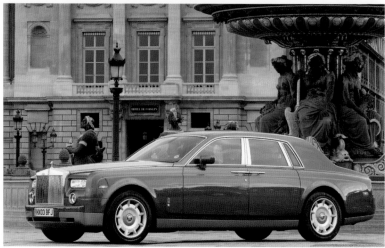

New Classic

Dans le cadre des quatre modes qui sont présentées ici, il n'existe pas de différences marquantes. L'interprétation de chaque mode dans le langage respectif de la marque devient intéressante car celle-ci doit constamment se développer. En outre, la relation au bon vieux temps prend une importance particulière. Celui qui n'est pas obligé de montrer une marque n'est pas forcément désavantagé : il dispose ainsi d'une plus grande liberté. Cependant, pour la première fois dans son histoire, le design automobile s'occupe simultanément de son passé et de son avenir. Malgré l'optimisme de l'industrie : personne n'est vraiment plus aussi courageux que dans le bon vieux temps, mais pourtant, tout autant créatif et diversifié.

L'évolution du Retro s'appelle New Classic. Dans cette mode, les éléments classiques sont de nouveau interprétés de manière à paraître traditionnels mais produire un effet très actuel, grâce aux toutes nouvelles proportions et aux détails innovateurs.

Dentro de las cuatro tendencias que se presentan aquí no existen diferencias claras. Más bien resulta interesante la interpretación de cada tendencia en el respectivo lenguaje de la marca puesto que ésta ha de seguir desarrollándose a sí misma continuamente. Aquí, la relación con los buenos viejos tiempos es de especial importancia. Pero quien no la puede demostrar no tiene necesariamente que vivir con una desventaja: A fin de cuentas dispone de mayor libertad. Sin embargo: Por primera vez en su historia, el diseño automovilístico se ocupa al mismo tiempo de su pasado y de su futuro. A pesar del optimismo de la industria: Tan valiente como en los buenos viejos tiempos ya no se es hoy realmente. Pero, a cambio, se es al menos igual de creativo y variado.

El desarrollo de Retro se llama New Classic. En esta tendencia los elementos clásicos son reinterpretados de manera que, por un lado, causan un efecto inconfundiblemente tradicional pero, por el otro, se evidencian como muy actuales por medio de proporciones completamente nuevas y detalles innovadores.

© 22
GM design
USA 1952

ROCKET CITY

48-59 specials

Saab 92
S 1949

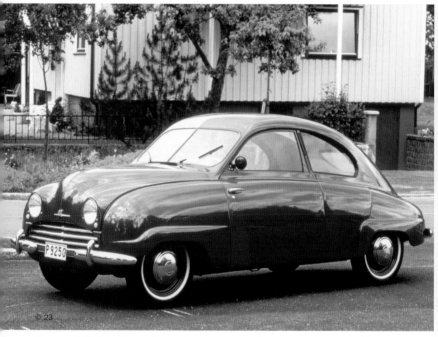

© 23

Compact, light, streamline—these cars were a sensation in the 1940s. Typical features: The "suicide doors" and the divided front windshield.

Kompakt, leicht, stromlinienförmig – diese Autos waren in den 40er Jahren eine Sensation. Typisch: die „Suizid-Türen" und die geteilte Frontscheibe.

Compactes, légères, aérodynamiques – ces voitures firent sensation dans les années 40. Détails typiques : les portes « suicide » et le pare-brise en deux parties.

Compactos, ligeros, aerodinámicos –estos automóviles fueron una sensación en los años 40. Típicas: Las "puertas suicidas" y el parabrisas partido.

Auto Union F9
D 1949

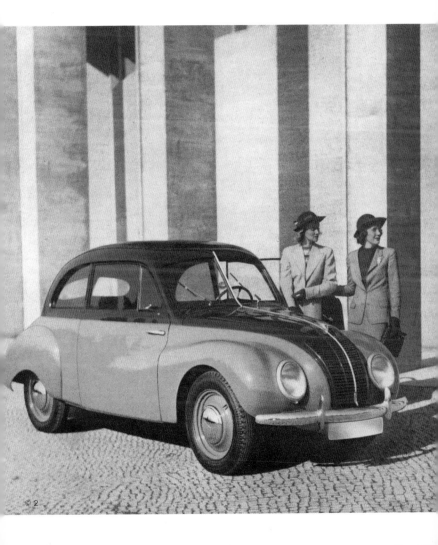

Buick Roadmaster
USA 1949

The American Dream: in 1949, the pillarless hard-top roof, the four portholes and the swung chrome trims were a world première.

Der amerikanische Traum: Das Hardtopdach ohne B-Säule, die 4 Lüftungslöcher und die geschwungenen Chromleisten waren 1949 eine Weltneuheit.

Le rêve américain : le toit rigide sans montant B, les 4 hublots et le jonc en chrome arqué étaient des nouveautés en 1949.

El sueño americano: El techo hardtop sin pilares, los agujeros de ventilación y las barras de cromo arqueadas fueron una novedad mundial en 1949.

Ford Station Wagon
USA 1949

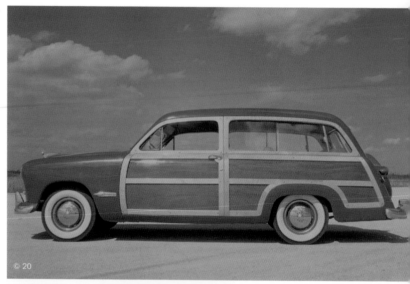

© 20

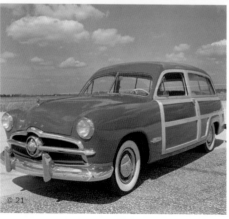

© 21

Tradition and novelty bump into each other. Soft Shell: in 1949, station wagons still had real wooden side panels. New Line: the 1954 Mercury Sun Valley was the first car from a series with a transparent roof.

Bewährtes und Neues treffen aufeinander. Soft Shell: Die Station Wagons trugen 1949 noch echte Holzpaneele an der Seite. Neue Linie: das 1954er Mercury Sun Valley war das erste Serienauto mit transparentem Dach.

Mercury Sun Valley
USA 1954

Le design éprouvé et la nouveauté se rencontrent. Soft Shell : en 1949, les breaks étaient encore équipés d'un panneau en bois. Nouvelle ligne : le modèle Mercury Sun Valley de 1954 était la première voiture de série équipée d'un toit transparent.

Lo acreditado y lo nuevo se encuentran frente a frente. Soft Shell: En 1949 los Station Wagons todavía llevaban en el lado auténticos paneles de madera. La Nueva Línea: El Mercury Sun Valley del 1954 fue el primer automóvil en serie con el techo transparente.

Porsche 356
D 1951

Baby Granturismo. The tail engine is responsible for the declining front hood of the Porsche 356. The Fiat 1100 S, with horizontal grill, is far more modern than the later Lancia Aurelia GT.

Baby-Granturismo. Der Heckmotor ist für die abfallende Fronthaube des Porsche 356 verantwortlich. Der Fiat 1100 S ist mit seinem horizontalen Grill weitaus moderner als der spätere Lancia Aurelia GT.

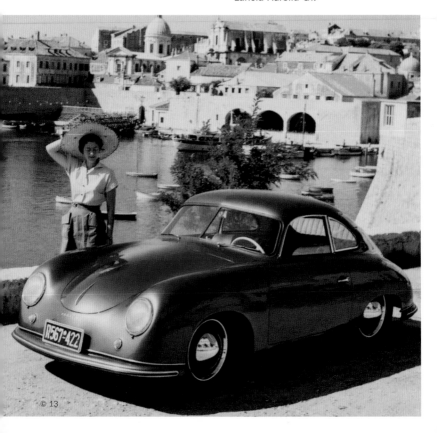

© 13

Fiat 1100 ES
I 1950
design: Pininfarina

Baby-Granturismo. Le moteur à l'arrière est la raison pour laquelle le capot avant de la Porsche 356 est si incliné. La Fiat 1100 S avec sa calandre horizontale est beaucoup plus moderne que la Lancia Aurelia GT.

Baby-Granturismo. El motor trasero es responsable del capó delantero en pendiente del Porsche 356. Con su parrilla horizontal, el Fiat 1100 S es mucho más moderno que el posterior Lancia Aurelia GT.

© 18

Volkswagen T1
D 1950

Life can be so beautiful: Who thinks that station wagons for the entire family are a 1980s invention?

So schön kann das Leben sein: Wer glaubt noch, dass Großraumfahrzeuge für die ganze Familie eine Erfindung der 80er Jahre sind?

La vie est belle : qui pense encore que les véhicules à grande capacité pour familles nombreuses sont une trouvaille des années 80 ?

Tan bella puede ser la vida: ¿Quién cree todavía que los vehículos de gran capacidad para toda la familia fueron un invento de los años 80?

Ford Taunus 12M
D 1952

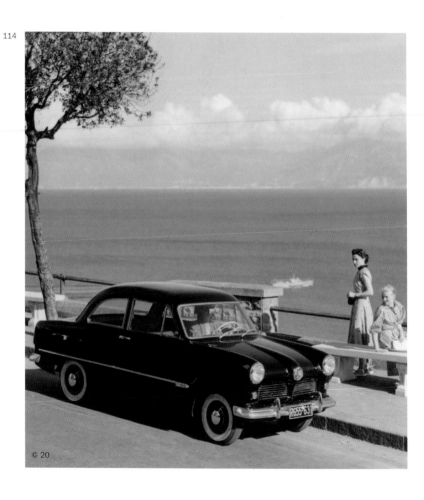

© 20

Fiat 1400
I 1954

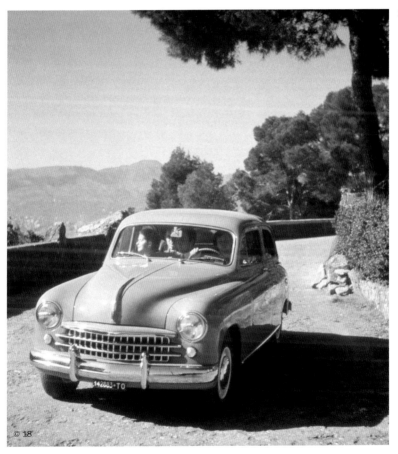

© 18

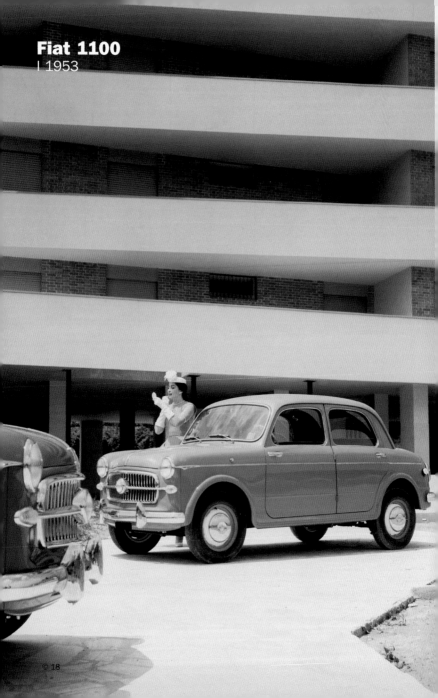

Fiat 1100
| 1953

© 18

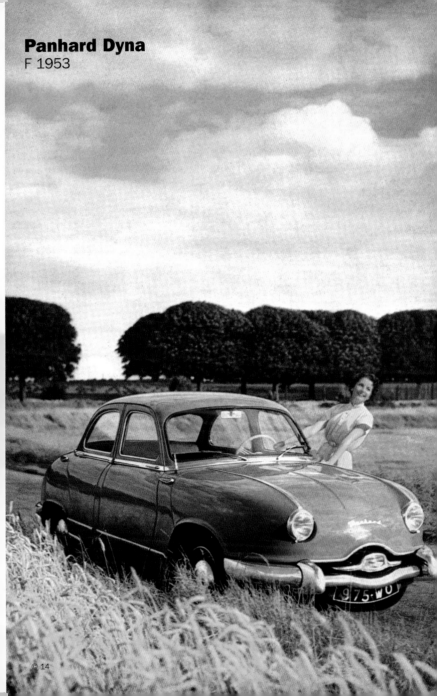

Panhard Dyna
F 1953

BMW Isetta

I / D 1953
design: Giovanni Michelotti

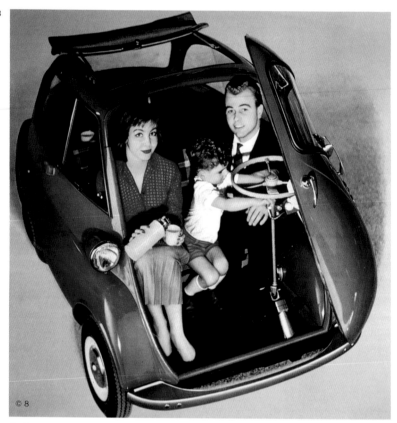

© 8

Only one strange door and the one at the front as well: in Italy, nobody wanted to drive the small Isetta because of this. By contrast, the highly attractive Karmann Ghia made hearts beat faster all over the world.

Nur eine seltsame Tür, und die auch noch vorne: in Italien wollte deswegen niemand die kleine Isetta fahren. Der bildschöne Karmann Ghia ließ dagegen die Herzen in aller Welt höher schlagen.

Volkswagen Karmann Ghia
D 1955
design: Ghia

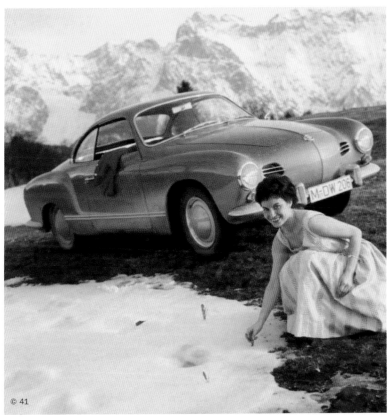

© 41

Seulement une porte bizarre et en plus devant : en Italie personne ne voulait conduire la petite Isetta. Par contre, la très belle Karmann Ghia fit battre les cœurs dans le monde entier.

Solamente una extraña puerta y además delante: Por eso en Italia nadie quiso conducir el pequeño Isetta. Por el contrario, el precioso Karmann Ghia hizo latir más fuerte los corazones en todo el mundo.

Chevrolet Corvette
USA 1953, concept

The Corvette family was initially an experiment due to its plastic body. The roadster was finally adopted in a series with no changes; the wonderful Nomad is probably the first sports station wagon of all time.

Die Corvette-Familie war wegen ihrer Kunststoffkarosserie zunächst nur ein Experiment. Der Roadster ging schließlich nahezu unverändert in Serie; der wunderschöne Nomad ist wohl der erste sportliche Kombi aller Zeiten.

La famille des Corvette fut d'abord expérimentale à cause de sa carrosserie en matériau synthétique. Le Roadster fut ensuite construit en série sans avoir subi de grosses modifications ; le modèle Nomad est le tout premier break de sport.

Debido a su carrocería de material sintético, la familia Corvette fue primero sólo un experimento. Finalmente, el Roadster se realizó en serie casi inalterado; el hermosísimo Nomad es el primer Station Wagon deportivo de todos los tiempos.

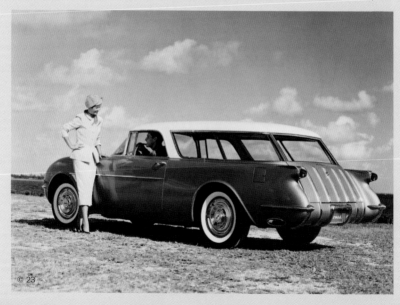

© 23

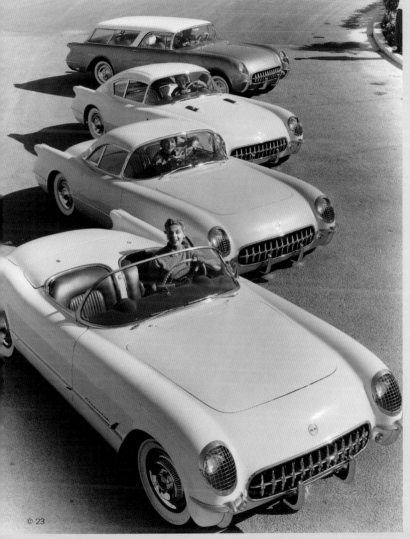

© 23

Studebaker
USA 1953
design: Raymond Loewy

Thanks to the creative advice of Raymond Loewy, in the 1950s the Studebaker represented America's design avantgarde. Flat, wide, smooth: the '53 Coupé Starliner was a real sensation. MoMa called it "a work of art".

Dank der kreativen Beratung von Raymond Loewy repräsentierte Studebaker in den 50er die Designavantgarde Amerikas. Flach, breit, glatt: der 53er Coupé Starliner war eine echte Sensation. Das MoMa nannte Ihn „ein Kunstwerk".

Grâce à la créativité de Raymond Loewy, la Studebaker des années 50 était à l'avant-garde du design en Amérique. Plat, large, lisse : le coupé Starliner de 1953 fit sensation. Il fut considéré comme un « chef d'œuvre » au musée MoMa.

Gracias a la asesoría creativa de Raymond Loewy, Studebaker representó en los 50 la vanguardia del diseño de América. Plano, ancho, liso: El Coupé Starliner del 53 fue una verdadera sensación. El MoMa lo llamó una "obra de arte".

1953 ST

1953 STUDEBAKER CHAMPIO
Also availab

© 15

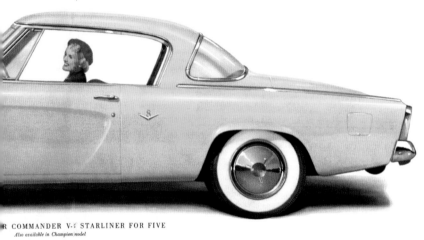

R COMMANDER V-8 STARLINER FOR FIVE

Also available in Champion model

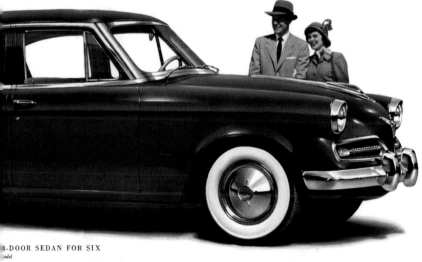

4-DOOR SEDAN FOR SIX

odel

Mercedes Benz 300 SL
D 1954

124 Due to the special construction, the wing-doors were actually necessary, in order to get into the car,—not without some trouble. This detail made the 300 SL into a legend.

Aufgrund der besonderen Konstruktion waren die Flügeltüren tatsächlich notwendig, um in das Auto – nicht ohne Mühe – einsteigen zu können. Das Detail machte den 300 SL zur Legende.

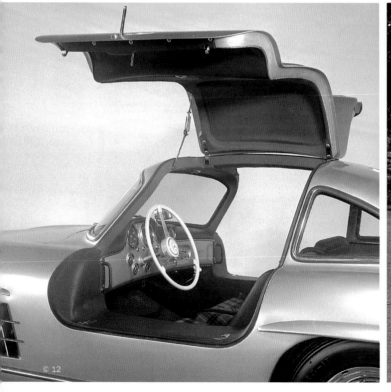

© 12

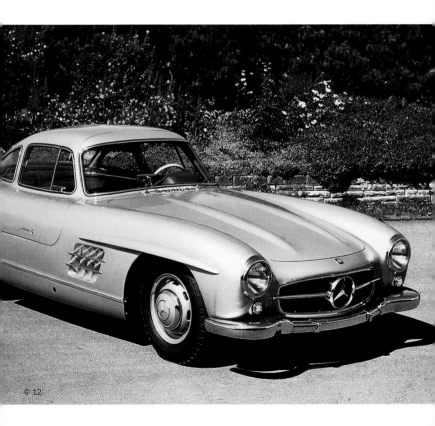

Les portes-papillons étaient nécessai-res pour entrer, non sans difficulté, dans cette voiture de construction par-ticulière. Ce détail fit de la 300 SL un mythe.

Debido a la construcción especial, las puertas de dos hojas eran realmente necesarias para poder subir –no sin es-fuerzo– al automóvil. Este detalle con-virtió el 300 SL en una leyenda.

© 12

Ford Thunderbird
USA 1954

Ford's answer to the Corvette: the T-Bird always influenced the development of the Ford design. The panoramic windshield (from the 1953 Cadillac Eldorado) was fashionable at the time, the rear lights were a typical Ford feature.

Fords Antwort auf die Corvette: Der T-Bird hat die Entwicklung des Ford-Designs stets beeinflusst. Die Panorama-Scheibe (aus dem 1953er Cadillac Eldorado) war damals modisch, die Rückleuchten ein typisches Ford-Merkmal.

La réponse de Ford à la Corvette : le modèle T-Bird a influencé le développement du design Ford. Le pare-brise panoramique (comme la Cadillac Eldorado de 1953) était à la mode, les feux arrière étaient typiques de Ford.

La respuesta de Ford a la Corvette: El T-Bird siempre ha influido en el desarrollo del diseño de Ford. La luna panorámica (del Cadillac Eldorado de 1953) estaba de moda por entonces, las luces traseras son una característica típica de Ford.

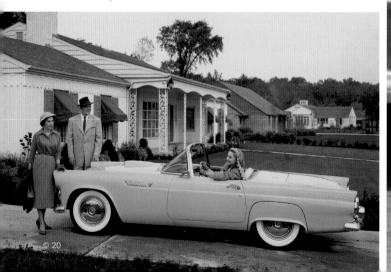

© 20

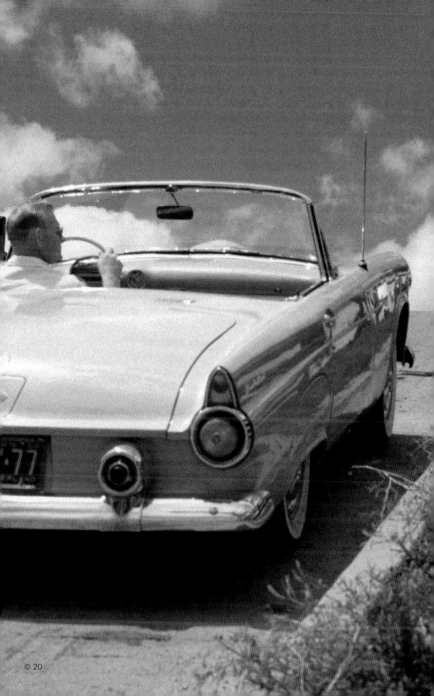

© 20

Dodge Fire Arrow
USA 1953
design: Mario Felice Boano

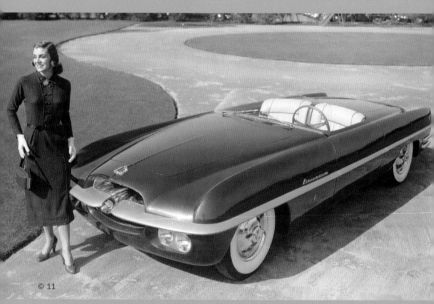

© 11

Boano was a master of automobile haute couture: his beautiful, élite cars were out of reach for ordinary people. The Fire Arrow seemed like a dream to them. Incidentally, this model has the first double headlights in automobile history.

Boano war ein Meister automobiler Haute Couture: seine schönen Elite-Autos waren unerreichbar für normale Menschen, denen der Fire Arrow wie ein Traum erschien. Er trägt übrigens die ersten Doppelscheinwerfer der Auto-geschichte.

Boano était un maître de la Haute Couture automobile : ses belles voitures étaient réservées à une élite, la Fire Arrow apparut comme un rêve. Elle est équipée des premiers phares doubles de l'histoire automobile.

Boano fue un maestro de la Haute Couture automovilística: Sus bellos automóviles de elite eran inalcanzables para las personas normales a las que el Fire Arrow les parecía como un sueño. Por cierto, éste lleva los primeros faros dobles de la historia del automóvil.

Lancia Aurelia Spyder

I 1955
design: Pininfarina

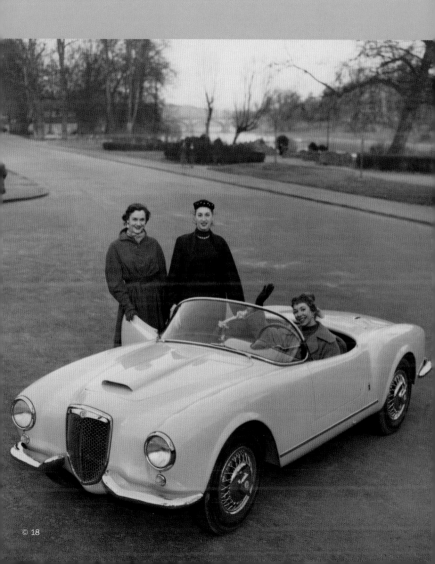

© 18

Citroën DS

F, 1955

4655-GG75

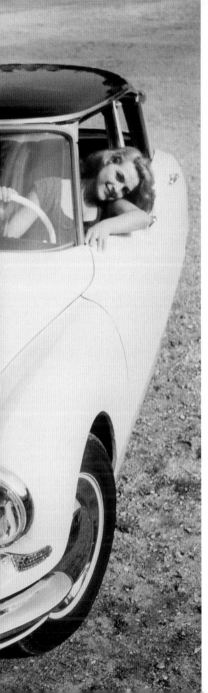

When the unique DS came out, no- body could quite believe that it was part of a series. Inside and out, as well as in every detail, this model is one of the most innovative vehicles in automobile history, from the whale-like shape to the half-transparent glass fibre roof.

Als die einmalige DS erschien, konnte man kaum glauben, dass es sich dabei um ein Serienauto handelte. Außen wie innen und in jedem Detail eines der innovativsten Fahrzeuge der Automobilgeschichte, von der walartigen Form bis zum halbtransparenten Glasfaserdach.

Lorsque la DS parut, personne ne crut qu'il s'agissait d'une voiture de série. A l'intérieur comme à l'extérieur, chaque détail fait de ce véhicule une innovation de l'histoire automobile, que ce soit sa forme baleine ou son toit en fibre de verre demi-transparent.

Cuando el excepcional DS apareció, apenas pudo creerse que se trataba de un automóvil en serie. Tanto en el exterior como en el interior y en todos los detalles, es uno de los automóviles más innovadores de la historia del automóvil, desde la forma de ballena hasta el techo de fibra de vidrio semitransparente.

BMW 507
D 1955
design: Albrecht Goertz

132 **The perfect proportions** of a classical sports car: clean lines, long engine hood, compact tail, small roof with panoramic glazing.

Die perfekten Proportionen eines klassischen Sportautos: lange Motorhaube, kompaktes Heck, kleines Dach mit Rundumverglasung.

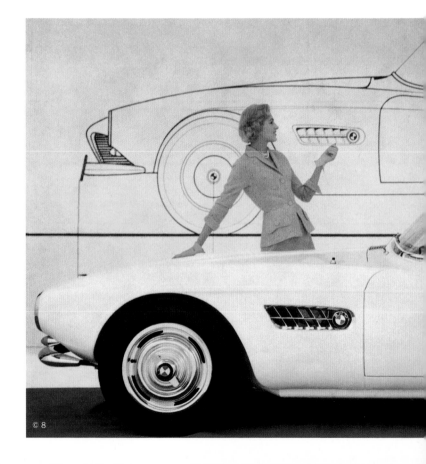

© 8

Les proportions parfaites d'une voiture de sport classique : lignes nettes, capot de moteur allongé, arrière compact, petit toit et vitres tout autour.

Las perfectas proporciones de un automóvil deportivo clásico: un capó largo, una parte trasera compacta, un techo pequeño con acristalamiento completo.

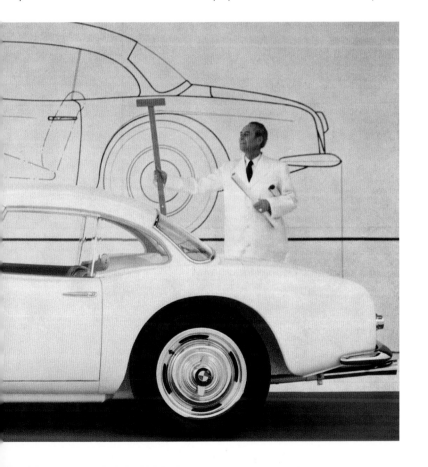

Fiat 600
I 1955

134 **The small car** which was made by the million became Italy's first mass-produced vehicle. Nevertheless, the customer's every wish was provided for: many special editions could be ordered, from the Ghias Jolly, an extravagant beach car with no roof and basket-weave seating, to the Multipla, a multi-functional station wagon for up to six persons.

Der millionenfach produzierte Klein-wagen wurde zum ersten Massenprodukt Italiens. Dennoch blieb kein Kundenwunsch offen: Von Ghias Jolly, einem extravaganten Strandauto ohne Dach und mit Sitzen aus Korbgeflecht, bis zum Multipla, einem multifunktionalen Großraumfahrzeug für bis zu sechs Personen, waren viele Sonderversionen bestellbar.

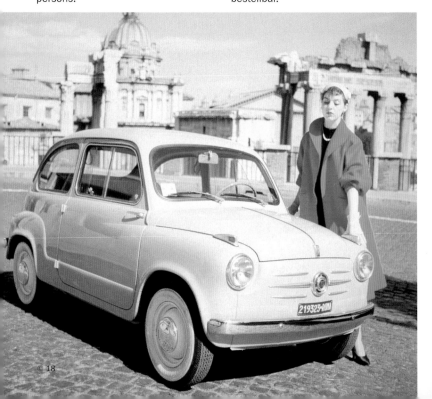

© 18

Fiat 600 Jolly
I 1958
design: Ghia

Cette petite voiture fut produite par millions et fut un des premiers articles de masse en Italie. Tous les souhaits des clients trouvèrent une réponse : par exemple la Jolly de Ghia, une voiture de plage extravagante sans toit avec des sièges en rotin, ou la Multipla, un véhicule multifonctionnel pour 6 personnes disponible dans de nombreuses versions spéciales.

El pequeño automóvil producido a millones se convirtió en el primer producto de masas de Italia. Sin embargo, ningún deseo de los clientes quedó pendiente: del Jolly de Ghia, un extravagante automóvil de playa sin techo y con asientos de mimbre, al Multipla, un automóvil de gran capacidad para hasta 6 personas, podían encargarse muchas versiones especiales.

© 14

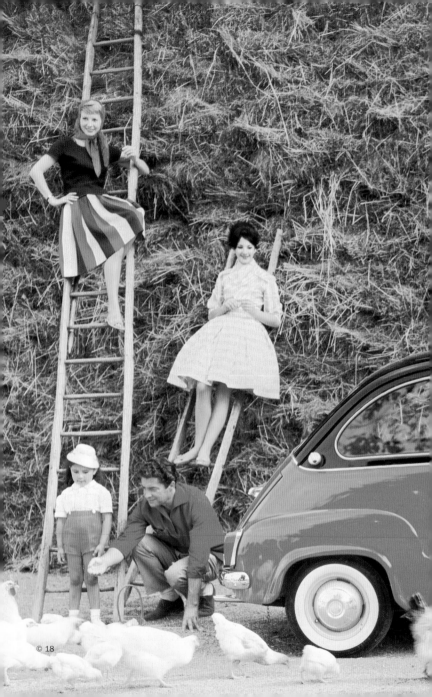

© 18

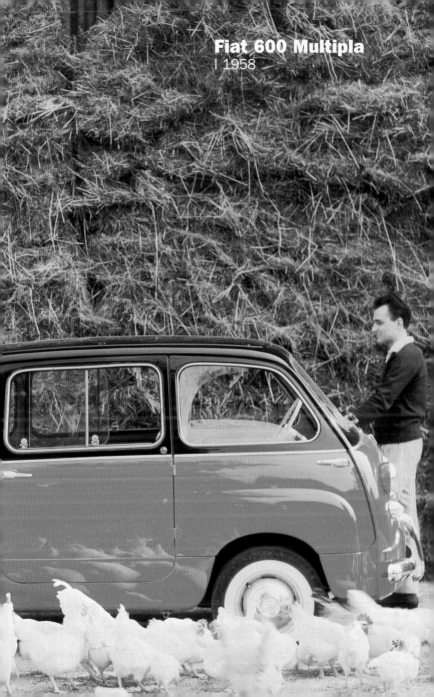

Fiat 600 Multipla
l 1958

Alfa Romeo Superflow
I 1956, concept
design: Pininfarina

138 **Cars like aircraft:** plexiglas fascinated all designers. Pininfarina later used the flowing forms of Superflow in the streamline Ferrari Superamerica and the Alfa Romeo Duetto.

Autos wie Flugzeuge: Plexiglas faszinierte alle Designer. Die Formen des Superflow verwendete Pininfarina später im Ferrari Superamerica und im Alfa Romeo Duetto.

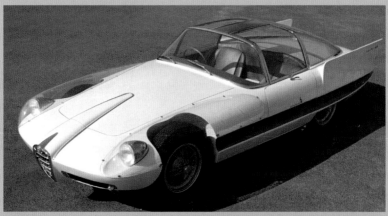

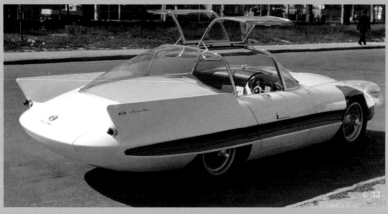

© 33

Ferrari 400 Superamerica
I 1960
design: Pininfarina

Des voitures semblables à des avions : le plexiglas fascinait tous les concepteurs. Pininfarina a utilisé les formes fluides du modèle Superflow pour la Ferrari Superamerica et l'Alfa Romeo Duetto.

Automóviles como aviones: El plexiglás fascinó a todos los diseñadores. Pininfarina utilizó mas tarde las formas fluidas del Superflow en el Ferrari Superamerica, y en el Alfa Romeo Duetto.

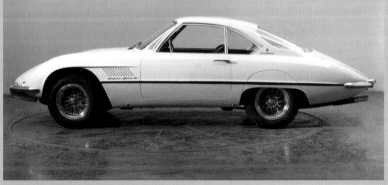

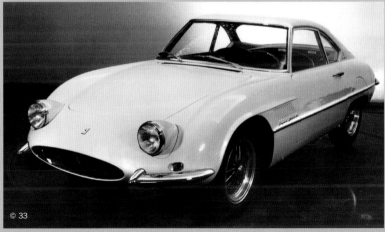

© 33

Lancia Flaminia
I 1956
design: Pininfarina

The elegant Flaminia, and even more so, its prototype, the 1954 Aurelia Floride, were the most significant design innovations of the fifties. The flat, straight trapeze line and the special bend in the sides, which made the whole profile appear more slender due to the play of the light, continued as the inspiration for modern design until the eighties.

Der edle Flaminia, und noch mehr dessen Prototyp Aurelia Floride von 1954, stellt die bedeutendste Designinnovation der 50er Jahre dar. Die flache, gerade Trapezlinie und der besondere Flankenknick, der die ganze Seite durch das spielende Licht schlanker erscheinen lässt, blieben bis in die 80er Jahre Vorbilder des modernen Designs.

© 33

La noble Flaminia et surtout son prototype Aurelia Floride de 1954 présentent l'innovation de design la plus importante des années 50. La forme plate en trapèze et le coude du flanc, sur lequel se reflète la lumière, amincit les côtés. Ces caractéristiques servirent de modèle au design moderne jusqu'aux années 80.

El noble Flaminia, y todavía más su prototipo Aurelia Floride de 1954, representa la innovación del diseño más importante de los años 50. La línea trapecial, recta y plana, y el especial pliegue de los flancos, que a través de una luz juguetona hace aparecer todo el lado más delgado, permanecieron los modelos para el diseño moderno hasta entrados los años 80.

Rambler Custom Cross Country
USA 1956

142 **Loads of Freestyle,** in a totally functional package: the colorful Cross Country—also available as one of the only hardtop wagons—was the design alternative to the mainstream models by GM, Ford and Chrysler.

Jede Menge Freestyle, ganz funktional verpackt. Der farbenfrohe Cross Country – als einziges Auto auch als Hardtop Wagon erhältlich – war die Designalternative zum Mainstream von GM, Ford und Chrysler.

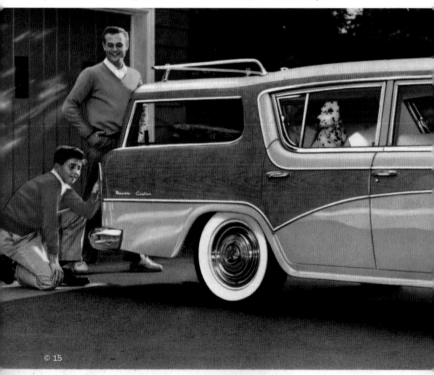

© 15

PRESENTING THE ALL-NEW

Why be satisfied with the "All Three Look"?

Make the Smart Switch ... for '56

Un style libre combiné au fonctionnel. Le modèle coloré Cross Country – le seul break à toit rigide – était la seule alternative aux voitures de série de GM, Ford et Chrysler.

Un montón de estilo libre envasado muy funcionalmente. El Cross Country, de rico colorido –como el único automóvil también en venta como Hardtop Wagon– fue la única alternativa del diseño al mainstream de GM, Ford y Chrysler.

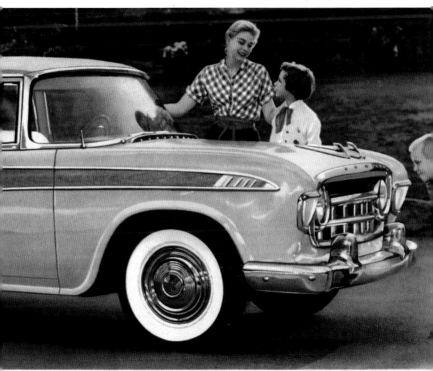

ss Country"

Ford Fairlane 500
USA 1957

144 **Ford never produced a model** as large and eye-catching as this baroque '57 model, which was available in 19 different body types.

Nie war ein Ford so groß und auffällig wie dieses barocke 57er Modell, das in 19 Karosserievarianten erhältlich war.

Ce modèle baroque de 1957, disponible dans 19 versions de carrosserie, était la voiture la plus grande et la plus surprenante de Ford.

Nunca un Ford fue tan grande y llamativo como este modelo Barroco del 57 que estuvo en venta en 19 variedades de carrocería.

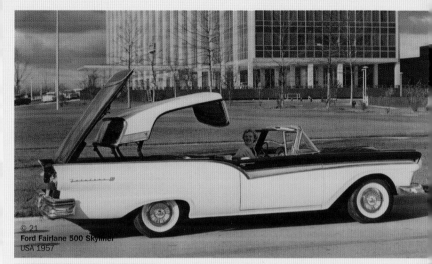

© 21
Ford Fairlane 500 Skyliner
USA 1957

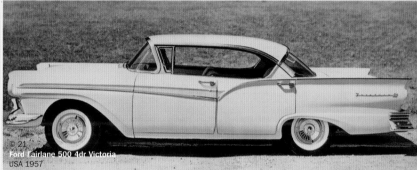

© 21
Ford Fairlane 500 4dr Victoria
USA 1957

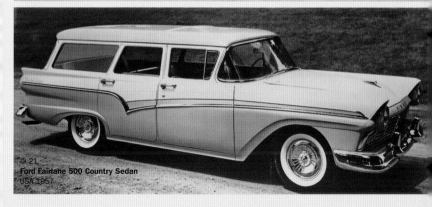

© 21
Ford Fairlane 500 Country Sedan
USA 1957

Chevrolet Nomad
USA 1957

Chevrolet Bel Air
USA 1957

Designed as a popular car, the '57 Chevrolet is a sort of miniature Cadillac. From the Nomad as a sports hatchback, or to the Bel Air hardtop Coupé—this Chevy is a reminder of the essence of the 1950s American Way of Life.

Als populäres Auto gedacht, ist der 57er Chevrolet eine Art Cadillac in Miniaturform. Sei es der Nomad als sportlicher Kombi oder der Bel Air als Hardtop Coupé – dieser Chevy bleibt als das Sinnbild des American Way of Life der 50er Jahre in Erinnerung.

La Chevrolet de 1957 était une Cadillac populaire en miniature. Que ce soit le break sportif Nomad ou le coupé à toit rigide Bel Air, Chevy reste le symbole du style de vie américain des années 50.

Pensado como un automóvil popular, el Chevrolet del 57 es una especie de Art Cadillac en miniatura. Tanto el Nomad como combi deportivo o el Bel Air como Hardtop Coupé, este Chevy queda en el recuerdo como el símbolo del American Way of Life de los años 50.

Edsel
USA 1958

The fate of a car: the Edsel was meant to be Ford's big coup. The eccentric front grill, whose shape reminded contemporaries of a vagina, made this model into one of the most famous marketing flops before New Coke.

Schicksal eines Autos: Der Edsel sollte Fords Grand-Coup sein. Der skurrile Frontgril, dessen Form die Zeitgenossen an eine Vagina erinnerte, machte ihn zum berühmtesten Marketing-Misserfolg vor der New Coke.

© 21

Le destin d'une voiture : avec le modèle Edsel, Ford voulait frapper un grand coup. La calandre bizarre qui rappelait la forme d'un vagin en fit le plus grand échec de marketing avant le New Coke.

El destino de un automóvil: El Edsel había de ser el Grand Coup de Ford. La extravagante parrilla frontal cuya forma recordaba a sus coetáneos a una vagina, hizo de él el fracaso de márketing más famoso antes del New Coke.

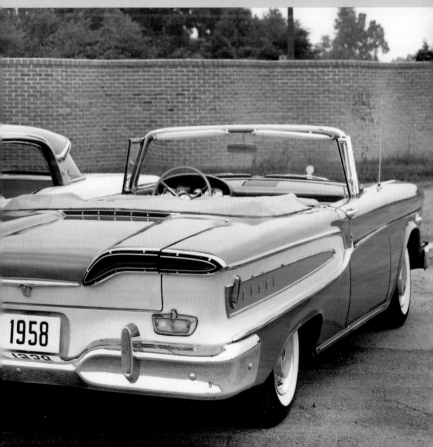

Jaguar Mark II
GB 1959

British car design was always synony-
mous with classical elegance. The Jaguar
Mark II, especially the 3.8 Liter engine
model, became the first sports sedan,
which remains one of the most attractive
versions today. The same can also be
said of the MG A.

Britisches Automobildesign war schon
immer ein Synonym für klassische Ele-
ganz. Der Jaguar Mark II wurde, vor allem
in der Version mit 3,8 Liter-Motor, zur
ersten Sportlimousine und ist bis heute
eine der schönsten geblieben. Dasselbe
kann man wohl für den MG A sagen.

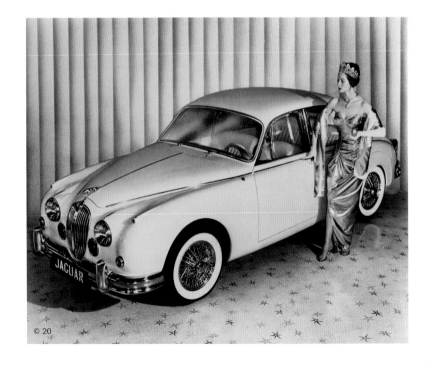

© 20

MG A
GB 1955

Le design automobile britannique est
toujours synonyme d'élégance classi-
que. La Jaguar Mark II prit la première
place dans les berlines de sport, surtout
dans sa version moteur à 3,8 litres ; elle
reste l'une des plus belles. On peut dire
la même chose du modèle MG A.

El diseño británico del automóvil siem-
pre fue un sinónimo de elegancia clási-
ca. El Jaguar Mark II se convirtió, sobre
todo en la versión con el motor de 3,8
litros, en la primera limusina deportiva y
sigue siendo hasta hoy una de las más
bellas. Lo mismo puede decirse del MG A.

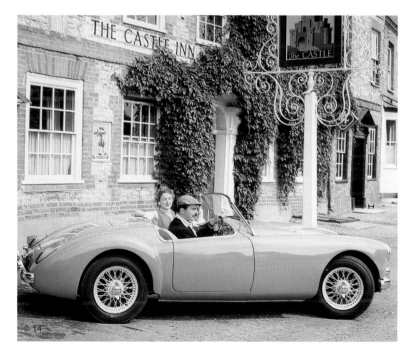

Lotus Elite
GB 1957

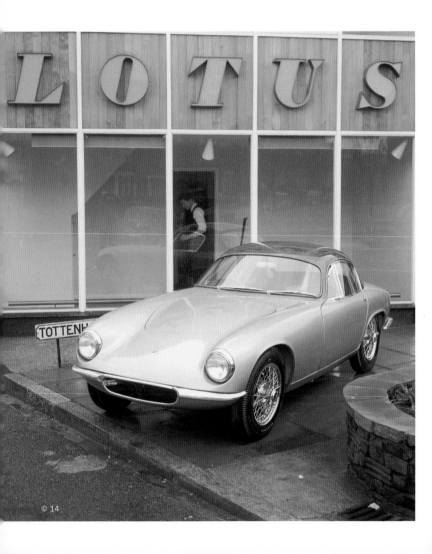

© 14

Austin Healey Sprite
GB 1958

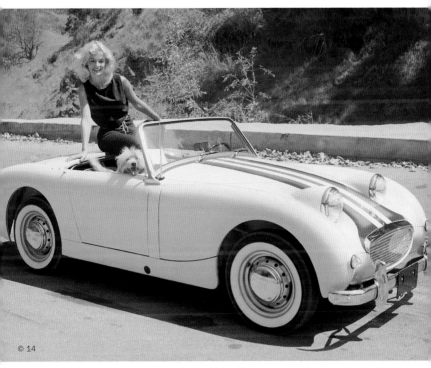

© 14

An unmistakable face: the special position of the headlights, also called frog-eye, gave the British roadster a super friendly image.

Ein unverwechselbares Gesicht: die besondere Position der Scheinwerfer, auch Froschaugen genannt, verleiht dem britischen Roadster ein super-sympathisches Image.

Une face unique : la position particulière des phares appelés Frog-eye donne un aspect très sympathique au Roadster anglais.

Una cara inconfundible: La posición especial de los faros, también llamados ojos de rana, dota al Roadster británico de una imagen súper-simpática.

Nash Metropolitan
USA / GB 1954

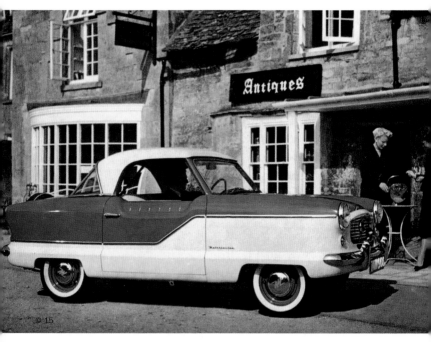

The Americans not only wanted to buy street cruisers, the English-built Metropolitan was a popular small car with fashionable appeal. On the other hand, the Austin A 40, with its functional body, paved the way to the rational designs of the 1970s: what prevented the model from being perfect was only the lack of a complete tailgate.

Die Amerikaner wollten nicht nur Straßenkreuzer kaufen; der in England gebaute Metropolitan war ein beliebter Kleinwagen mit modischem Anspruch. Der Austin A 40 bereitete dagegen mit seiner funktionalen Karosserie den Weg zum rationalen Automobildesign der 70er Jahre: um perfekt zu sein, fehlte ihm nur eine vollständige Heckklappe.

Austin A 40
GB 1959
design: Pininfarina

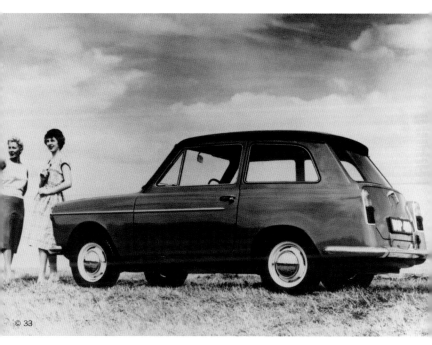

© 33

Les Américains ne voulaient pas seulement conduire des croiseurs de rue, la Metropolitan fabriquée en Angleterre était une petite voiture à la mode très appréciée. Le modèle Austin A 40 à la carrosserie fonctionnelle ouvrait la voie du style automobile des années 70 : pour être parfait, il lui manquait seulement un hayon arrière complet.

Los americanos no sólo querían comprar cochazos; el Metropolitan, construido en Inglaterra, fue un pequeño automóvil apreciado con pretensiones de moda. Por el contrario, el Austin A 40 preparó con su carrocería funcional el camino hacia el diseño automovilístico racional de los 70: Para ser perfecto solamente le faltaba un portaequipajes completo.

Fiat 600
I 1955
design: Pininfarina

156 **The negative incline** of the rear windshield was primarily meant to give more space in the Coupés. This feature was invented by—who else—Pininfarina. It soon became a new trend.

Die negativ geneigte Heckscheibe sollte vor allem bei Coupés für ein besseres Platzangebot sorgen. Erfunden wurde diese von – wem sonst – Pininfarina. Sie wurde bald zum Trend der Zeit.

La vitre arrière inclinée en négatif devait offrir plus d'espace, surtout pour les coupés. C'était une idée de Pininfarina. Elle devint la mode de l'époque.

La luneta trasera, negativamente inclinada, había de proporcionar una mejor oferta de espacio especialmente en los Coupés. Fue inventada por –quién si n– Pininfarina. Pronto se convirtió en la moda de la época.

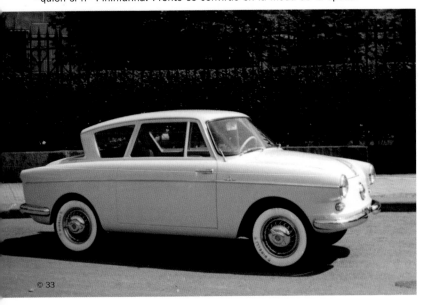

© 33

Ford Anglia
GB 1959

On the Ford Anglia, the windshield became a continual feature of communication—even the sales brochure was designed in this style. Ford features: tail lights like those on the T-Bird.

Beim Anglia wurde die Scheibe zu einem durchgängigen Motiv in der Kommunikation – selbst der Verkaufsprospekt war in dieser Form gestaltet. Fordtypisch: Rückleuchten wie im T-Bird.

La vitre de l'Anglia devint un motif courant de communication, même le prospectus en avait la forme. Typique de Ford : les feux arrière comme ceux de la T-Bird.

En el Anglia la luneta se convirtió en un motivo universal en la comunicación – incluso el prospecto de venta estaba configurado en esta forma. Típico de Ford: Las luces traseras como en el T-Bird.

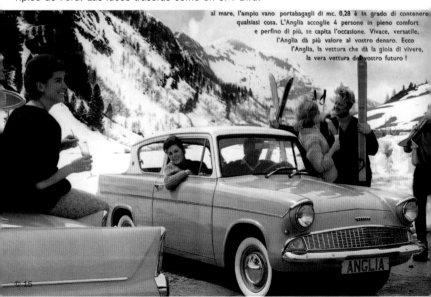

Lancia Flaminia Sport
I, 1958
design: Zagato

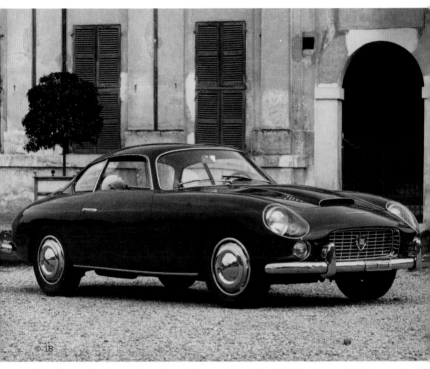

© 18

Sporty and elegant—a true "Granturismo all'Italiana" was like this. The curve in the roof—for more head space — is Zagato's trademark.

Sportlich und Elegant, so war ein echter „Granturismo all'Italiana". Die Dachbuckel – für mehr Helmfreiheit – sind Zagatos Kennzeichen.

Sportif et élégant, un véritable modèle « Granturismo all'Italiana ». Le toit bombé offrant plus d'espace pour le casque est une des caractéristiques de Zagato.

Deportivo y elegante, así era un auténtico "Granturismo all'Italiana". El abombamiento del techo –para una mayor libertad para el casco– es la característica de Zagato.

Renault Floride

F 1959
design: Pietro Frua

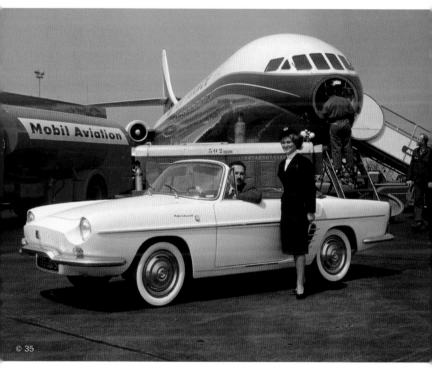

© 35

Florida, Florida, Florida. From Riva boats, Pininfarina prototypes or this handsome French model with Italian design: America let Europe dream.

Florida, Florida, Florida. Ob Riva-Boote, Pininfarina Prototype oder dieser schöne Franzose mit italienischem Design: Amerika ließ Europa träumen.

Floride, Floride, Floride. Que ce soit les bateaux de Riva, les prototypes de Pininfarina ou les modèles français au style italien : l'Amérique fait rêver les Européens.

Florida, Florida, Florida. Tanto los botes de Riva, los prototipos de Pininfarina o este hermoso francés con diseño italiano: América hizo soñar a Europa.

Fiat 1800-2100
I 1959

160 **A six seater car** of the Italian luxury class. With respectable elegance and still a little chrome, Europeans interpreted American style. The angular form of the flat trim was the height of fashion at the end of the 1950s.

6-Sitzer der italienischen Luxusklasse. Mit dezenter Eleganz und doch ein wenig Chrom interpretierte man in Europa den amerikanischen Stil. Der kantige Schnitt mit flacher Gürtellinie war Ende der 50er Jahre voll im Trend.

Un modèle de luxe italien à 6 places. En Europe, on interprétait le style américain avec une élégance décente et un peu de chrome. La coupe carrée avec une ligne de ceinture plate était à la grande mode à la fin des années 50.

El 6 plazas de la clase italiana de lujo. Con una elegancia discreta pero con un poco de cromo se interpretó en Europa el estilo americano. El corte anguloso con el guardabarros plano estuvo totalmente de moda a finales de los años 50.

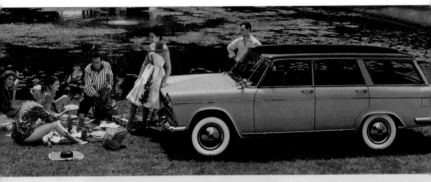

1800-2100 FAMILIARE
(STATION-WAGON")

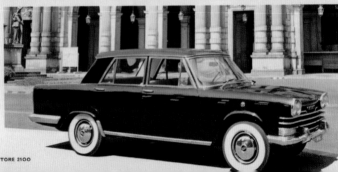

© 15

BERLINA SPECIALE CON MOTORE 2100

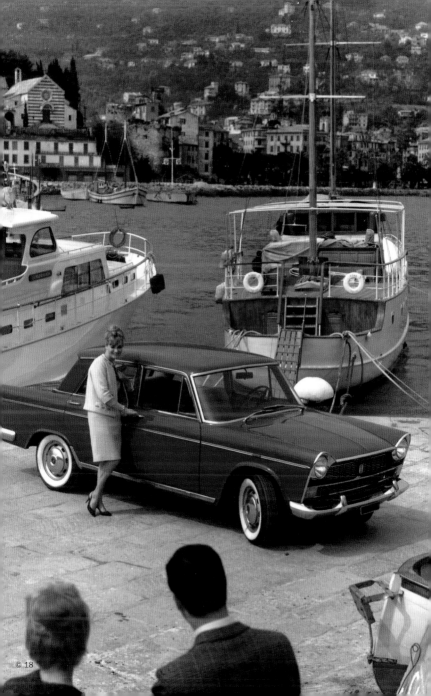

© 18

Mercedes Benz 220 S
D 1959

¹⁶² **All for the sake of a wing:** despite the baroque trend, Europeans could not do without elegance.

Der Flosse zuliebe: Die Europäer konnten trotz Barock-Trend auf Eleganz nicht verzichten.

En faveur des ailettes : les Européens ne pouvaient pas renoncer à l'élégance en dépit de la tendance baroque.

Por amor a los estabilizadores: Los europeos no pudieron renunciar a la elegancia a pesar de la moda del Barroco.

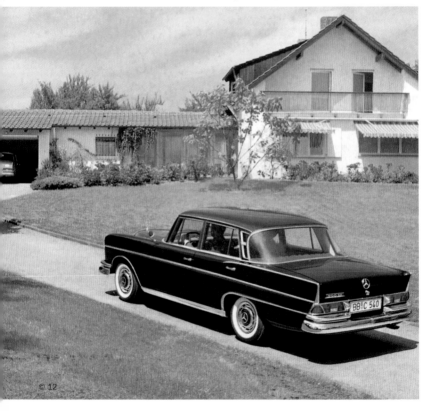

© 12

Volvo P 1800
1959
design: Pietro Frua

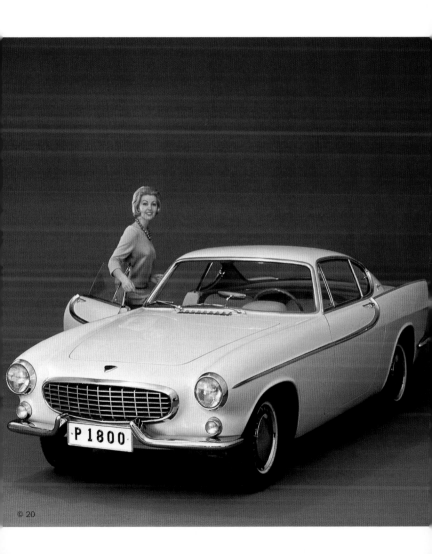

© 20

Austin Mini
GB 1959

Spatial miracle Mini: The most attractive and best mobile package of all time.

Raumwunder Mini: Die schönste und beste mobile Verpackung aller Zeiten.

Miracle de l'espace pour la Mini : la boîte mobile la plus belle et la plus réussie.

Mini, el milagro del espacio: El envoltorio móvil mejor y más bello de todos los tiempos.

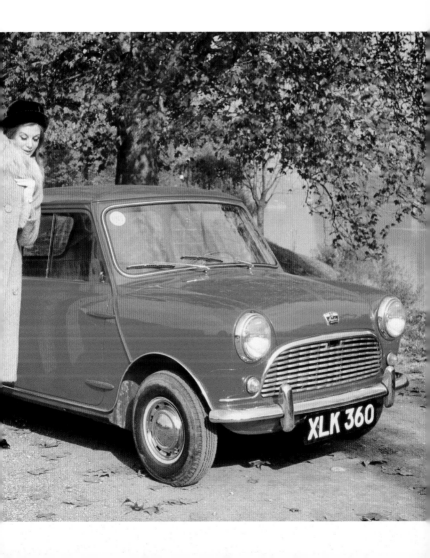

Studebaker Lark
USA 1959

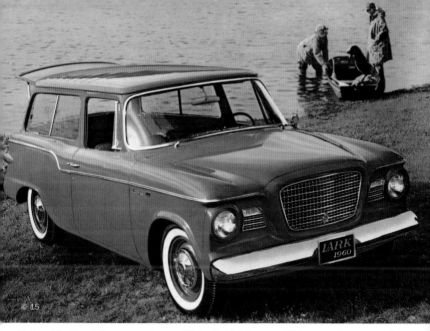

Refreshingly different: a larger Mini for Americans.

Erfrischend anders: für Amerikaner ein Mini.

Agréablement différente : pour les Américains, une Mini

Refrescante de otra manera: un Mini para los americanos.

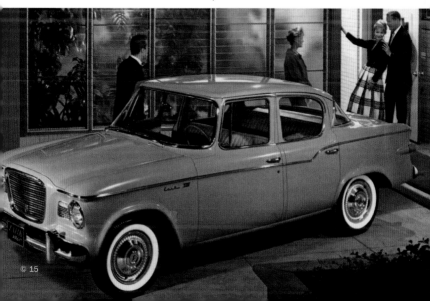

Chevrolet Corvair
USA 1959

168 **"Unsafe at any speed"**: Ralph Nader heavily criticized GM's most innovative car due to its driving qualities. This model marked the end of the mania for wings and was subsequently copied all over the world.

„**Unsafe at any speed**": wegen seiner Fahreigenschaften hatte Ralph Nader das innovativste Auto von GM heftig kritisiert. Dessen Linie markierte das Ende des Flossenwahns und wurde anschließend weltweit imitiert.

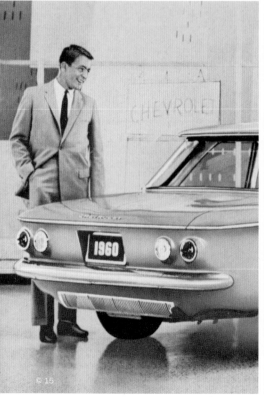

© 15

© 15

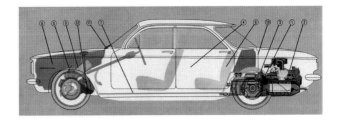

« **Unsafe at any speed** » : Ralph Nader a critiqué la voiture la plus innovatrice de GM à cause de sa conduite. Sa ligne mettait fin à la folie des ailettes et fut ensuite copiée dans le monde entier.

"**Unsafe at any speed**": Ralph Nader había criticado vehementemente el automóvil más innovador de GM. Su línea marcó el final de la locura de los estabilizadores siendo imitada a continuación en el mundo entero.

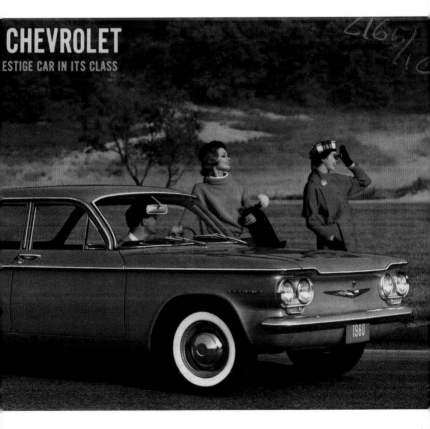

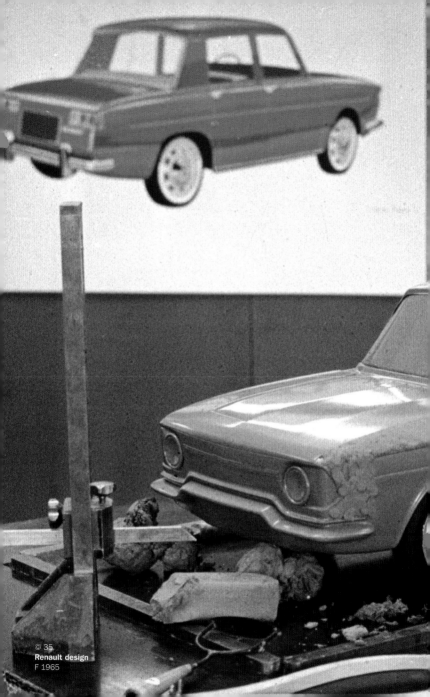

© 35
Renault design
F 1965

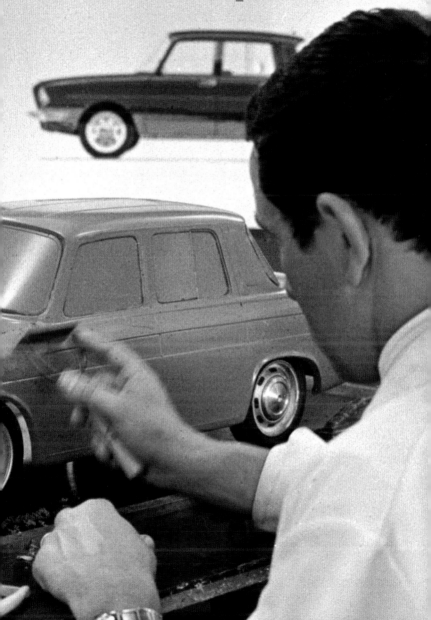

60s specials

Ford Taunus 17 M
D 1960

Good Morning Flow Line. Aerodynamic, efficient, pure: cars should look like this in the future. But competitors called the Ford model the "Bath"—and this is how the car became a legend.

Guten Morgen Flow Line. Aerodynamisch, effizient, pur: So sollten die Autos der Zukunft aussehen. Die Wettbewerber nannten den Ford aber „Badewanne" – und machten ihn zur Legende.

Bonjour Flow Line. Aérodynamiques, efficaces, pures : ainsi devaient être les voitures de l'avenir. Les concurrents de Ford appelèrent ce modèle « baignoire » et en firent ainsi un mythe.

Buenos días Flow Line. Aerodinámicos, eficientes, puros: Este aspecto debían tener los automóviles del futuro. Pero los competidores llamaron al Ford "bañera" convirtiéndolo de esta manera en leyenda.

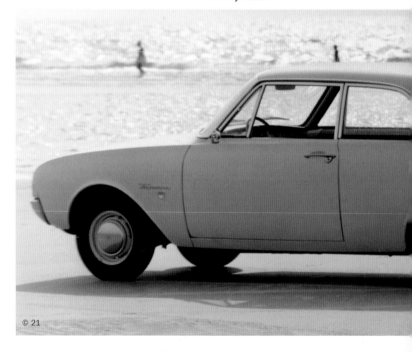

© 21

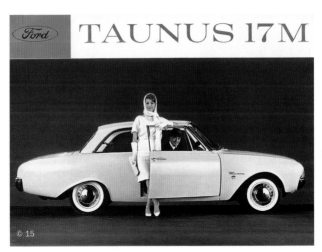

© 15

173

Jaguar XK E type
GB 1961

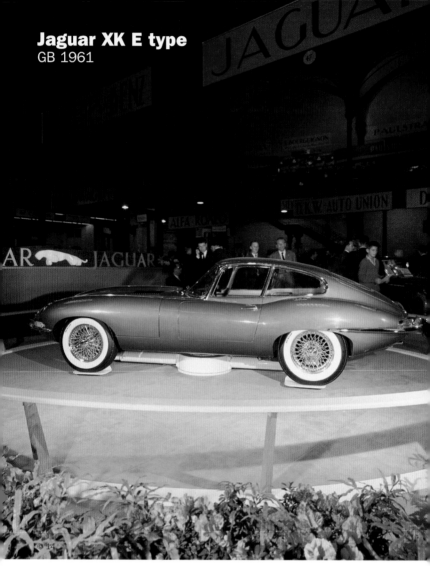

The hottest tail in automobile history, with one of the most erotic cars of all time. The breathtakingly fast E Type was an absolute sensation in 1961. Its typical tailgate still makes this a very functional model.

Der heißeste Hintern der Automobilgeschichte in einem der erotischsten Autos aller Zeiten. Der schnelle E-Type war 1961 eine absolute Sensation. Seine typische Heckklappe macht ihn dabei sogar noch sehr funktional.

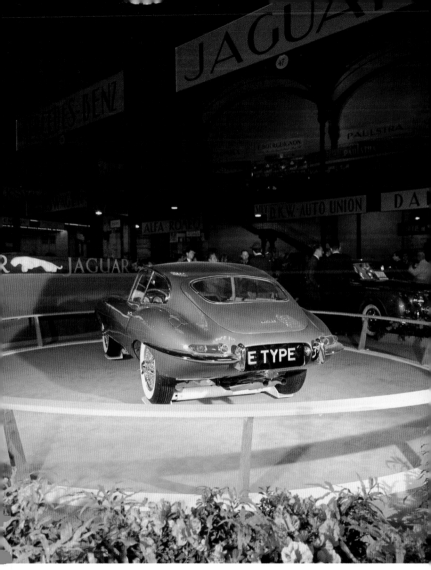

L'arrière le plus sexy de l'histoire automobile et une des voitures les plus érotiques de tous les temps. Le type E incroyablement rapide fit sensation en 1961. Son hayon arrière typique le rendait en plus très fonctionnel.

La parte trasera más caliente de la historia del automóvil en uno de los vehículos más eróticos. El E Type fue en 1961 una sensación absoluta. Su típico portaequipajes lo hace al mismo tiempo incluso muy funcional.

Alfa Romeo 2600 Sprint

I 1960
design: Bertone

© 19

BMW 1500

D 1961
design: Giovanni Michelotti

Simca 1000
F 1961

Hillman Imp
GB 1963

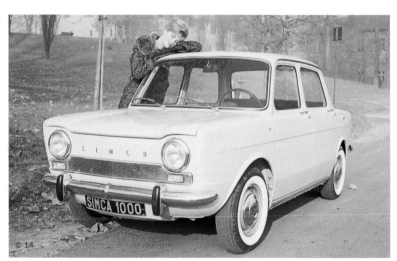

© 14

Greetings from the Chevrolet Corvair. **Der Chevrolet Corvair** lässt grüßen.

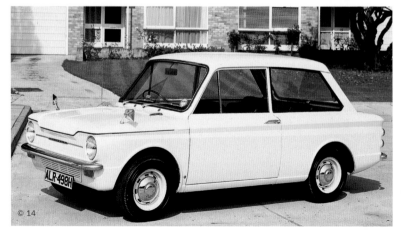

© 14

Fiat 1300-1500
I 1961

NSU Prinz 4L
D 1961

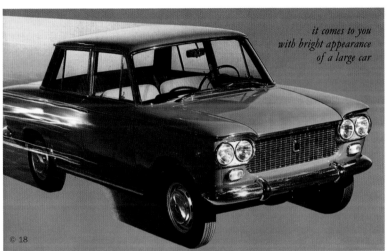

*it comes to you
with bright appearance
of a large car*

© 18

La Chevrolet Corvair vous salue. **El Chevrolet Corvair** lo saluda.

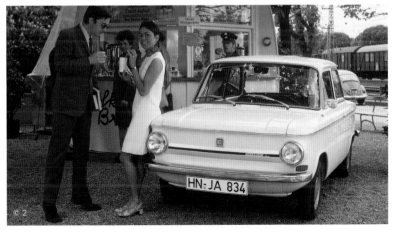

© 2

Alfa Romeo Giulia ti
I 1961

© 19

180 **A controversial Alfa Romeo:** the technically innovative sports sedan with sporty cut-off end tended towards baroque design in terms of detail. Was this a hommage to the Edsel?

Ein kontroverser Alfa Romeo: Die technisch innovative Sportlimousine mit geschnittenem Kammheck neigte im Detail zum Barock. Eine Hommage an den Edsel?

Une Alfa Romeo controversée : la berline de sport de technique innovatrice à l'arrière coupé tournait au baroque dans les détails. Un hommage à Edsel ?

Un Alfa Romeo controvertido: La limusina deportiva técnicamente innovadora con la parte trasera cortada en cresta tendía al Barroco en los detalles. ¿Un homenaje al Edsel?

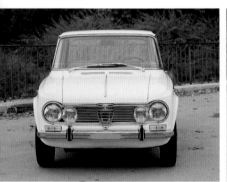

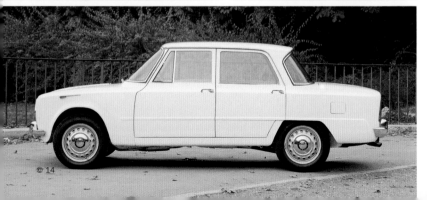

© 14

Renault R4
F 1961

© 36

Form follows function: there is hardly anything that the Renault 4 cannot offer.

Form follows function: Es gibt kaum etwas, was der Renault 4 nicht bieten kann.

Forme et fonctionalité : la Renault 4 donne une réponse à tout.

Form follows function: No hay apenas nada que el Renault 4 no pueda ofrecer.

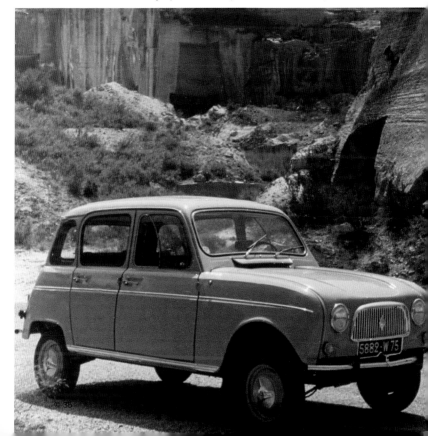

© 36

Ford Thunderbird
USA 1961

Horizontal space was an obsession of American 1960s designs. The cars became bigger and bigger, wider and, of course, flatter. It is hard to believe that the four seater T-Bird is meant to be a sporty car.

Horizontalität war eine Obsession des amerikanischen Designs in den 60er Jahren. So wurden die Autos immer größer, breiter und natürlich flacher. Kaum zu glauben: der 4-Sitzer T-Bird soll ein sportliches Auto sein.

L'horizontale était une obsession du style américain des années 60. Les voitures devinrent toujours plus grandes, plus larges et bien sûr plus plates. Difficile à croire : la T-Bird à 4 places devait être une voiture sportive.

La horizontalidad fue una obsesión del diseño americano en los años 60. Así, los automóviles fueron cada vez más grandes, más anchos y naturalmente más planos. Difícil de creer: Se supone que el 4 plazas T-Bird es un automóvil deportivo.

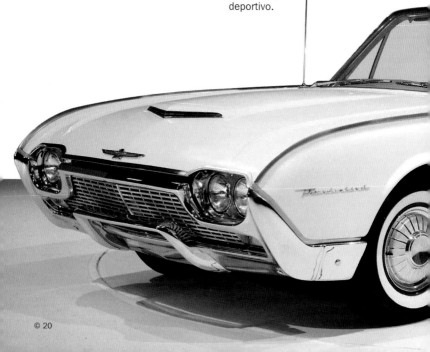

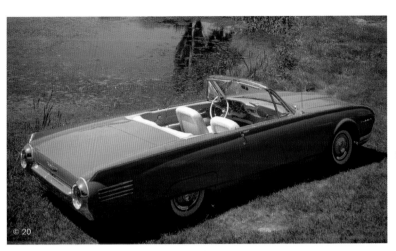

© 20

183

Lincoln Continental Mark 3
USA 1961

184 **New Line:** despite its size, the smooth, flowing Continental was clearly a sign of modern understatement.

Neue Linie: trotz seiner Größe war der glatte, fließende Continental eindeutig ein Zeichen des modernen Understatement.

Nouvelle ligne : malgré sa grande taille, la Continental était un symbole moderne de la discrétion.

La Nueva Línea: A pesar de su dimensión, el liso y fluido Continental fue claramente un signo de la falsa modestia moderna.

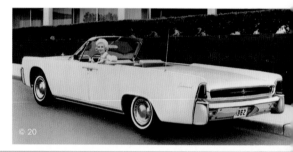

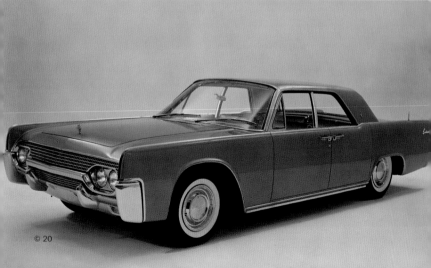

Rolls Royce Silver Shadow
GB 1965

A royal scandal: too small, too flat, too innovative—and to drive oneself as well! The best car in the world was nevertheless simply wonderful.

Skandal royal: zu klein, zu flach, zu innovativ – und auch noch für Selbstfahrer! Das beste Auto der Welt war trotzdem simply wonderful.

Scandale royal : trop petite, trop plate, trop innovatrice, et à conduire soi-même ! La meilleure voiture au monde était tout simplement merveilleuse.

Escándalo royal: pequeño, plano, innovador –ie incluso también para quienes conducen ellos mismos!– El mejor automóvil del mundo era bellísimo.

185

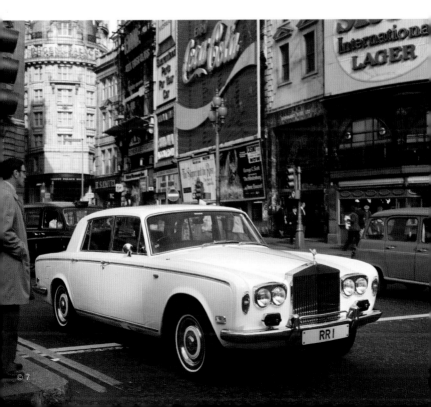

© 7

Mercedes Benz 220 SE Coupé
D 1961

186 **The new Mercedes model** for the 1960s is a perfect combination of modernity and timeless elegance.

Die neue Mercedes Linie für die 60er verbindet in perfekter Weise Modernität mit zeitloser Eleganz.

La nouvelle ligne de Mercedes des années 60 associe parfaitement le modernisme et l'élégance intemporelle.

La Nueva Línea de Mercedes para los 60 une de manera perfecta lo moderno con una elegancia atemporal.

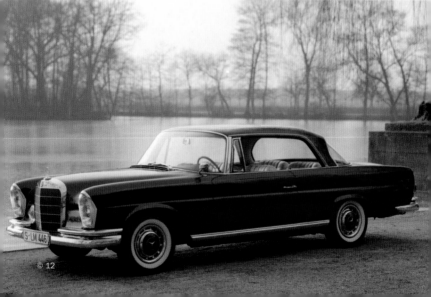

© 12

Mercedes Benz 230 SL
D 1963

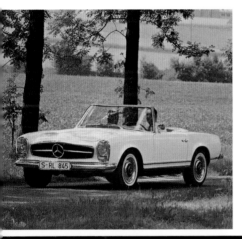

A roadster with all weather function: a pagoda roof for tall Germans.

Roadster mit Allwetter Funktion: Ein Pagodendach für große Deutsche.

Le Roadster pour tous les temps : un toit pagode pour les allemands grands de taille.

El Roadster con función para todos los climas: Un techo de pagoda para alemanes altos.

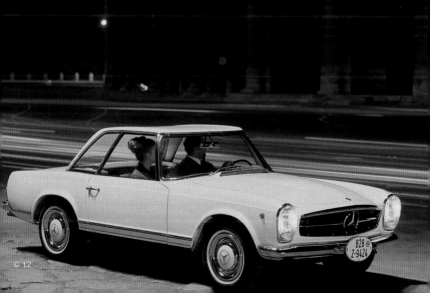

© 12

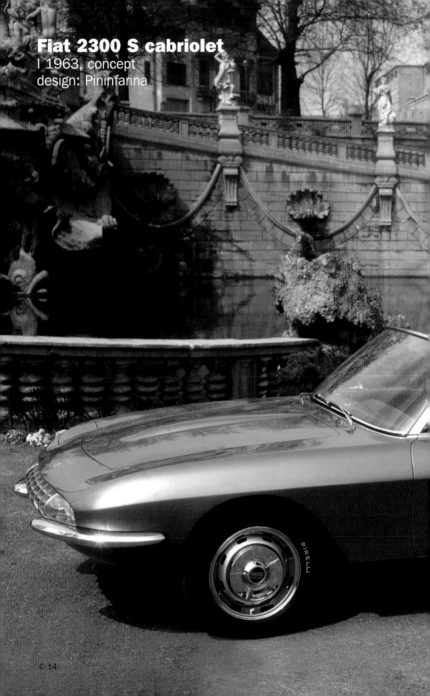

Fiat 2300 S cabriolet
I 1963, concept
design: Pininfarina

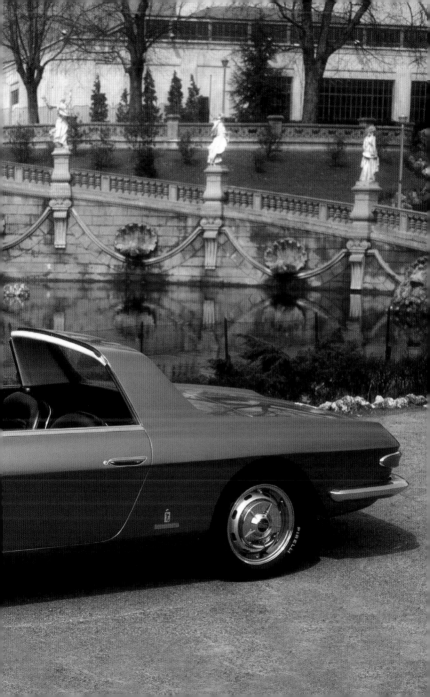

Chevrolet Corvette Sting Ray
USA 1963

Mitchell's Stingray design was produced as a series with the 1963 Corvette. The roof in the shape of a water droplet with a divided rear window, heavily emphasized fenders and adjustable headlights made it into a popular status symbol.

Mitchell's Stingray Design ging 1963 als Corvette in Serie. Tropfenförmiges Dach mit geteilter Heckscheibe, stark betonte Kotflügel und versenkbare Scheinwerfer machten ihn zu einem beliebten Vorzeigeobjekt.

Le design Stingray de Mitchell fut construit en série en 1963 avec la Corvette. Le toit en goutte avec la vitre arrière en deux parties, les ailes très soulignées et les phares escamotables en firent un objet à exhiber très apprécié.

El diseño Stingray de Mitchell pasó a hacerse en serie como Corvette en 1963. El techo con forma de gota con luneta partida, guardabarros muy acentuados y faros abatibles hicieron de él un apreciado objeto para exhibir.

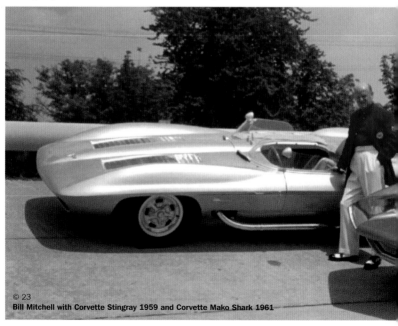

© 23
Bill Mitchell with Corvette Stingray 1959 and Corvette Mako Shark 1961

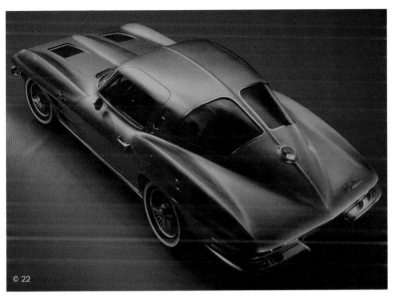

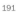
191

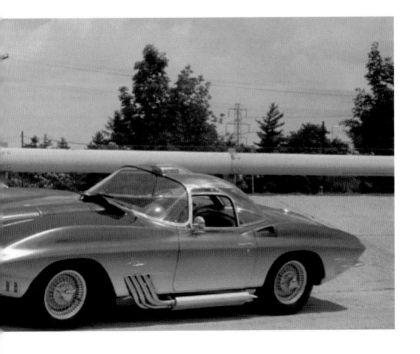

© 22

Ford Cortina Super SW
GB 1963

192 **A free interpretation** of American style: the English Cortina with curved wood applications.

Freie Interpretation des amerikanischen Stils: der englische Cortina mit geschwungenen Holzapplikationen.

Interprétation libre du style américain : la Cortina anglaise avec des applications courbes en bois.

La interpretación libre del estilo americano: El Cortina inglés con aplicaciones arqueadas de madera.

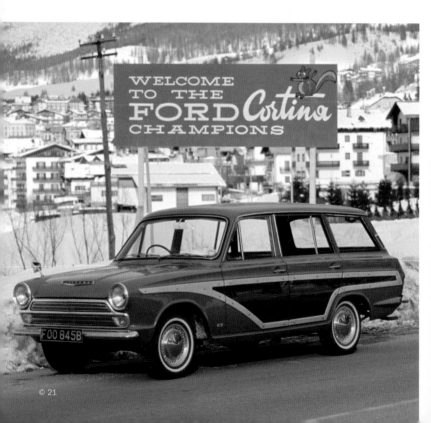

© 21

Porsche 911
D 1963

© 13

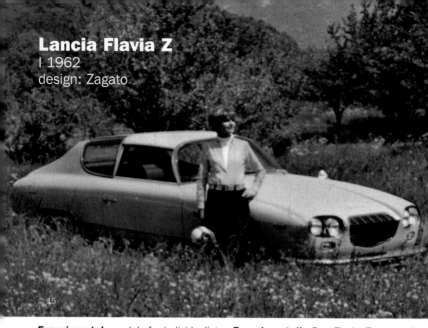

Lancia Flavia Z
I 1962
design: Zagato

© 15

Experimental: models for individualists were the Flavia Zagato with its characteristic, panoramic windows and concave tail line, as well as the thoroughly styled Panhard with plastic body.

Experimentell: Der Flavia Zagato mit seinen charakteristischen Panoramafenstern sowie der durchgestylte Panhard mit Kunststoffkarosserie waren Stoff für Individualisten.

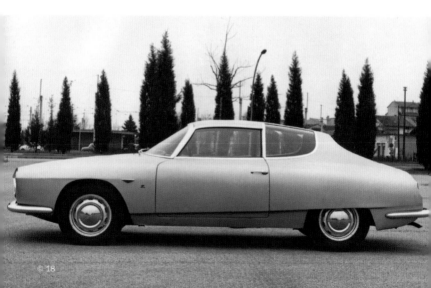

© 18

Panhard 24
F 1963

Expérimentales : la Flavia Zagato avec ses vitres panoramiques typiques, ainsi que la Panhard stylée en carrosserie de matière synthétique étaient des voitures pour individualistes.

Experimental: El Flavia Zagato con sus ventanas panorámicas características así como el Panhard totalmente diseñado, con la carrocería sintética, fueron un caso para individualistas.

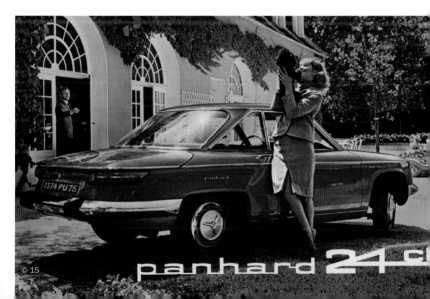

Maserati Mistral
I 1963
design: Pietro Frua

196 **Functionality**: Frua's large, glass tailgate keeps turning up later on. The target group in the sixties: Ghia's 2300 S Club for hunters with attitude. The "Shooting Wagon" was born.

Funktionalität im Sportauto: Fruas große Heckklappe aus Glas. Mit Ghias 2300 S Club für Jäger mit Stilbewusstsein war der „Shooting Wagon" geboren.

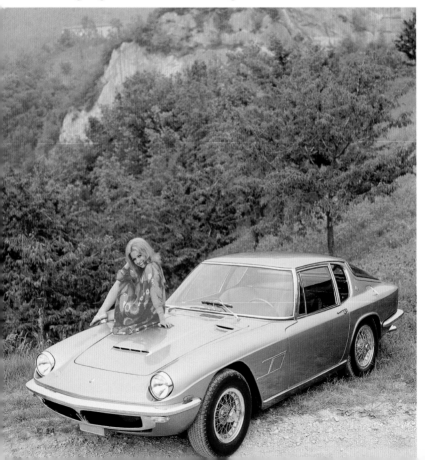

Fiat 2300 S Club

I 1963, concept
design: Ghia

La fonctionalité dans les voitures de sport: Le hayon arrière en verre de Frua. Avec le modèle 2300 S Club pour chasseur ayant de l'aplomb le « Shooting Wagon » était né.

La funcionalidad en el automóvil deportivo: El gran portaequipajes de vidrio de Frua. Con el 2300 S Club para cazadores con conciencia de estilo había nacido el "Shooting Wagon".

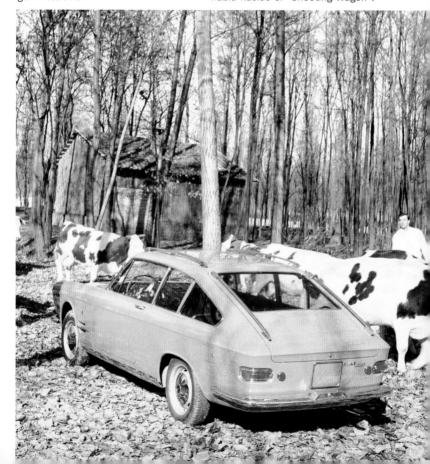

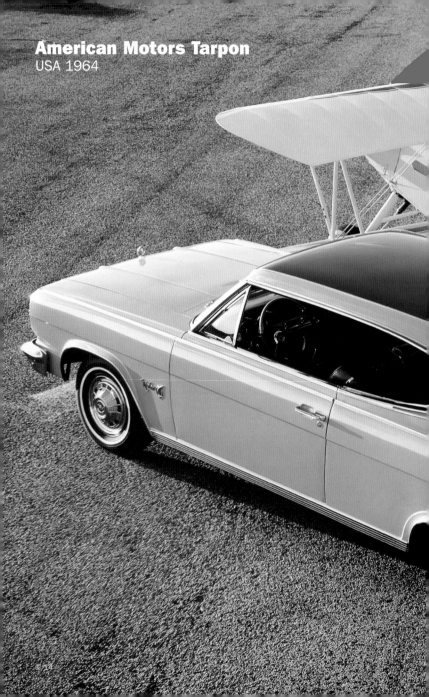

American Motors Tarpon
USA 1964

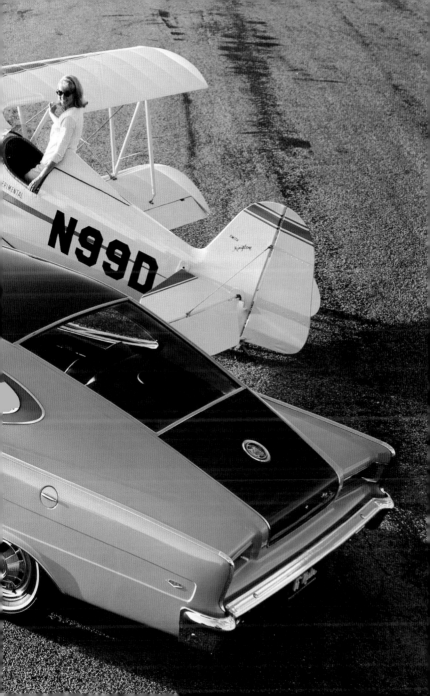

Ford Mustang II
USA 1964

The Mustang was a cheap sports car, which caught the mood of the time and created a storm. The long engine hood, the 'Hop-up' bend at the hip and the fastback roof (as below) influenced design trends.

Als billiges Sportauto traf der Mustang den Nerv der Zeit und machte Furore. Die lange Motorhaube, der „Hop-up"-Knick an der Hüfte und das Fastbackdach (hier unten) haben Schule gemacht.

La voiture de sport bon marché Mustang tomba juste et fit fureur en Europe. Le capot moteur allongé, le coude « hop-up » sur les flancs et le toit Fastback (ci-dessous) se sont imposés.

Como un automóvil deportivo barato, el Mustang tocó el nervio de la época e hizo furor. El largo capó, el pliegue Hop-up en las caderas y el techo Fastback (aquí abajo) han hecho escuela.

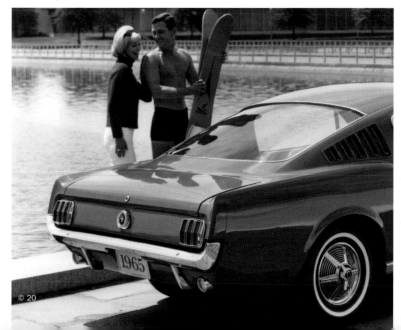

© 20

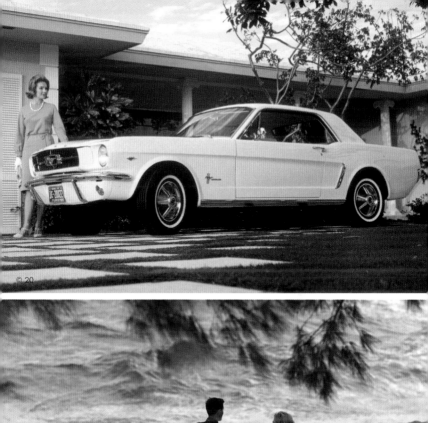
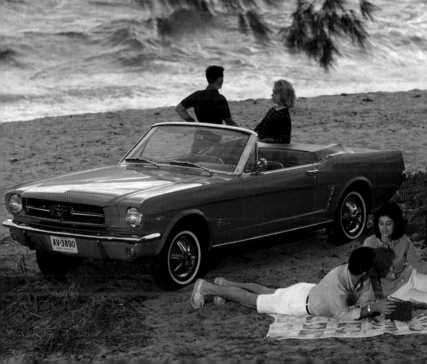

Opel Commodore
D 1964

Buick Riviera
USA 1964

The Riviera is the predecessor of New Baroque design. The line and proportions are modern, but in terms of detail, the design was unnecessarily overworked.

Der Riviera ist der Vorgänger des New Baroque Design. Die Linie und die Proportionen sind modern, im Detail wurde das Design aber unnötig überreizt.

Riviera est le modèle prédécesseur du design New Baroque. La ligne et les proportions sont modernes, les détails sont inutilement exagérés.

El Riviera es el precursor del diseño New Baroque. La línea y las proporciones son modernas; sin embargo, en los detalles el diseño se crispó innecesariamente.

Oldsmobile Toronado
USA 1966

The front wheel drive Toronado was a revolution in the USA. The design, a mixture of Flow and Edge elements, was also way ahead of its time.

Der Toronado mit Vorderradantrieb war eine Revolution in den USA. Auch sein Design, eine Mischung aus Flow und Edge Elementen, war seiner Zeit weit voraus.

Toronado était le premier véhicule de la classe supérieure à traction avant, une révolution aux Etats-Unis. Les éléments Flow et Edge de son design étaient aussi en avance sur son temps.

El Toronado con tracción delantera fue una revolución en los EEUU. También su diseño, una mezcla de elementos de Flow y Edge se adelantó mucho a su tiempo.

© 22

Audi 1700
D 1965

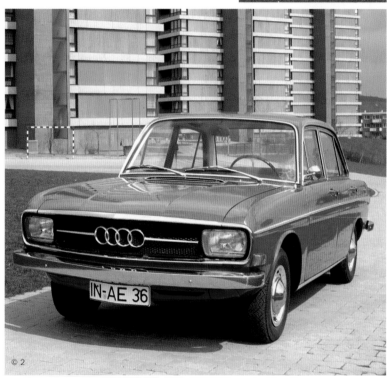

© 2

The first Audi claimed to be highly progressive. The angular headlights, the wide, black front grill made this model appear especially modern.

La première Audi fut ostensiblement progressive. Ses phares carrés et sa large calandre noire lui donnaient un aspect particulièrement moderne.

Der erste Audi gab sich betont progressiv. Die eckigen Scheinwerfer und der breite schwarze Frontgrill ließen ihn besonders modern aussehen.

El primer Audi se las dio marcadamente de progresista. Los faros cuadrados y la parrilla frontal ancha lo hicieron aparecer especialmente moderno.

BMW 2000 CS
D 1965
design: Giovanni Michelotti

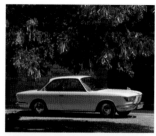

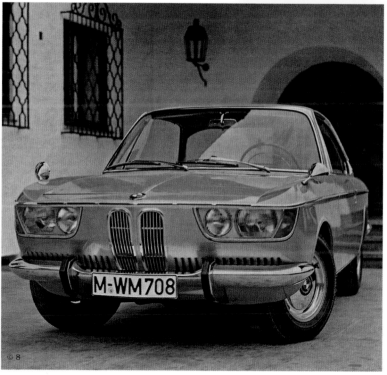

© 8

Noble, slender, light: Michelotti's design for the Coupé CS represented the superior class of BMW until the 1980s.

Edel, schlank, leicht: Michelottis Design für das Coupé CS steht bis in die 80er Jahre stellvertretend für die Oberklasse von BMW.

Racé, mince, léger : le design de Michelotti pour le coupé CS reste synonyme de classe supérieure pour BMW jusque dans les années 80.

Noble, delgado, ligero: El diseño de Michelotti para el Coupé CS aparece hasta entrados los años 80 como el representante de la clase superior de BMW.

Jeep Gladiator, Wagoneer
USA 1963

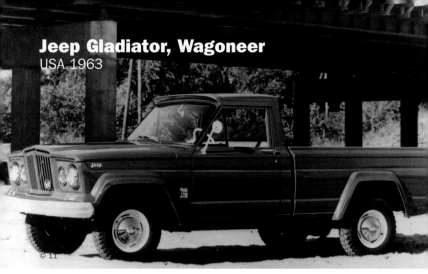

© 11

The Wagoneer was the first big Cross Country vehicle with a station wagon look. Two cars for the price of one: the Ford Bronco was both a fun and family car. Both are forerunners of what is today known as the 'Sport Utility Vehicle'.

Der Wagoneer war der erste große Geländewagen im Station Wagon Look. Zwei Autos in einem: der Ford Bronco war Funcar und Familienauto zugleich. Beide sind die Vorläufer dessen, was heute „Sport Utility Vehicle" genannt wird.

Le modèle Wagoneer est la première voiture tout terrain de type break. Deux voitures pour le prix d'une : le modèle Ford Bronco était à la fois une voiture de tourisme et une voiture familiale. Ces deux modèles sont les précurseurs du style « Sport Utility Vehicle ».

El Wagoneer fue el primer todo terreno con aspecto de un Station Waggon. Dos vehículos en uno: El Ford Bronco fue Funcar y vehículo familiar al mismo tiempo. Ambos son los precursores de lo que actualmente se llama "Sport Utility Vehicle".

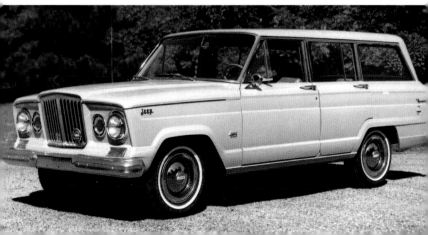

Ford Bronco
USA 1966

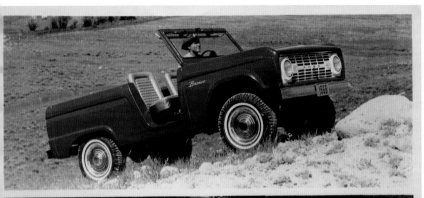

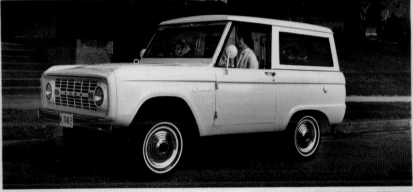

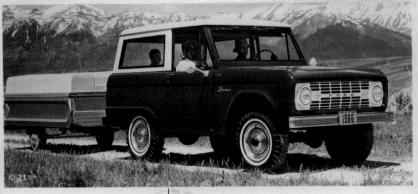

Lincoln Continental MK III
USA 1968

Modern baroque from the USA: at the front, a Greek temple, a copy of the cabrio roof and a spare wheel.

Modernes Barock aus den USA: griechischer Tempel vorne, imitiertes Cabriodach bzw. Reserverad.

Le baroque moderne des Etats-Unis : temple grec à l'avant, imitation de toit cabriolet ou roue de secours.

El Barroco moderno de los EEUU: delante el templo griego, techo Cabrio imitado o rueda de repuesto respectivamente.

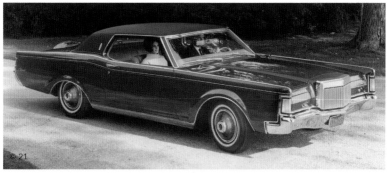

© 21

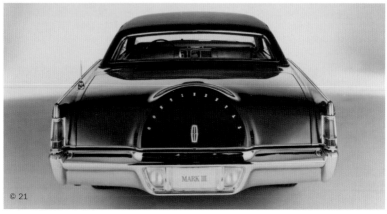

© 21

Opel Admiral, Diplomat

D 1964

Two Americans in Europe: Opel's imposing flagship could hardly be copied by anybody in old Europe.

Zwei Amerikaner in Europa: Die imposanten Flaggschiffe von Opel konnte auf dem alten Kontinent kaum jemand überbieten.

Deux Américains en Europe : personne ne pouvait surpasser le vaisseau imposant d'Opel sur le vieux continent européen.

Dos americanos en Europa: En el viejo continente apenas nadie podía superar los imponentes buques insignia de Opel.

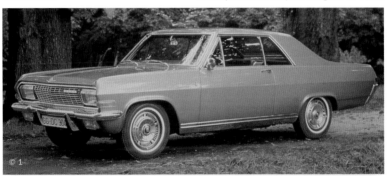

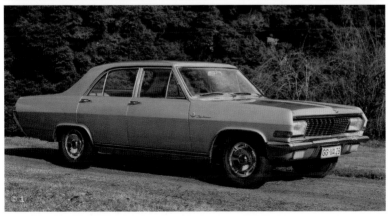

Renault R16
F 1964

212 **The essence of new 1960s values** was a mixture of sedan and station wagon: the R16 represented a new type of automobile, which continues to be successful today. Volvo offered security for the whole family.

Sinnbild der neuen Werte der 60er Jahre: Zwischen Limousine und Kombi stellte der R16 einen neuen Automobiltypus dar, der noch bis heute erfolgreich ist. Volvo bot Sicherheit für die ganze Familie an.

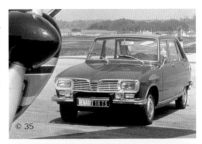

© 35

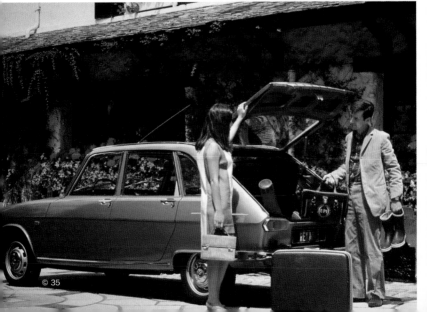

© 35

Volvo 144, 145
S 1966

© 20

Symbole des nouvelles valeurs des 213
années 60 : entre berline et break, la
R16 représentait un nouveau type auto-
mobile qui fait succès encore aujourd'-
hui. Volvo offrit la sécurité à toute la
famille.

El símbolo de los nuevos valores de
los años 60: Entre la limusina y el
Combi, el R16 representó un nuevo tipo
de automóvil que tiene éxito todavía
hasta hoy. El Volvo ofrecía seguridad
para toda la familia.

© 20

OA 93958

Dino 206 Berlinetta

I 1965, concept
design: Pininfarina

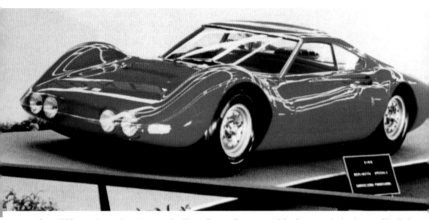

So different and yet so similar. Dedicated to the deceased son of Enzo Ferrari, in the 1960s, the Dino became a cult car. The 2000 GT is the most attractive Japanese model ever to be produced. The round, tail lights with chrome edging were actually a Japanese innovation.

So verschieden und doch so ähnlich. Pininfarina widmete den Dino dem verstorbenen Sohn von Enzo Ferrari. Der Dino wurde in den 60ern zum Kult. Der 2000 GT ist der schönste Japaner, der je produziert wurde. Die runden Heckleuchten mit Chromrand waren tatsächlich eine japanische Erfindung.

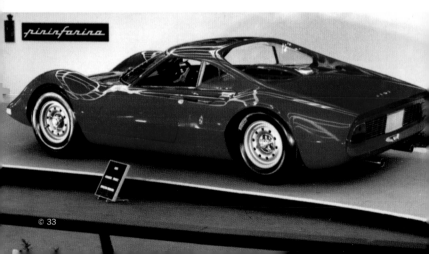

© 33

Toyota 2000 GT
J 1964

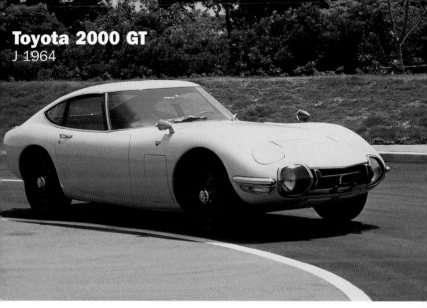

Si différentes et pourtant semblables. Pininfarina dédicaça la Dino au fils défunt de Enzo Ferrari. La Dino devint un mythe dans les années 60. Le modèle 2000 GT est la plus belle voiture japonaise qui fut jamais produite. Les feux arrière ronds cerclés de chrome sont véritablement une invention japonaise.

Tan distintos y sin embargo tan parecidos. Pininfarina dedicó el Dino al hijo fallecido de Enzo Ferrari. El Dino se convirtió en los 60 en objeto de culto. El 2000 GT es el japonés más bello que se produjo jamás. Las luces traseras redondas con el borde de cromo fueron realmente una invención japonesa.

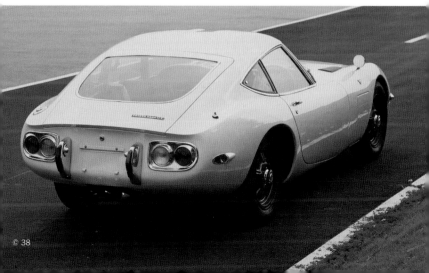

Daf City

I 1966, concept
design: OSI

216 **A city car concept** with sliding doors has unfortunately not yet been designed.

Ein City-Car Konzept mit Schiebetüren hat es leider noch nicht gegeben.

Le concept d'une voiture de ville aux portes coulissantes n'existe malheureusement pas.

Lamentablemente todavía no ha habido un proyecto para un City Car con puertas correderas.

© 14

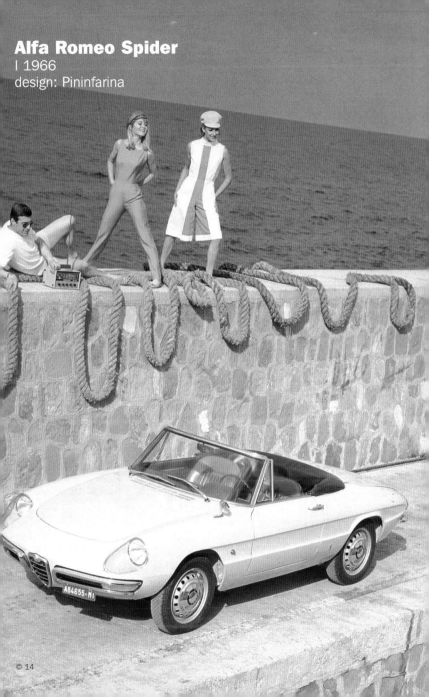

Alfa Romeo Spider
I 1966
design: Pininfarina

Iso Rivolta S4
I 1967
design: Ghia

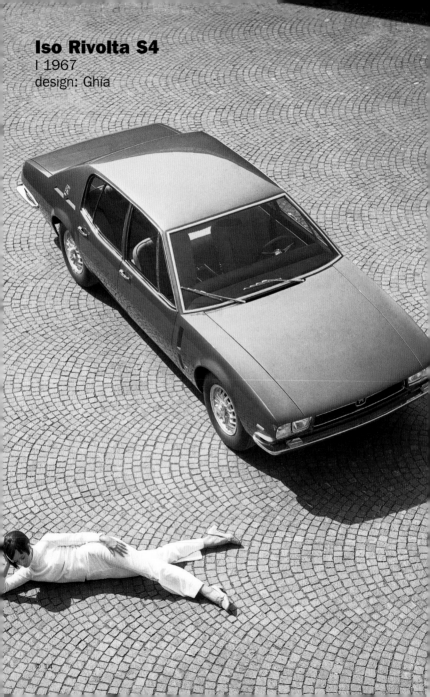

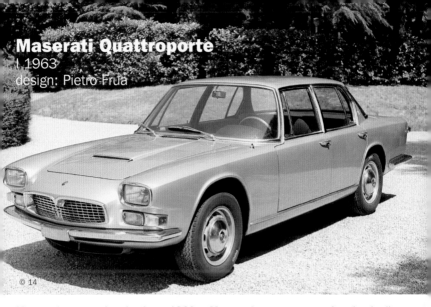

Maserati Quattroporte
I 1963
design: Pietro Frua

© 14

Maserati as an inspiration: 1960s sports sedans for fathers who no longer wanted a chauffeur.

Maserati als Vorbild: Sportlimousinen der 60er für Familienväter, die sich keinen Chauffeur mehr wünschten.

Maserati comme exemple : les berlines de sport des années 60 pour les pères de famille qui ne voulaient plus de chauffeurs.

Maserati como ejemplo: Las limusinas deportivas de los 60 para padres de familia que ya no deseaban un chófer.

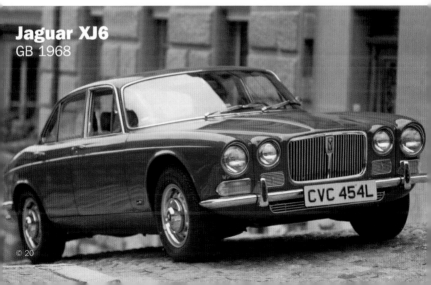

Jaguar XJ6
GB 1968

CVC 454L

© 20

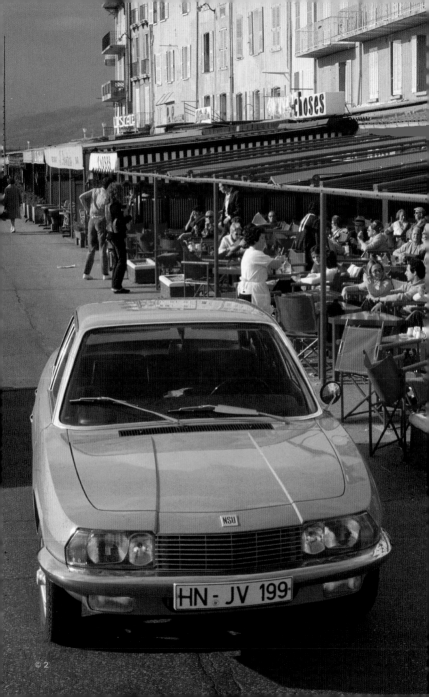

NSU Ro80
D 1967

A long wheel support, rounded lines, a short, high tail: 221
the Ro80 actually looks like an '80s car, although with a
touch of Pininfarina in the front section.

Langer Radstand, abgerundete Linien, kurzes hohes Heck:
der Ro80 sieht tatsächlich wie ein Auto der 80er Jahre aus.
Freilich mit einem Hauch Pininfarina in der Frontpartie.

Long empattement, lignes arrondies, arrière élevé et
court : la Ro80 ressemble vraiment à une voiture des
années 80. Cependant avec un air de Pininfarina à l'avant.

Una larga distancia entre los ejes, líneas redondeadas,
parte trasera corta y alta: El Ro80 tiene realmente el
aspecto de un automóvil de los años 80. Desde luego,
con un toque de Pininfarina en la parte frontal.

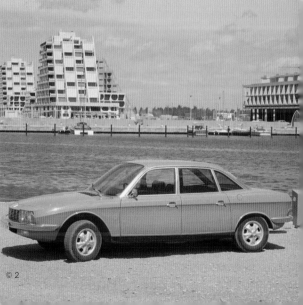

© 2

Alfa Romeo Montreal
I 1967
design: Bertone

This design for a dream car for the 1967 Montreal Expo later went into production as a series. Bertone's typical 1970s Graph elements are already identifiable.

Als Traumauto für die 1967er Expo von Montreal entworfen, ging er später in Serie. Bertones typische Graph-Elemente der 70er Jahre sind bereits erkennbar.

La voiture de rêve Montreal fut créée pour l'exposition de 1967 mais elle fut ensuite construite en série. Les éléments Graph typiques de Bertone dans les années 70 sont déjà présents.

Proyectado como el automóvil de ensueño para la Expo de Montreal de 1967, se realizó más tarde en serie. Ya son reconocibles los típicos elementos Graph de Bertone de los años 70.

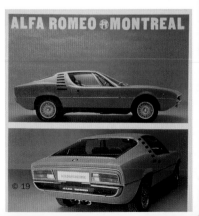

© 19

© 19

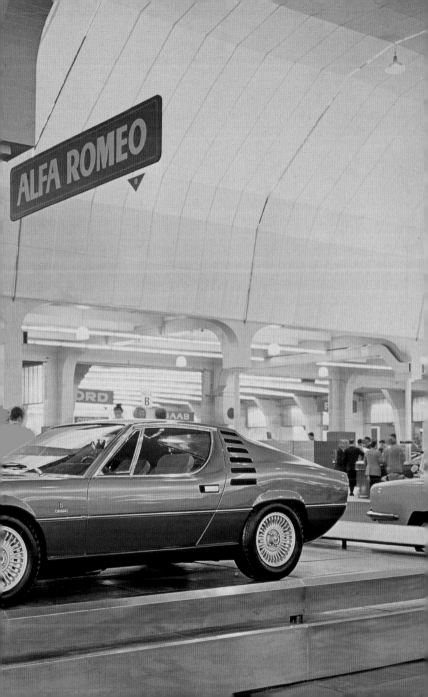

Pontiac GTO
USA 1968

224 **An evil look** guarantees sporting performance.

Böses Aussehen als Garantie sportlicher Leistung.

Un aspect méchant pour garantir la performance sportive.

Un aspecto malvado como garantía de un rendimiento deportivo.

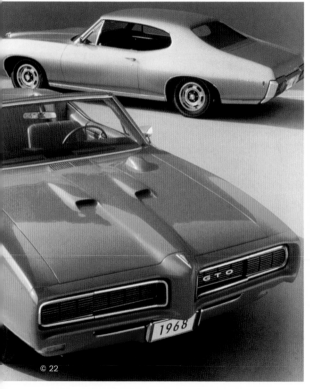

© 22

© 22

Pontiac Firebird

USA 1967

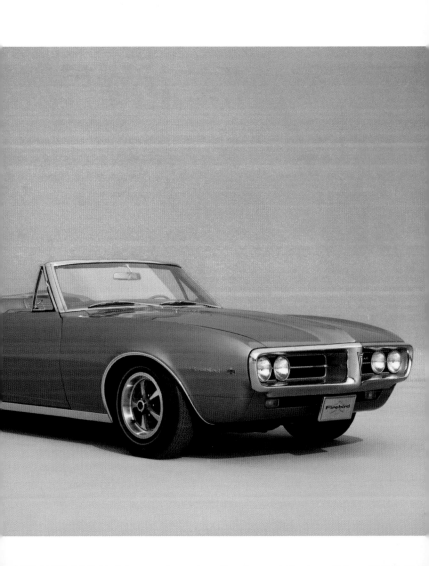

Audi 100 Coupé S
D 1969

226 **Pininfarina's fastback sedan** was a vision of the future that was fashionable.

Pininfarinas Fastback Limousine mit fließenden Linien und schnittigem Heck war eine Zukunftsvision, die Mode machte.

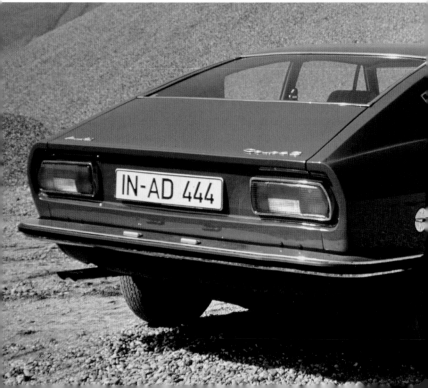

Pininfarina BMC 1800
I 1967, concept
design: Pininfarina

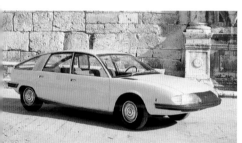

La berline Fastback de Pininfarina avec ses lignes fluides et son arrière élégant était une vision de l'avenir et lança une mode.

La limusina Fastback de Pininfarina con líneas fluidas y parte trasera en línea elegante fue una visión de futuro que creó moda.

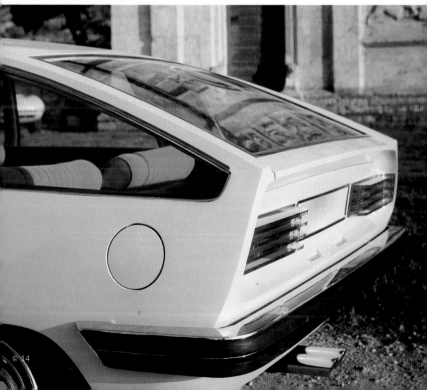

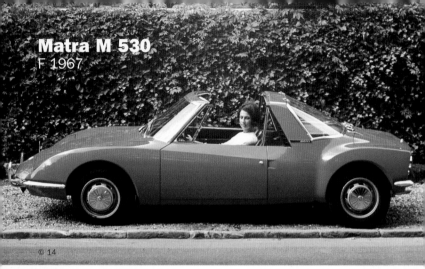

Matra M 530
F 1967

© 14

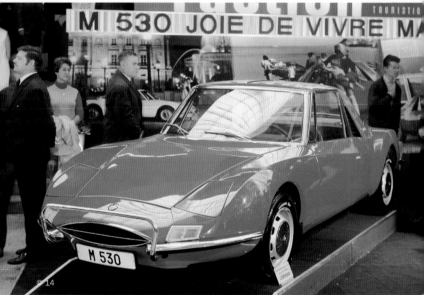

© 14

From French eccentricity to German simplicity: the Targa roadster offered functionality and lots of joy and vitality. On the Matra, the T-Top was divided into two, the Porsche had two trunks; and the roof could also be stowed away in the rear one.

Ob französische Exzentrizität oder deutsche Schlichtheit: Der Targa Roadster bot Funktionalität und viel Lebensfreude. Beim Matra war das T-Top zweigeteilt, der Porsche hatte zwei Kofferräume; im hinteren konnte auch das Dach verstaut werden.

Volkswagen Porsche 914
D 1969

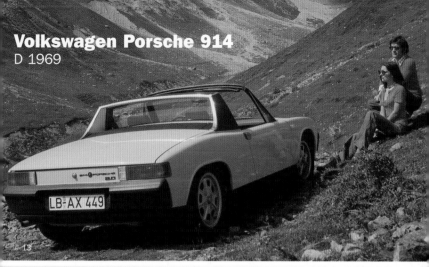

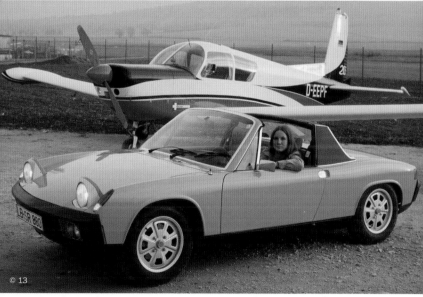

Excentricité française ou simplicité allemande : le Roadster Targa offrait la fonctionalité et une grande joie de vivre. Le toit Targa de la Matra était en deux partie, la Porsche avait deux coffres à bagages ; on pouvait ranger le toit à l'arrière.

Excentricidad francesa o sencillez alemana: El Targa Roadster ofrecía funcionalidad y mucha alegría de vivir. En el Matra, el T-Top estaba dividido en dos, el Porsche tenía dos maleteros; en el posterior también se podía guardar el techo.

Lamborghini Espada
I 1968
design: Bertone

Trunk with window: Bertone's Graph design is fascinating. The super flat Espade is pure avant-garde.

Kofferraum mit Fenster: Bertones Graph Design fasziniert. Der hyperflache Espada ist pure Avantgarde.

Coffre à bagages avec fenêtre : le design Graph de Bertone fascinait. L'Espada extra plate est de pur style avant-garde.

Un maletero con ventana: El diseño Graph de Bertone fascina. El planísimo Espada es vanguardia pura.

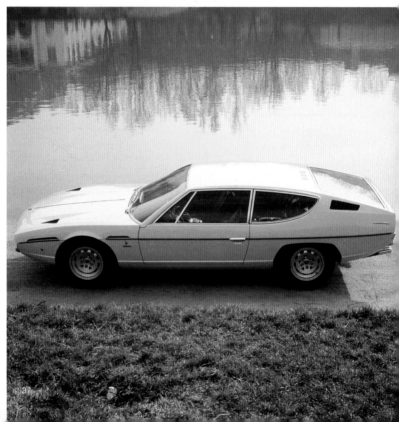

Ferrari Daytona
I 1968
design: Pininfarina

Classical sports car proportions with attitude: a continual acrylic motif on the front section.

Klassische Sportwagen-Proportionen mit Pfiff: durchgehendes Acryl-Motiv in der Frontpartie.

Proportions classiques de la voiture de sport chic : motif acrylique continu à l'avant

Las proporciones clásicas de un automóvil deportivo con un toque especial: el motivo universal de fibra acrílica en la parte frontal.

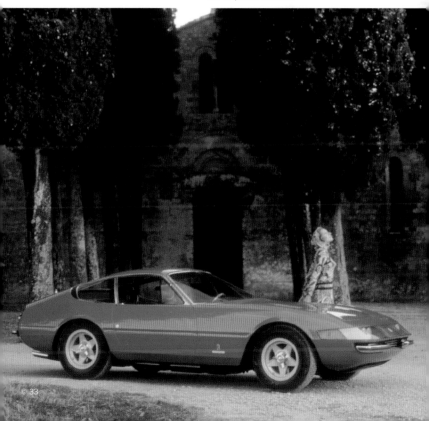

© 33

Ford Capri
D 1969

232 **GM versus Ford.** The Capri promised the sporty dolce vita as a European version of the Mustang, which everybody was dreaming about. Opel's answer was the Manta—by the way, this is the Italian word for 'Stingray', the name of the earlier Corvette.

GM gegen Ford. Als europäischer Mustang versprach der Capri das sportliche Dolce Vita, von dem jeder träumte. Opel antwortete mit dem Manta – übrigens das italienische Wort für ‚Stingray' und der Name der früheren Corvette.

© 21

Opel Manta
D 1970

GM contre Ford. La Capri, version européenne de la Mustang, offrait la Dolce Vita sportive dont tout le monde rêvait. Opel répondit avec la Manta, la traduction italienne de « Stingray » et l'ancien nom de la Corvette.

GM contra Ford. Como Mustang europeo, el Capri prometía la Dolce Vita deportiva con la que todos soñaban. Opel respondió con el Manta –por cierto, la palabra italiana para "Stingray" y el nombre de la antigua Corvette.

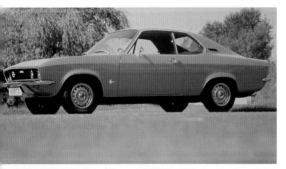

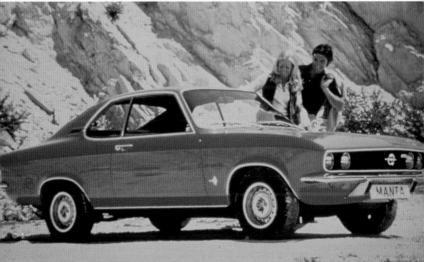

Autodynamics Deserter S1
USA 1968

For roaming in the sand dunes: Buggies were pure fun cars and hip for a short time.

Für Sanddünen gedacht: Die Buggies waren pure Spaßautos und für kurze Zeit sehr hip.

Pour les dunes de sable : les buggies étaient des voitures conçues pour le plaisir et furent très à la mode.

Pensado para dunas de arena: Los Buggies fueron puros automóviles para divertirse y muy hip.

Citroën Dyane

F 1967

Trendy again today? The "2CV in angular look" disappeared at that time as fast as 1970s fashion.

Heute wieder trendig? „Der 2CV im eckigen Look" verschwand damals so schnell wie die Mode der 70er.

De nouveau à la mode ? La 2CV carrée disparut aussi vite que la mode des années 70.

¿Actualmente otra vez de moda? El "2CV con el aspecto cuadrado" desapareció entonces tan rápidamente como la moda de los 70.

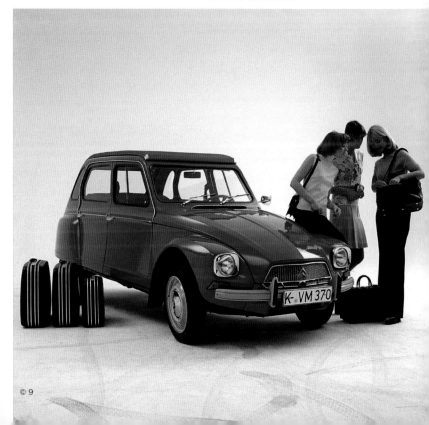

© 9

Chrysler Town & Country
USA 1969

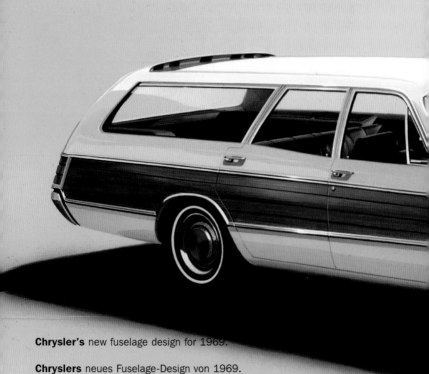

Chrysler's new fuselage design for 1969.

Chryslers neues Fuselage-Design von 1969.

Le nouveau fuselage design de Chrysler en 1969.

El nuevo fuselage design de Chrysler de 1969.

© 23
Vauxhall design, 1970s

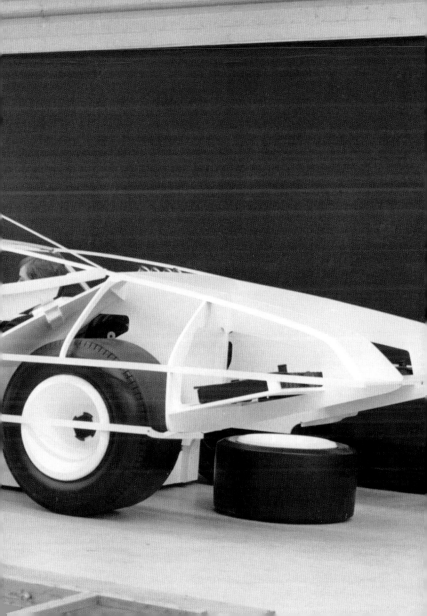

Citroën SM
F 1970

240 **Floating vision:** in 1970, the futuristic SM looked like a UFO.

Gleitende Vision: der futuristische SM sah 1970 wie ein UFO aus.

Vision qui passe : le modèle SM de 1970 ressemblait à un vaisseau spatial.

Una visión deslizante: El futurista SM tenía en 1970 la apariencia de un OVNI.

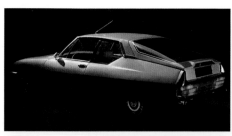

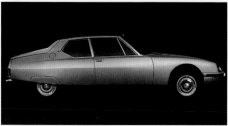

© 14

Range Rover
GB 1970

242 **An air-conditioned Cross Country** ve-
hicle to drive in town: the Range Rover
immediately became a status symbol.

Une voiture climatisée tout terrain
pour la ville : la Range Rover devint
immédiatement un symbole de prestige.

Ein klimatisierter Geländewagen für
die Stadt: der Range Rover wurde sofort
ein Statussymbol.

Un vehículo todo terreno climatizado
para la ciudad: El Range Rover se con-
virtió inmediatamente en un símbolo de
categoría social.

© 15

Fiat 130 Coupé
I 1971
design: Pininfarina

Despite the picture, this model was not for cross country: Pininfarina's purist beauty in Edge Line design was unfortunately only available in the coupé version.

Trotz des Bildes nichts fürs Gelände: Pininfarinas puristische Schönheit im Edge Line Design war leider nur als Coupé zu haben.

Malgré l'apparence, pas tout terrain : la beauté en design Edge Line de Pininfarina n'était disponible qu'en coupé.

A pesar de la imagen no es nada para el campo: La belleza purista de Pininfarina en diseño Edge Line sólo podía adquirirse, lamentablemente, como Coupé.

© 18

Mercedes Benz 350 SL
D 1971

244 **An innovative original image** of the modern Mercedes Benz, with horizontal, angular headlights, rimmed tail lights and fine lines. The only contrast are the convex hoods of the engine and concave trunk.

Innovatives Urbild des modernen Mercedes Benz mit horizontalen, eckigen Scheinwerfern, gerillten Rückleuchten und feiner Linienführung. Einziger Kontrast: konvexe Motorhaube vs. konkave Kofferhaube.

Original innovateur de la Mercedes Benz moderne avec des phares rectangulaires, des feux arrière rainurés et une ligne chic. Seul contraste : un capot moteur convexe en opposition au coffre à bagage concave.

Un prototipo innovador del Mercedes Benz moderno con faros horizontales cuadrados, luces traseras estriadas y un fino trazado de líneas. El único contraste: El capó convexo del motor contra la puerta cóncava del maletero.

© 12

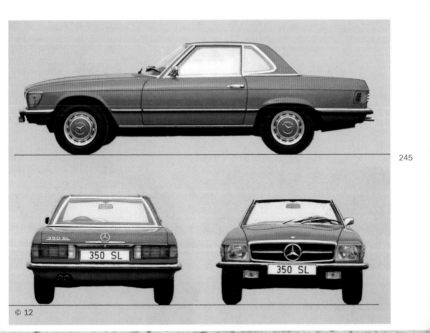

245

© 12

Toyota Celica
J 1971

Japanese Mustang with personal style.

Japanischer Mustang mit persönlichem Stil.

Mustang japonaise au style personnel.

Un Mustang japonés con diseño personal.

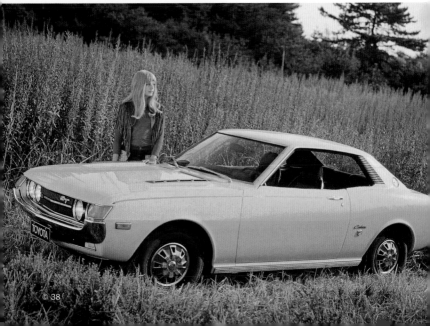

Honda Z
J 1972

© 15

A lifestyle racer in matt-black look: ²⁴⁷ Honda's Baby-Z has cult character.

Ein Lifestyle-Racer in mattschwarzer Ästhetik: Hondas Baby-Z hat Kultcharakter.

Un style de vie sportif avec une esthétique noir mat : la Baby-Z de Honda a un caractère mythique.

Un Lifestyle-Racer en estética negra mate: El Baby-Z de Honda tiene carácter de culto.

© 15

Chevrolet Malibu
USA 1971

The prominent 'Knudsen nose' and the 'Hop-up' bend at the side—whether on a GM or Ford, in 1970, they represented the American design formula for the global market.

Prominente „Knudsen Nase" und „Hop-up"-Knick an der Flanke – ob GM oder Ford, so lautete 1970 das amerikanische Designrezept für den globalen Markt.

Le nez marquant à la Knudsen et le coude Hop-up du flanc étaient les recettes du design américain en 1970, que ce soit chez GM ou Ford.

La prominente "Nariz de Knudsen" y el pliegue "Hop-up" en el flanco: Tanto GM como Ford, en ello consistía la receta de diseño americana para el mercado global en 1970.

© 22

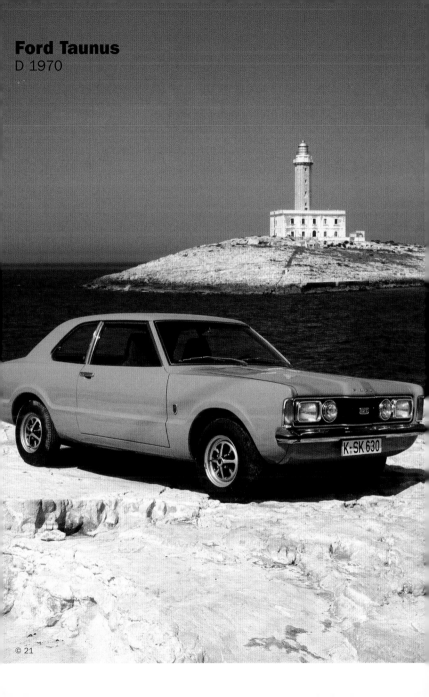

Ford Taunus
D 1970

© 21

Ford Mustang
USA 1972

Muscle cars with metallic Full Metal Jacket and Indian style deco-stickers: it is hard to imagine a quicker fastback model than the Mustang …

Muscle Cars mit blechernem Full Metal Jacket und indianisch anmutenden Deko-Aufklebern. Ein schnelleres Fastback als den Mustang kann man sich kaum vorstellen…

Les Muscle Car en veste métallique avec autocollants à l'indienne. Une voiture Fastback plus rapide que la Mustang est difficile à imaginer…

Los Muscle Cars con Full Metal Jacket de hojalata y adhesivos decorativos que recuerdan lo indio. Uno apenas puede imaginarse un Fastback más rápido que el Mustang …

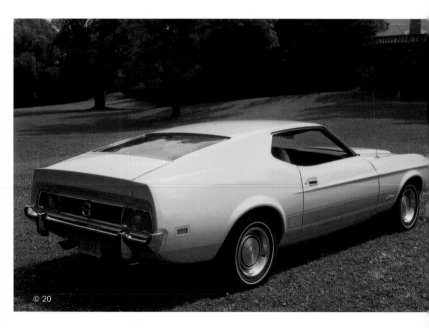

© 20

AMC Gremlin X
USA 1972

... or even a thicker C-column than on the Gremlin.

...eine dickere C-Säule als beim Gremlin auch nicht.

... un montant C plus épais que celui de la Gremlin, aussi !

...tampoco un pilar más grueso que en el Gremlin.

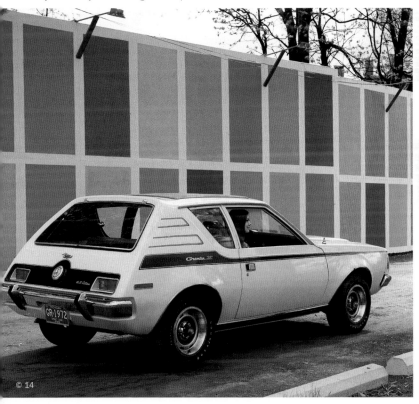

© 14

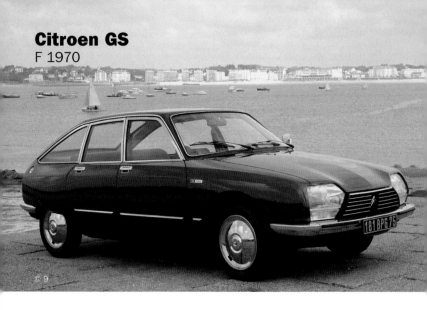

Citroen GS
F 1970

© 9

Modern flow-tail sedans offered more aerodynamics than functionality: the tailgate could not be fully opened on any of these models.

Moderne Fließheck-Limousinen boten mehr Aerodynamik als Funktionalität: bei keinem dieser Autos ließ sich die Heckklappe ganz öffnen.

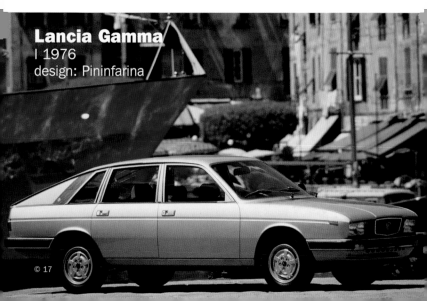

Lancia Gamma
I 1976
design: Pininfarina

© 17

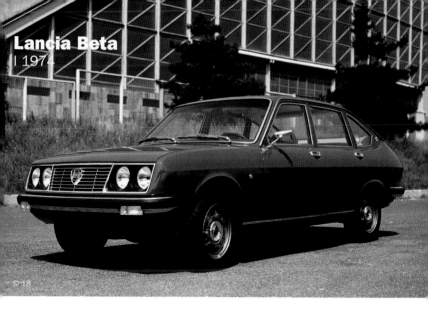

Lancia Beta
I 1974

Les berlines modernes à hayon arrière offraient plus d'aérodynamique que de fonctionalité : il était impossible d'ouvrir complètement le hayon arrière dans toutes ces voitures.

Las limusinas modernas de portón trasero alargado ofrecían más aerodinámica que funcionalidad: En ninguno de estos automóviles podía abrirse la puerta del maletero totalmente.

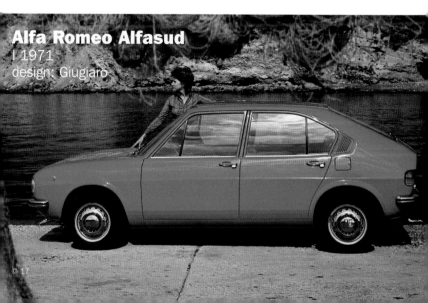

Alfa Romeo Alfasud
I 1971
design: Giugiaro

BMW 5
D 1972

254 **Fashion from Bavaria 1:** the new BMW design lasted longer than 25 years.

Mode aus Bayern 1: das neue BMW Design hielt länger als 25 Jahre.

Mode de Bavière 1 : le nouveau design de BMW dura plus de 25 ans.

La moda desde Baviera 1: El nuevo diseño BMW se mantuvo más de 25 años.

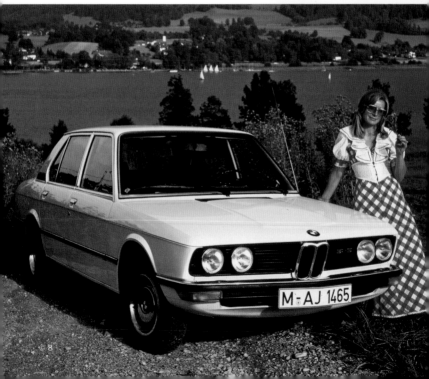

Audi 80
D 1972

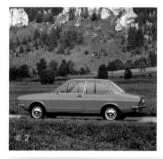

Fashion from Bavaria 2: Audi's Edge Line was also preferred by VW.

Mode aus Bayern 2: Audis Edge Line wurde gerne auch von VW getragen.

Mode de Bavière 2 : la ligne Edge se portait aussi chez VW.

La moda desde Baviera 2: También a VW le gustó llevar la Edge Line de Audi.

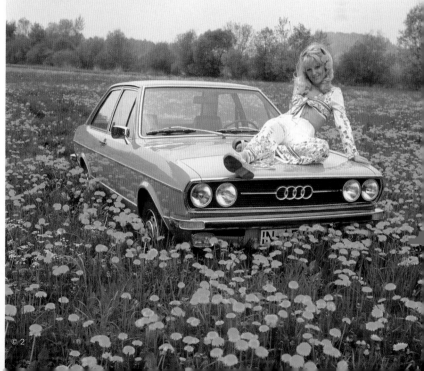

Matra Simca Bagheera

F 1973

256 **A radical step:** thanks to folding head-lights, cars no longer have a face. Instead, on the Matra, there are three seats at the front.

Radikaler Schnitt: Dank Klappschein-werfern haben Autos kein Gesicht mehr. Dafür gibt es beim Matra vorne 3 Sitze.

Coupe radicale : grâce aux phares ré-tractables, les voitures n'ont plus de face. Pour compenser, la Matra a 3 places à l'avant.

Un corte radical: Gracias a los faros plegables los automóviles ya no tienen una cara. En lugar de ello, en el Matra hay tres asientos delante.

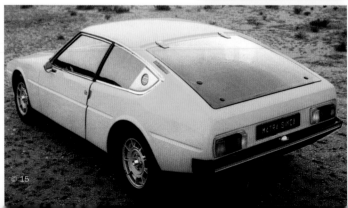

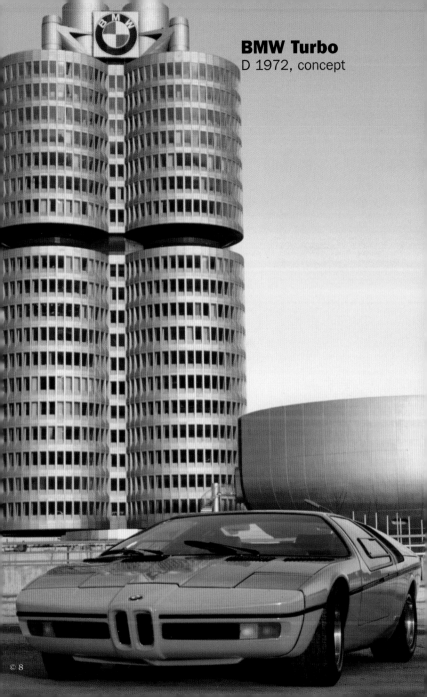

BMW Turbo
D 1972, concept

© 8

Alfa Romeo Alfetta GT
I 1974
design: Giugiaro

258 **The modern Granturismo:** four seats and a large tailgate.

Modernes Granturismo: 4 Sitze und große Heckklappe.

Granturismo moderne : 4 places et grand hayon arrière.

Un Granturismo moderno: 4 plazas y un gran maletero.

© 19

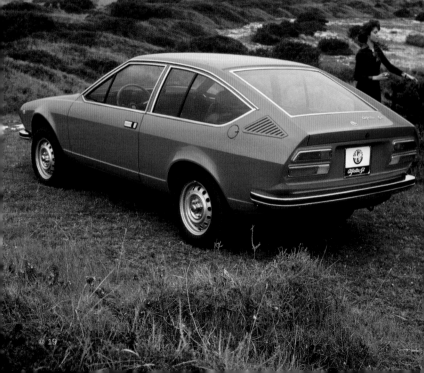

© 19

Fiat X1/9
I 1972
design: Bertone

37

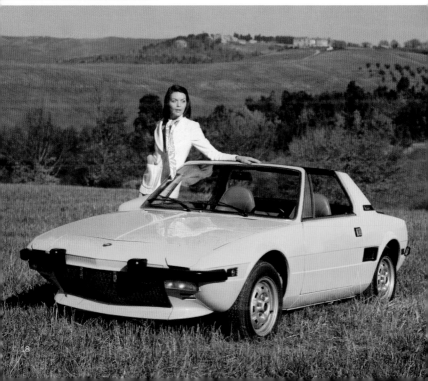

Volkswagen Golf

D 1974
design: Giugiaro

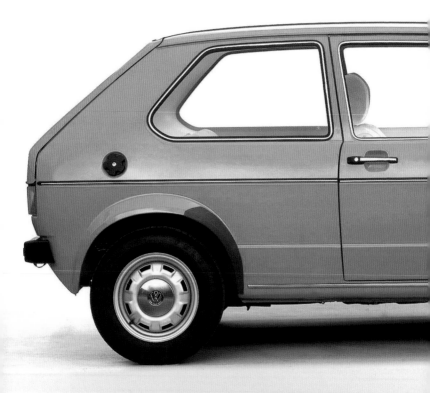

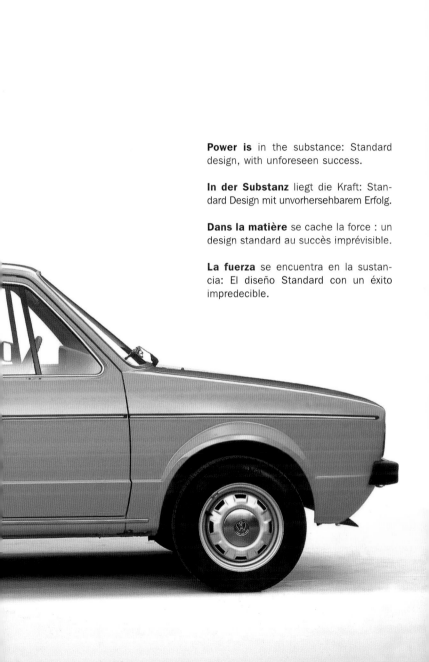

Power is in the substance: Standard design, with unforeseen success.

In der Substanz liegt die Kraft: Standard Design mit unvorhersehbarem Erfolg.

Dans la matière se cache la force : un design standard au succès imprévisible.

La fuerza se encuentra en la sustancia: El diseño Standard con un éxito impredecible.

Renault R5
F 1972

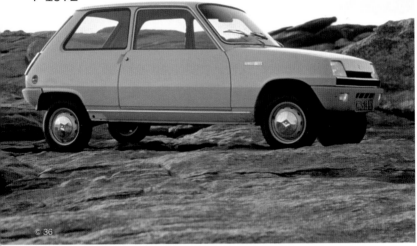

New aesthetic look: the first car with integrated plastic bumpers.

Neue Ästhetik: Das erste Auto mit integrierten Stoßstangen aus Kunststoff.

Nouvelle esthétique : la première voiture avec un pare-chocs synthétique intégré.

La nueva estética: El primer automóvil con parachoques integrados de material sintético.

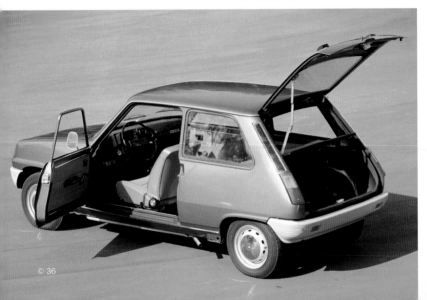

AMC Pacer
USA 1975

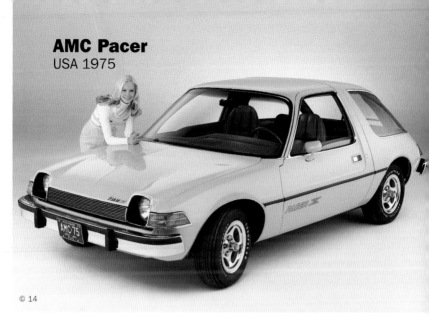

© 14

Unique design functionality: a thick B-column, round tail, all-over glazing.

Einmalige designerische Funktionalität: Dicke B-Säule, rundes Heck, Rundumverglasung.

Fonctionalité unique du design : montant épais, arrière rond, vitres tout autour.

Una funcionalidad del diseño sin precedentes: pilares gruesos, parte trasera redonda, acristalado total.

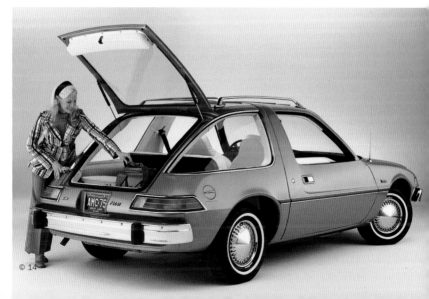

© 14

Triumph TR7
GB 1975

264 **Penetrating:** the subtle message of Wedge Line design could not be better shown.

Penetrant: Die implizite Botschaft des Wedge Line Design kann man nicht besser darstellen.

© 14

© 14

Pénétrant : le message implicite du design Wedge Line ne peut pas être mieux représenté.

Penetrante: El mensaje implícito del diseño Wedge Line no puede representarse mejor.

Renault R14
F 1976

© 36

A provocation to current fashion: the R14 anticipated 1980s Flow Box design.

Provokativ gegen den Trend: der R14 antizipierte das Flow Box Design der 80er Jahre.

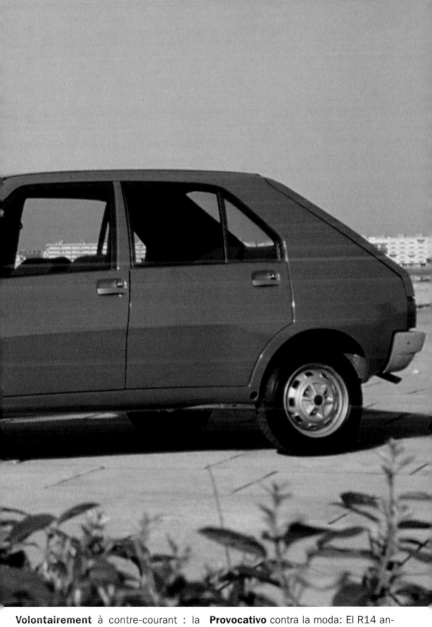

Volontairement à contre-courant : la R14 anticipait le design Flow Box des années 80.

Provocativo contra la moda: El R14 anticipó el diseño Flow Box de los años 80.

Lancia Gamma Coupé
I 1976
design: Pininfarina

© 18

A strong graphic form, fine detail: a perfect balance of chrome, black plastic and color. The metallic bumpers anticipated the trend.

Betont graphisch in der Form, fein im Detail: ein perfektes Gleichgewicht zwischen Chrom, schwarzem Kunststoff und Farbe. Die lackierten Stoßstangen antizipieren den Trend.

Graphisme souligné de la forme, finesse du détail : un équilibre parfait entre le chrome, le synthétique noir et la couleur. Les pare-chocs laqués anticipaient la mode.

Acentuadamente gráfico en la forma, fino en el detalle: una armonía perfecta entre el cromo, el material sintético negro y el color. Los parachoques pintados anticipan la moda.

PORSCHE 928

Une voiture polyvalente bénéficiant d'une garantie long et nécessitant peu d'entretien

urée

BMW 6
D 1976

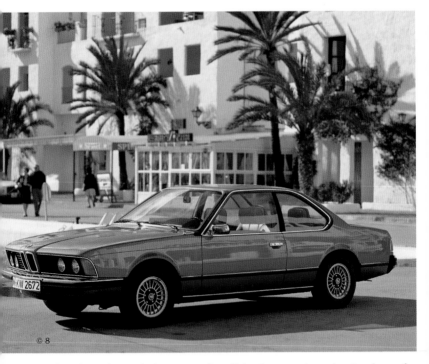

© 8

All for show: large window areas give the sporty BMW 6 series an elegant touch.

Sehen und gesehen werden: große Glasflächen verleihen dem sportlichen 6er BMW eine elegante Note.

Voir et se montrer : les grandes surfaces vitrées de la sportive série 6 de BMW lui apportent une touche élégante.

Ver y dejarse ver: Las grandes superficies acristaladas dotan de una nota elegante al BMW deportivo de 6 plazas.

Opel Monza
D 1977

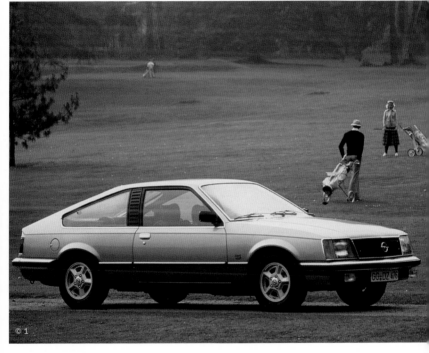

From the golf course to the D-I-Y store: too much functionality can also damage the image of a beautiful car.

Vom Golfplatz zum Baumarkt. Zu viel Funktionalität kann dem Image eines schönen Autos auch schaden.

Du terrain de golf au marché du bricolage. Trop de fonctionalité risque de détruire l'image d'une belle voiture.

Del campo de golf al mercado de materiales para la construcción. Demasiada funcionalidad también puede dañar la imagen de un automóvil bello.

Aston Martin Lagonda
GB 1976

274 **Wedge Line** with dramatic proportions:
you have see this car 'live'.

Wedge Line mit dramatischen Propor-
tionen: dieses Auto muss man live ge-
sehen haben.

La Wedge Line aux proportions théâ-
trales : il faut avoir réellement vu cette
voiture.

Wedge Line con proporciones dramáti-
cas: A este automóvil hay que haberlo
visto en vivo.

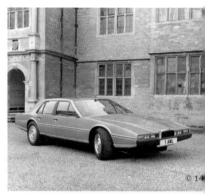

© 14

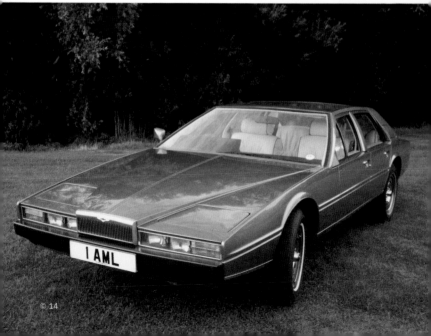

© 14

Porsche 924
D 1975

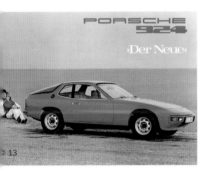

1970s Porsche rationality.

Porsche-Vernunft der 70er Jahre.

La raison Porsche des années 70.

La racionalidad Porsche de los años 70.

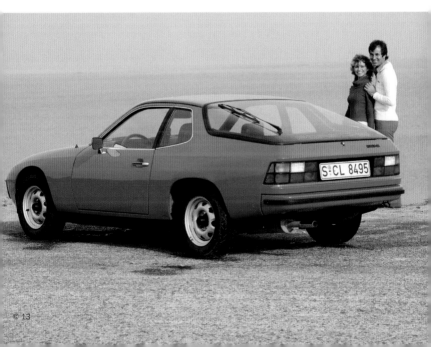

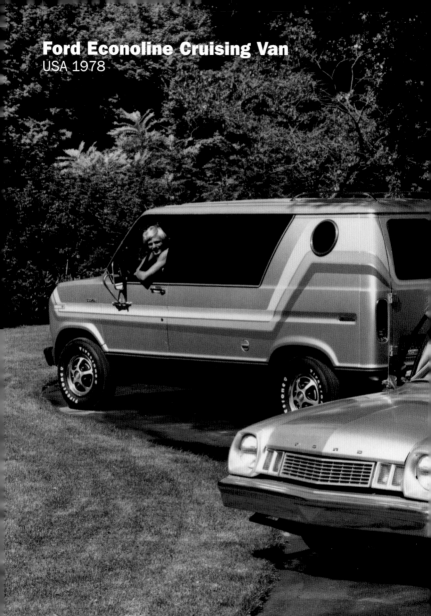

Ford Econoline Cruising Van
USA 1978

The late 1970s fashion is the van: the interior space is like an alcove or cabin —naturally with bull-eyes.

Die Mode der späten 70er heißt Van: Innenraum als Alkoven oder Kajüte – natürlich mit Bullaugen.

© 21

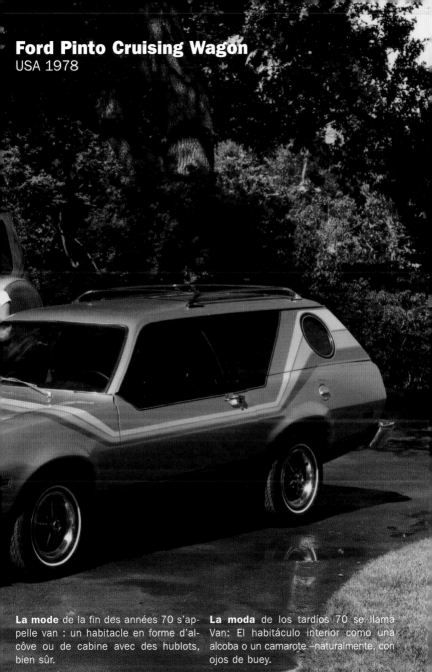

Ford Pinto Cruising Wagon
USA 1978

La mode de la fin des années 70 s'appelle van : un habitacle en forme d'alcôve ou de cabine avec des hublots, bien sûr.

La moda de los tardíos 70 se llama Van: El habitáculo interior como una alcoba o un camarote –naturalmente, con ojos de buey.

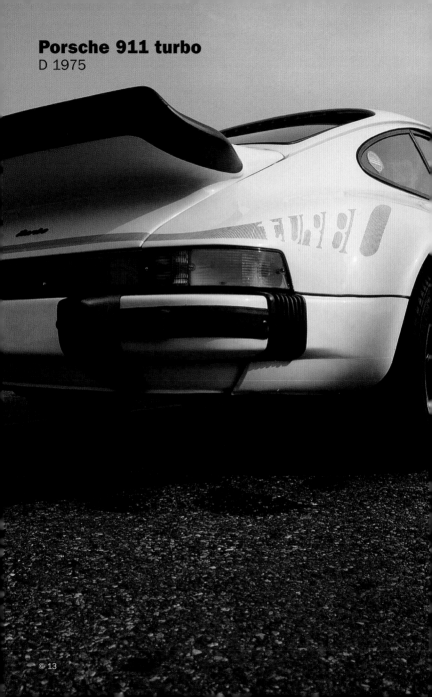

Porsche 911 turbo
D 1975

Renault R5 Turbo
F 1980

Deeper, wider, blacker, spoiler: the new Turbo look.

Tiefer, breiter, schwarzer, Spoiler: die neue Ästhetik der Turbo-Zeiten.

Plus basse, plus large, plus noire, avec becquet : la nouvelle esthétique de l'époque Turbo

Más profundo, más ancho, más negro, spoiler: la nueva estética de la época Turbo.

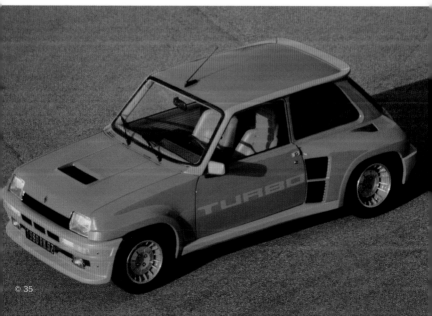

© 35

Matra Simca Ranch
F 1977

280 **Life before the Camel Trophy:** A normal car—in this case a Simca 1100—can also be disguised as a Range Rover with lots of black plastic.

Leben vor der Camel Trophy: Mit viel schwarzem Kunststoff lässt sich auch ein normales Auto – in diesem Fall ein Simca 1100 – als Range Rover verkleiden.

La vie avant le Camel Trophy : avec beaucoup de synthétique noir, on peut transformer une voiture normale en Range Rover, dans ce cas une Simca 1100.

La vida antes del Camel Trophy: Con mucho material sintético negro puede revestirse también un automóvil normal –en este caso un Simca 1100– como un Range Rover.

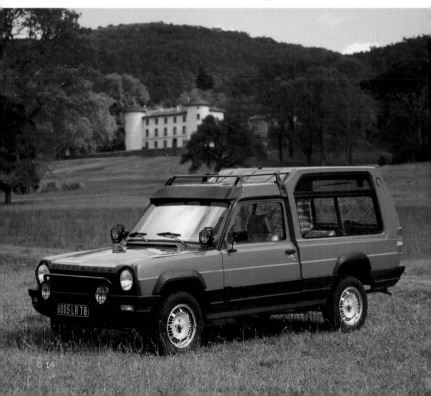

© 14

Mercedes Benz G
D 1979

In the name of the people: even serious vehicles had to wear questionable colors.

Im Namen des Volkes: selbst ernsthafte Fahrzeuge mussten fragwürdige Farbstreifen tragen.

Au nom du peuple : même les véhicules sérieux devaient porter des bandes de couleur.

En nombre del pueblo: Incluso los vehículos serios tenían que llevar dudosas rayas de colores.

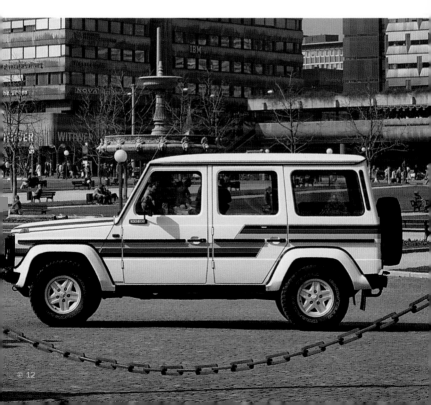

Chevrolet Caprice
USA 1978

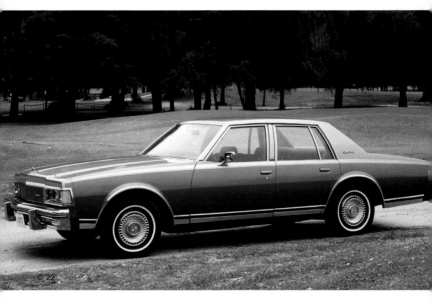

Simple Edge Line design from America also convinced the Europeans.

Schlichtes Edge Line Design aus den USA überzeugte auch die Europäer.

Le design Edge Line simple des Etats-Unis avait aussi convaincu les Européens.

El sencillo diseño Edge Line de los EEUU convenció también a los europeos.

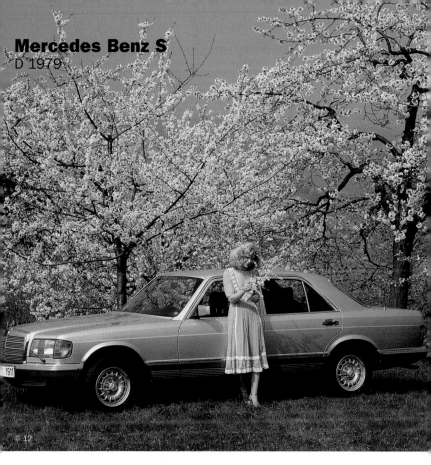

Mercedes Benz S
D 1979

© 12

A small revolution. The first Mercedes Benz with all-round protective plastic.

Eine kleine Revolution. Der erste Mercedes Benz mit Kunststoffschutz rundum.

Une petite révolution. La première Mercedes Benz avec une protection synthétique sur le pourtour.

Una pequeña revolución. El primer Mercedes Benz completamente con protección de material sintético.

Opel Kadett GT/E
D 1975

284 **Typical German:** matt black and yellow as racing colors for the Opel GT/E. The additional, double headlights were part of the victor's image.

Typisch deutsch: mattschwarz und gelb als Rennfarben für den Opel GT/E. Die doppelten Zusatzscheinwerfer gehörten zum Siegerimage dazu.

Typiquement allemand : l'Opel GT/E en noir mat et jaune. Les phares doubles supplémentaires faisaient partie de l'image du vainqueur.

Típicamente alemán: negro mate y amarillo como los colores de carreras para el Opel GT/E. Los faros dobles adicionales formaban parte de la imagen de ganador.

Saab 99 Turbo
S 1977

The flow-tail Saab became an icon. The styling of the 99 model, already released in 1967, was adapted to a contemporary Turbo look.

Der Fließheck-Saab wurde zur Ikone. Die Ästhetik des bereits 1967 präsentierten 99 wurde dem zeitgenössischen Turbo-Look angepasst.

La Saab au hayon arrière devint un mythe. L'esthétique du modèle 1999 déjà présenté en 1967 acquit le look contemporain Turbo.

El Saab con portón trasero alargado se convirtió en un icono. La estética del 99, ya presentado en 1967, fue adaptada al aspecto Turbo coetáneo.

© 35
Renault Berex design atelier, 1982

80s specials

Fiat Panda
I 1979
design: Giugiaro

288 **With the exception of the flat windshield,** this was the most economic, functional car around. As the adverts suggested at the time: "If the Panda was not here, we would have to invent it."

Bis auf die flache Windschutzscheibe das ökonomische, funktionale Auto schlechthin. Wie die Werbung damals sagte: „Gäbe es den Panda nicht, müsste man ihn erfinden."

A l'exception du pare-brise plat, une voiture absolument économique et fonctionnelle. Comme le slogan publicitaire le disait à l'époque : « Si la Panda n'existait pas, il faudrait l'inventer ».

A excepción del parabrisas plano, el automóvil económico y funcional por antonomasia. Como decía la publicidad de entonces: "Si no existiera el Panda, habría que inventarlo".

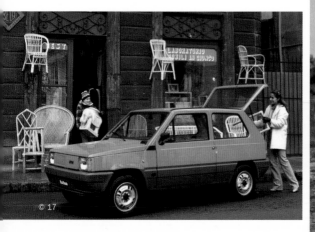

© 17

© 17

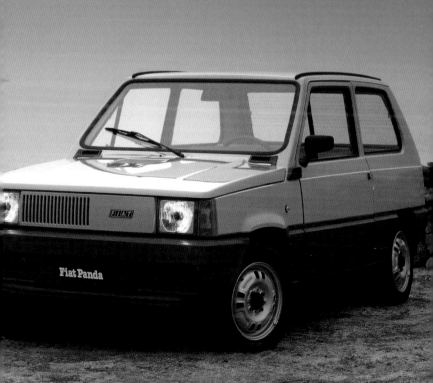

Audi Quattro Quartz

l 1981, concept
design: Pininfarina

The debut for Pininfarina's Fontana-style cut.

Erstaufführung für Pininfarinas Schnitt à la Fontana

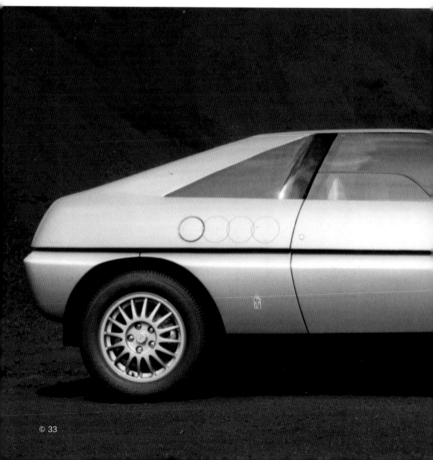

© 33

Une première pour la coupe à la Fontana de Pininfarina

El estreno del corte à la Fontana de Pininfarina.

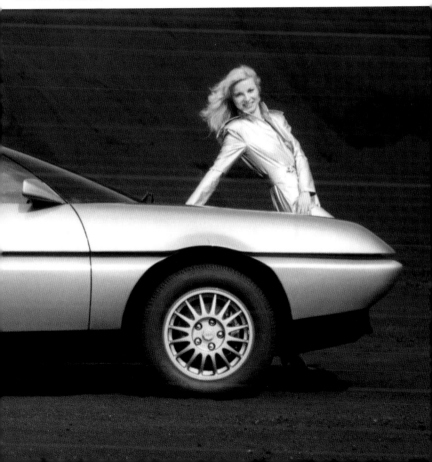

AMC Eagle 4WD
USA 1982

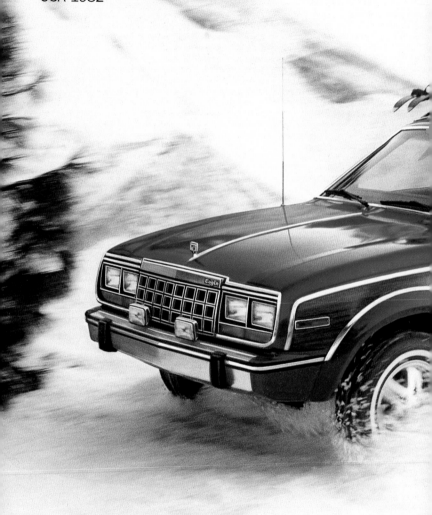

The mother of all Quattros.

© 14

Die Mutter aller Quattros.

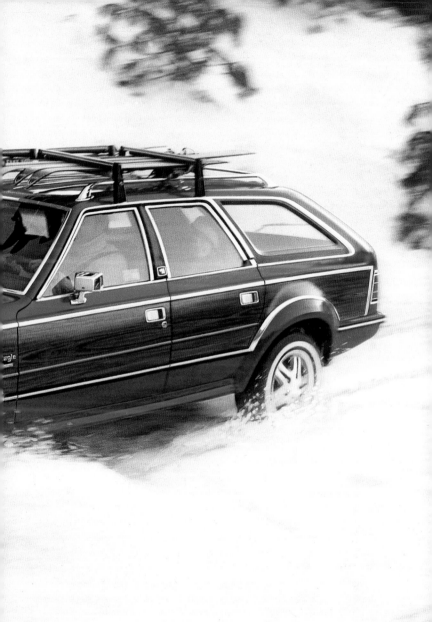

La mère de toutes les Quattro. **La madre** de todos los Quattros.

Italdesign Capsula

l 1982, concept
design: Giugiaro

© 25

© 25

In the 1980s, important design themes are modularity, multifunctionality and economy of material. Nevertheless, many ideas were never suitable for inclusion in a car series.

Modularität, Multifunktionalität und Materialökonomie sind wichtige Themen im Automobildesign der 80er Jahre. Viele Konzepte wurden dennoch nie serienreif.

Renault Rodeo
F 1982

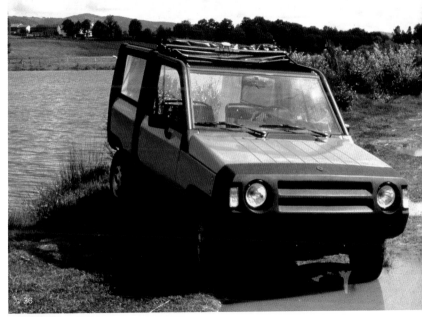

© 36

© 36

Modularité, multifonctionalité et économie de matériau sont les thèmes essentiels du design automobile des années 80. De nombreux concepts n'atteignirent jamais le stade de la fabrication en série.

Lo modular, la multifuncionalidad y la economía de materiales son temas importantes del diseño del automóvil de los años 80. Sin embargo, muchos proyectos nunca llegaron a desarrollarse para ser producidos en serie.

Renault Fuego
F 1980

296 **Experiments** from the Graph design era. A broad, black piece emphasizes the trim on the flowing Fuego, elementary geometry defines the surface and volume of the angular BX.

Experimente der Graph Design Zeit. Eine breite, schwarze Leiste betont die Gürtellinie des fließenden Fuegos, elementare Geometrien definieren die Flächen und das Volumen des kantigen BX.

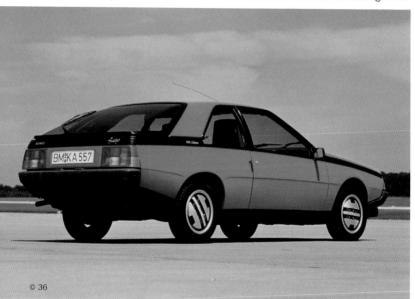

© 36

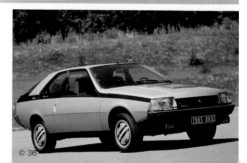

© 36

Citroën BX

F 1982
design: Bertone

Les expériences de l'époque du design Graph. Un large jonc noir souligne la ligne de caisse de la Fuego fluide, une géométrie élémentaire définit les surfaces et le volume de la BX carrée.

Experimentos de la época del diseño Graph. Una barra ancha y negra acentúa el guardabarros del fluido Fuego, las geometrías elementales definen las superficies y el volumen del angular BX.

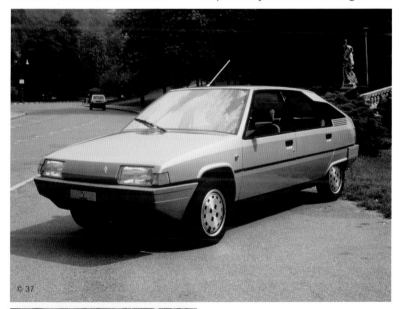

© 37

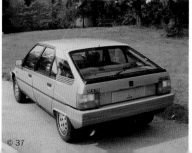

© 37

Audi 100
D 1982

298 **Aerodynamic** to the last detail—as for instance, window surfaces which were on a level with the body. A forerunner of Smooth Body design.

Aerodynamisch in allen Details – wie etwa die Glasflächen, die mit der Karosserie auf einer Ebene liegen. Ein Vorreiter des Smooth Body Design.

Aérodynamique dans tous les détails, comme les surfaces vitrées qui sont au même niveau que la carrosserie. Un précurseur du design Smooth Body.

Aerodinámico en todos los detalles, como por ejemplo las superficies de vidrio que se encuentran a un nivel con la carrocería. Un precursor del diseño Smooth Body.

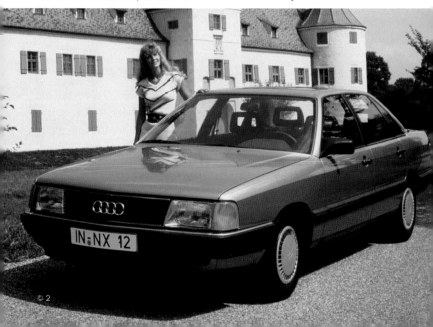

Ford Sierra
D 1984

Aerodynamic functionality: the round Sierra with large tailgate.

Aerodynamische Funktionalität: runder Sierra mit großer Heckklappe.

La fonctionalité aérodynamique : la Sierra ronde au grand hayon arrière

La funcionalidad aerodinámica: el Sierra redondo con una gran puerta del maletero.

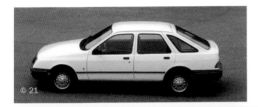

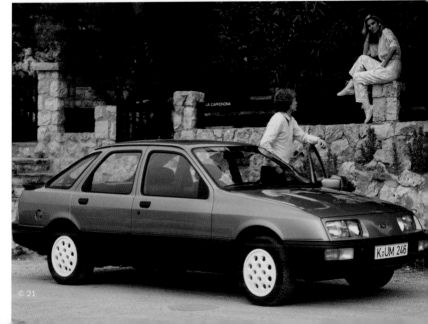

Volvo 760
S 1982

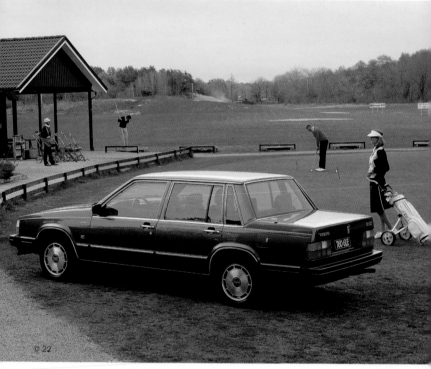

© 22

A beautiful, Swedish global car: Edge Box design with a vertically cut rear window. A baroque ornament inspired by American design meets Europe's functional design concept.

Schönes schwedisches Weltauto: Edge Box Design mit vertikal geschnittener Heckscheibe. Von Amerika inspiriertes, barockes Ornament trifft europäisch-funktionales Design.

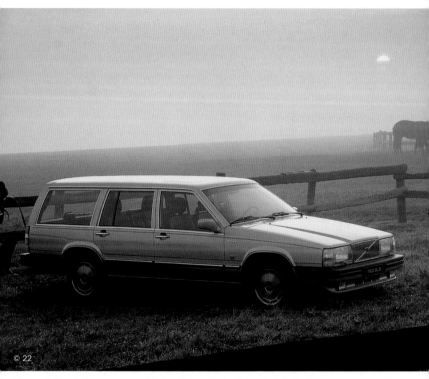

© 22

Un monde automobile suédois plein de beauté : le design Edge Box avec une vitre arrière coupée verticalement. Les ornements baroques inspirés des Américains rencontrent le design fonctionnel européen.

Un bello automóvil universal sueco: El diseño Edge Box con la luneta trasera cortada verticalmente. El ornamento Barroco inspirado por América se encuentra con el diseño funcional europeo.

Mercedes Benz 190
D 1984

302 **Fine design:** the precisely modelled Mercedes offers aerodynamic functionality.

Feines Design: Der präzise modellierte Mercedes mit kurzen Übergängen bot aerodynamische Funktionalität.

Un design de classe : la Mercedes modelée avec précision pour offrir une fonctionalité dynamique.

Un fino diseño: El Mercedes, modelado con precisión ofrecía una funcionalidad aerodinámica.

© 12

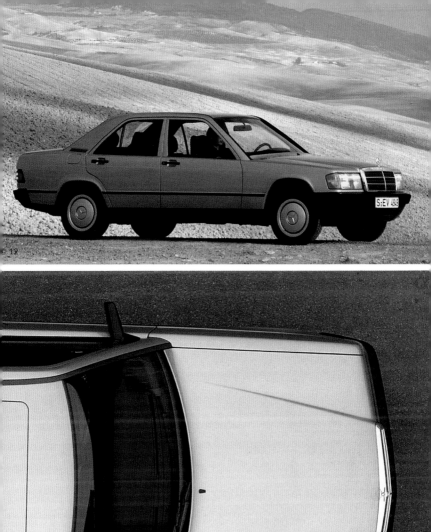

© 12

Ferrari Testarossa
I 1984
design: Pininfarina

Sheer functionality as a contrast to clean lines: the controversial 1980s at Ferrari.

Brutaler Funktionalismus als Gegensatz zur sauberen Linienführung: kontroverse 80er Jahre bei Ferrari.

Un fonctionnalisme brutal en opposition à des lignes nettes : la controverse des années 80 chez Ferrari.

El funcionalismo brutal como una contraposición al limpio trazado de líneas: los controvertidos años 80 en Ferrari.

© 33

Chevrolet Corvette
USA 1986

Classical proportions and modern lines in the most elegant Corvette of all time.

Klassische Proportionen und moderne Linien in der elegantesten Corvette aller Zeiten.

Des proportions classiques et des lignes modernes pour la plus élégante des Corvette.

Las proporciones clásicas y las líneas modernas en la Corvette más elegante de todos los tiempos.

Autobianchi Y10
I 1985

© 17

Even white can be trendy: the Y10 on the Fila special gives up its typical trademark: the matt, black metallic tailgate is not every customer's preference.

Auch weiß kann trendy sein: Der Y10 in der Fila Sonderedition verzichtet auf sein typisches Markenzeichen: die mattschwarz lackierte Heckklappe, die nicht jeder Kunde mochte.

Le blanc peut aussi être en vogue. Le modèle Y10 de la série spéciale Fila fait abstraction de sa caractéristique typique : le hayon arrière noir mat laqué qui n'était pas apprécié par tous les clients.

También el blanco puede estar de moda: El Y10 en la edición especial Fila renuncia a su característica típica: La puerta del maletero pintada en negro mate que no todos los clientes querían.

Volvo 480es
S 1986

308 **Something new** for sporty Yuppies: the taste for design extravagance returned in the 1980s.

Für sportliche Yuppies mal was Neues: In den späten 80ern kehrte die Lust auf extravagantes Design zurück.

© 20

Du nouveau pour les yuppies : à la fin des années 80 revint le désir de l'extra-vagance dans le design.

Esta vez algo nuevo para los yuppies deportistas: En los tardíos 80 volvió el placer por la extravagancia del diseño.

Alfa Romeo 164
I 1987
design: Pininfarina

Functional 1980s beauty: black lower and colorful upper part. Pininfarina's style: emphasized side line with integrated tail lights on the Alfa. An extended wheel support for even more space on the Passat, with a deliberately neutral design.

Funktionale Schönheit der 80er: schwarzes Unter-, buntes Oberteil. Pininfarinas Hand: betonte Seitenlinie mit integrierten Rückleuchten beim Alfa. Überlanger Radstand für noch mehr Raum im bewusst neutral gehaltenen Passatdesign.

Volkswagen Passat
D 1988

Beauté fonctionnelle des années 80 :
partie inférieure noire, partie supérieure
en couleur. La signature de Pininfarina :
une ligne latérale accentuée et des feux
arrière intégrés pour l'Alfa. Un empatte-
ment très long pour augmenter l'espace
et un design volontairement neutre ca-
ractérisent la Passat.

La belleza funcional de los años 80:
parte inferior negra, parte superior de
color. La mano de Pininfarina: la línea
lateral acentuada con luces traseras in-
tegradas en el Alfa. Una distancia entre
ejes extra larga para un mayor espacio
en el diseño Passat que es intenciona-
damente neutral.

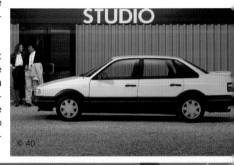

© 40

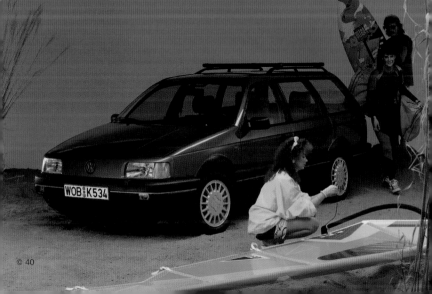

© 40

Ferrari Pinin

I 1980, concept
design: Pininfarina

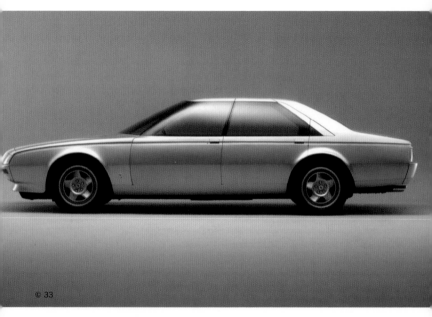

© 33

Too early for the 1980s: silky Smooth design by Pininfarina for Ferrari. 20 years ahead of its time: tail lights in clear glass optics, fully integrated bumpers in metallic color. More flowing still: Nissan's prototype model, six years later.

Zu früh für die 80er: seidenglattes Smooth Design von Pininfarina für Ferrari. 20 Jahre voraus: Rückleuchten in Klarglasoptik, voll integrierte Stoßstangen in Lackfarbe. Noch fließender: Nissans Prototyp, 6 Jahre später.

Nissan cue-x

J 1986, concept

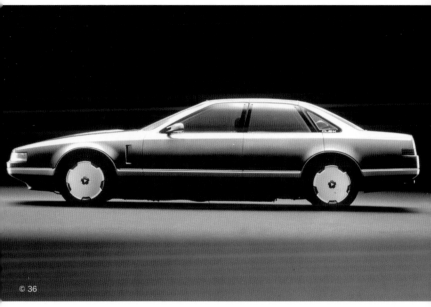

© 36

Trop tôt pour les années 80 : le design Smooth lisse comme de la soie de Pininfarina pour Ferrari. 20 ans en avance : les feux arrière en optique de verre transparent, les pare-chocs laqués en couleur et totalement intégrés. Encore plus fluide : le prototype Nissan, 6 années plus tard.

Demasiado pronto para los 80: El diseño Smooth de Pininfarina para Ferrari, suave como la seda. Con 20 años de antelación: Las luces traseras en óptica de vidrio claro, guardabarros en barniz brillante completamente integrados. Todavía más fluido: El prototipo del Nissan 6 años más tarde.

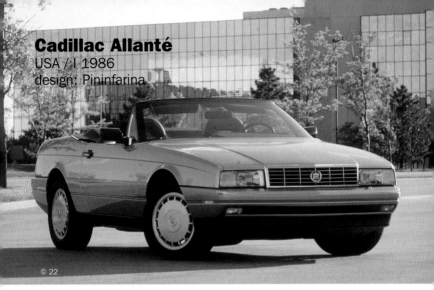

Cadillac Allanté
USA / I 1986
design: Pininfarina

© 22

The time is ripe for new glamour: the plastic, tone-on-tone look is also the height of fashion for luxury roadsters. The '86 Cadillac is pure 1980s style, the 1989 SL anticipates 1990s Smooth design. Unique security by Mercedes: automatic roll bars.

Die Zeit ist Reif für neues Glamour: Der Kunststoff-Look Ton-sur-Ton ist auch bei Luxus-Roadstern voll im Trend. Der 86er Cadillac ist purer 80er Stil, der SL antizipiert 1989 das Smooth Design der 90er Jahre. Einmalige Sicherheit bei Mercedes: automatische Überrollbügel.

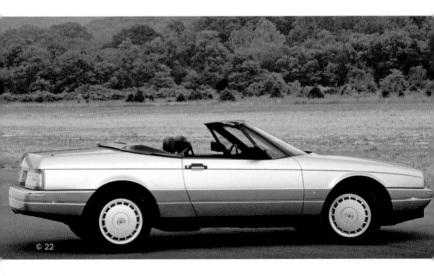

© 22

Mercedes Benz SL
D 1989

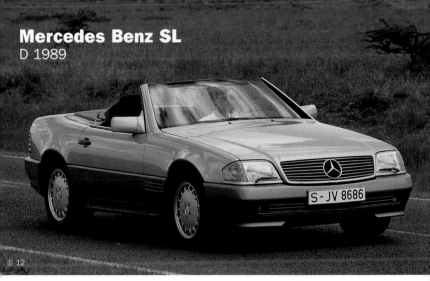

© 12

L'époque est prête pour un nouveau charme : l'aspect synthétique ton sur ton est aussi en vogue pour les cabriolets de luxe. La Cadillac de 1986 est du plus pur style années 80, la SL de 1989 anticipe le design Smooth des années 90. Sécurité unique chez Mercedes : les arceaux automatiques.

Ha llegado el momento de un nuevo glamour: El aspecto sintético Ton-sur-Ton también está totalmente de moda en el Roadstern de lujo. El Cadillac del 86 es puro estilo de los 80, el SL anticipa en 1989 el diseño Smooth de los años 90. Una seguridad sin precedentes en Mercedes: los arcos de seguridad automáticos.

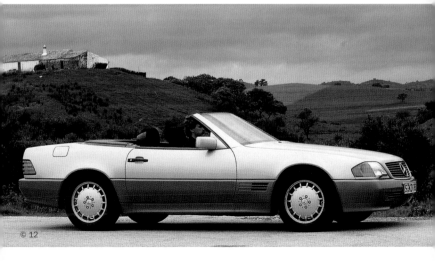

© 12

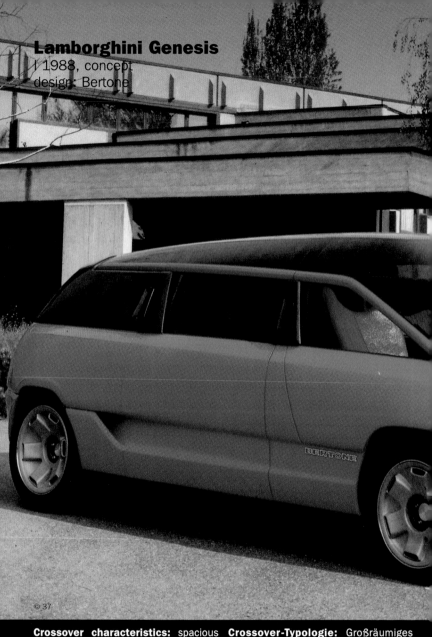

Lamborghini Genesis
I 1988, concept
design: Bertone

© 37

Crossover characteristics: spacious
sports car in Smooth design with a

Crossover-Typologie: Großräumiges
Sportauto im Smooth Design mit Glas-

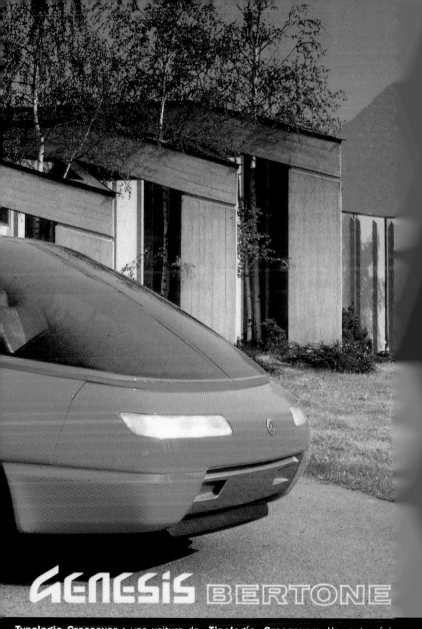

GENESIS BERTONE

Typologie Crossover : une voiture de sport spacieuse de design Smooth avec

Tipología Crossover: Un automóvi deportivo de gran capacidad en diseño

Nissan 300 ZX
J 1989

318 **Exemplary lines:** late 1980s Japanese design quality.

Vorbildliche Linienführung: japanische Designqualität der späten 80er.

Un tracé de ligne exemplaire : le design japonais de qualité de la fin des années 80.

Un trazado de líneas ejemplar: la calidad del diseño japonés de los tardíos años 80.

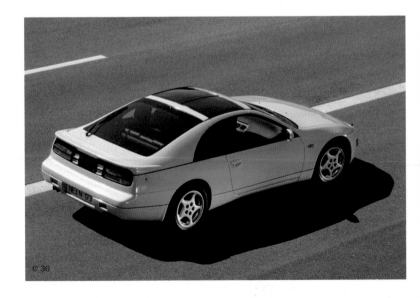

© 36

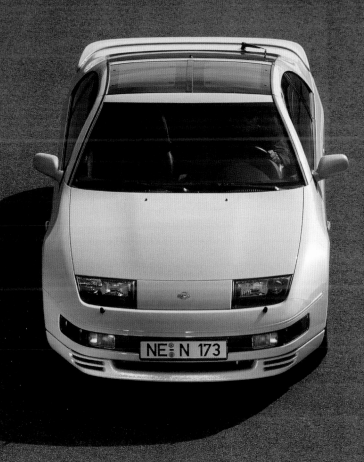

Mazda MX-5 Miata
J 1989

© 6

Rejuvenation of past emotionality.

Wiederbelebung vergangener Emotionalität.

Renaissance de l'émotion passée.

La reactivación de la emotividad pasada.

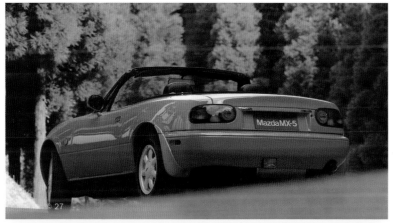

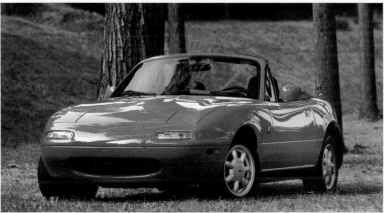

© 12
Mercedes Benz design: virtual reality wall.

Nissan Micra
J 1992

Nissan Bolero
J 1997

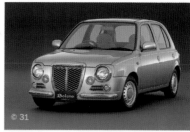

© 31

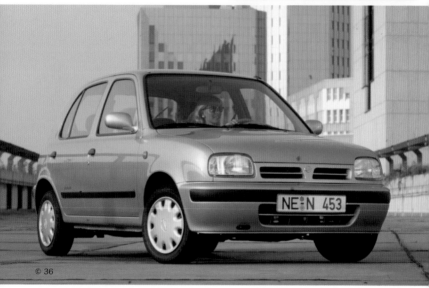

© 36

Flow Box design on 1990s small cars. The smooth Micra was influenced by the old Mini. Very trendy in Japan: Bolero version with Old England look for the front section.

Flow Box Design bei den Kleinautos der 90er Jahre. Dem Micra stand der alte Mini Pate. In Japan sehr trendy: auf Sonderbestellung Old England-Look für die Frontpartie.

Le design Flow Box des petites voitures des années 90. La Micra était de la même souche que la Mini. Très en vogue au Japon : sur demande le style Old England pour l'avant.

El diseño Flow Box en los automóviles pequeños de los años 90. Frente al Micra estaba el viejo Mini Pate. En Japón muy de moda: Una apariencia Old England para la parte frontal por encargo especial.

Fiat Punto
I 1993

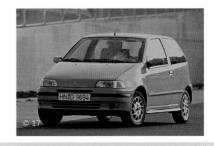

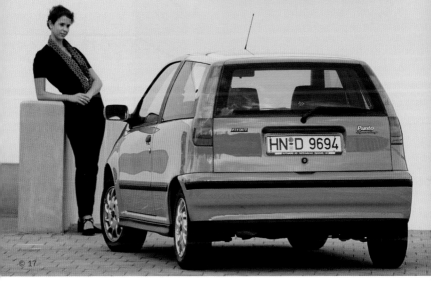

Farewell to the matt black look. Metallic bumpers are integated into the body: in the functional city car as well only a small plastic strip serves as protection.

Mattschwarz adieu. Lackierte Stoßstangen werden in die Karosserie integriert: auch im funktionalen Stadtauto bleibt nur eine kleine Kunststoffleiste als Schutz.

Adieu au noir mat ! Les pare-chocs laqués sont intégrés à la carrosserie : même le véhicule urbain fonctionnel ne garde qu'un petit jonc de protection synthétique.

Adieu al negro mate. Los parachoques pintados son integrados en la carrocería: También en el funcional automóvil de ciudad queda sólo una pequeña barra de material sintético como protección.

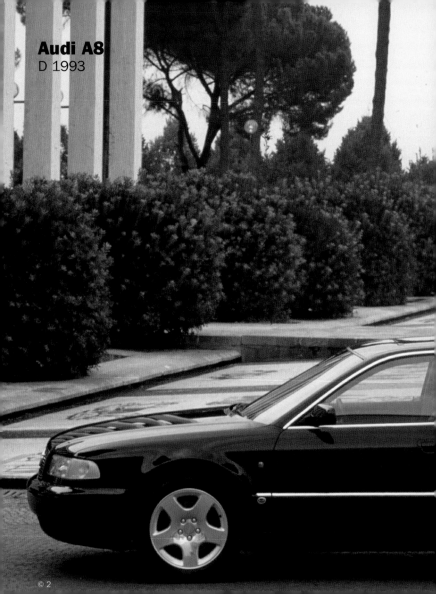

Audi A8
D 1993

© 2

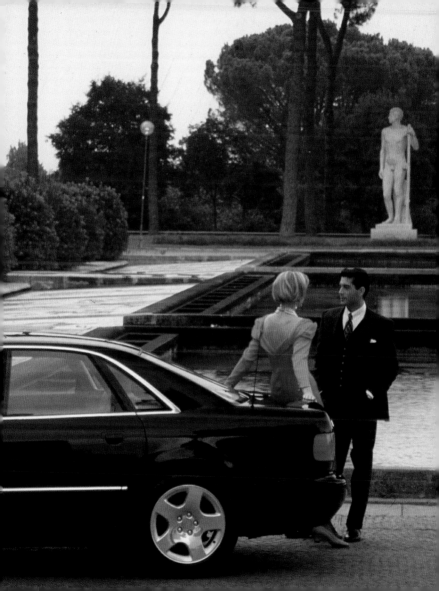

Smart
D 1998

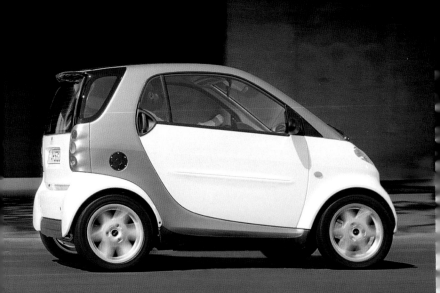

Swatch look: Plastic and metal components are deliberately kept in two colors.

Swatch-Look: Kunststoff- und Metallteile sind gewollt zweifarbig gehalten.

Le style Swatch: Les parties en synthétique et en métal sont bicolores.

Una apariencia Swatch: Las partes de metal y de material sintético son intencionadamente de dos colores.

Renault Twingo
F 1992

Function meets emotion: an innovative, spatious small car with a friendly frog-eye face.

Funktion trifft Emotion: innovatives Großraum-Kleinauto mit sympathischem frog-eye Gesicht.

Le fonctionnel rencontre l'émotionnel : une petite voiture spacieuse et innovatrice avec une face sympathique Frog-eye.

La función se encuentra con la emoción: El innovador automóvil pequeño de gran capacidad con la simpática cara frog-eye.

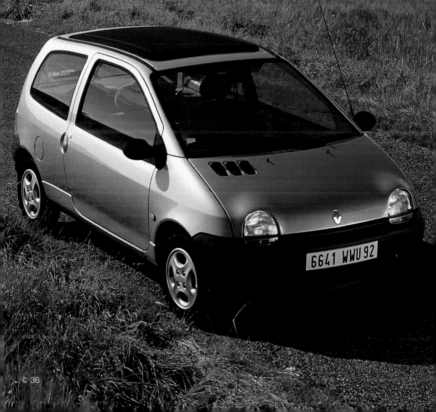

© 36

Porsche Boxster
D 1996

330 **They don't come softer:** whether in Germany or the USA, at the end of the 1990s, Vanilla design was very popular.

Weicher geht es nicht: ob aus Deutschland oder aus den USA, Vanilla-Design war Ende der 90er sehr beliebt.

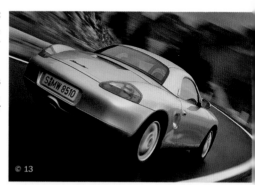

© 13

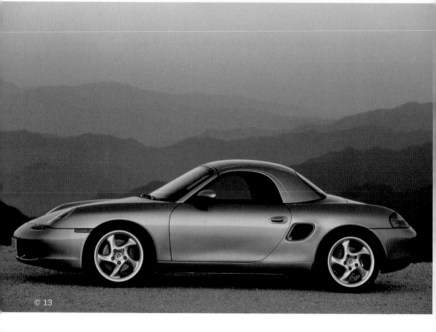

© 13

Ford Taurus
USA 1996

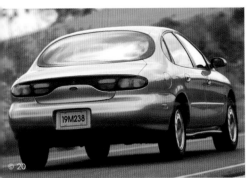

© 20

Impossible de faire plus **doux :** le design Vanille était très populaire à la fin des années 90, que ce soit en Allemagne ou aux Etats-Unis.

Más suave imposible: Tanto de Alemania como de EEUU, el diseño Vanilla fue muy apreciado a finales de los 90.

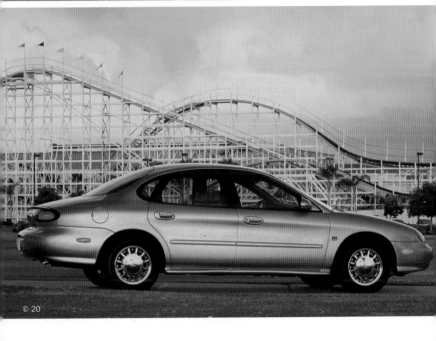

© 20

Volkswagen Passat
D 1996

1990s design quality: a very personal car with few basic touches.

Designqualität der 90er: mit wenigen elementaren Strichen ein sehr persönliches Auto.

Caractéristique du design des années 90 : une voiture très personnelle en quelques traits élémentaires.

La calidad del diseño de los 90: Un automóvil muy personal con pocos trazados elementales.

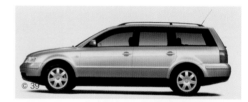

© 39

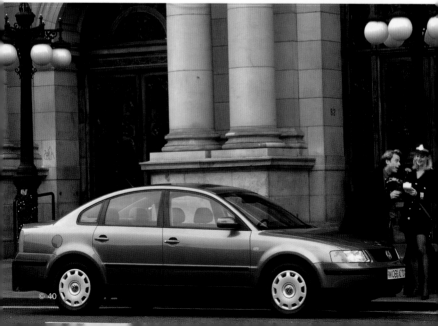

© 40

Mercedes SLK
D 1996

No more worries: the roadster with electric hardtop is a hit.

Keine Hemmungen mehr: Der Roadster mit elektrischem Stahldach ist ein Hit.

Plus d'inhibition : le Roadster au toit acier électrique est un succès.

Sin más escrúpulos: El Roadster con el techo de acero eléctrico es un hit.

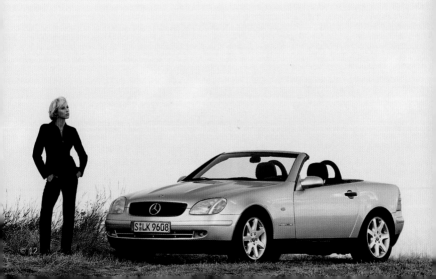

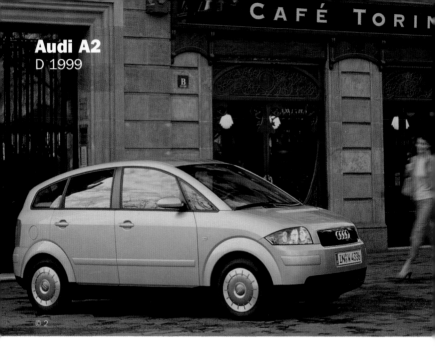

Audi A2
D 1999

Individuality, flexibiliy, functionality: new values for car design.

Individualität, Flexibilität, Funktionalität: neue Werte fürs Automobildesign.

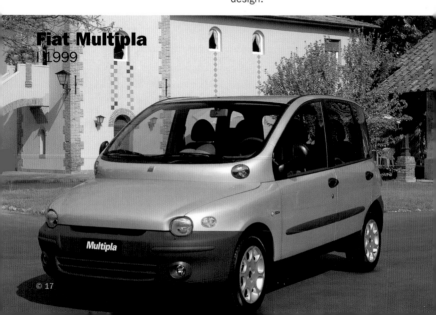

Fiat Multipla
I 1999

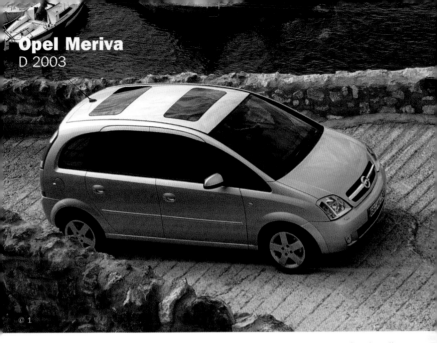

Opel Meriva
D 2003

© 1

Individualité, flexibilité, fonctionalité : les nouvelles valeurs du design automobile.

Individualidad, flexibilidad, funcionalidad: los nuevos valores para el diseño del automóvil.

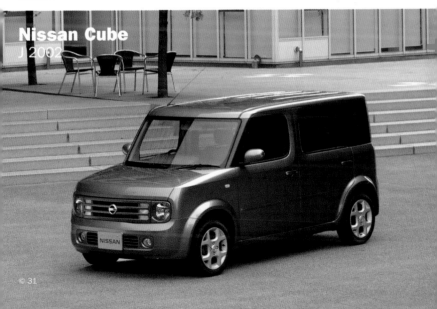

Nissan Cube
J 2002

© 31

BMW 5 Touring
D 1997

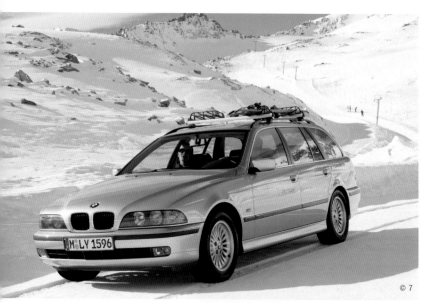

© 7

In fashion: sporty station wagons for a sporty target group.

Macht Mode: Sportliche Kombis für eine sportliche Zielgruppe.

Ils font fureur : les nouveaux breaks sportifs pour un groupe-cible sportif.

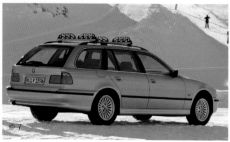

© 7

Crea moda: los combis deportivos para un grupo destinatario deportista.

Alfa Romeo 156

I 2000

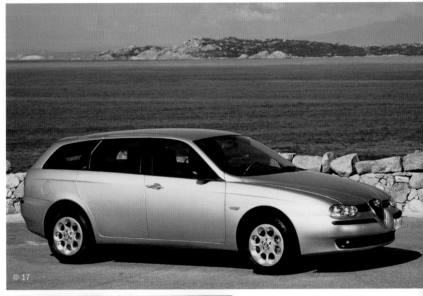

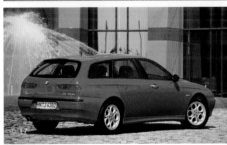

This model offers the feel of the Coupé: the hidden rear door handle is nothing for children.

Bietet Coupégefühle: Der verborgene Türgriff hinten ist nichts für Kinder.

Il offre un style de coupé : la poignée de porte cachée n'est pas faite pour les enfants.

Ofrece sensación de Coupé: La manilla de la puerta escondida no es para niños.

BMW Concept 1
D 2001, concept

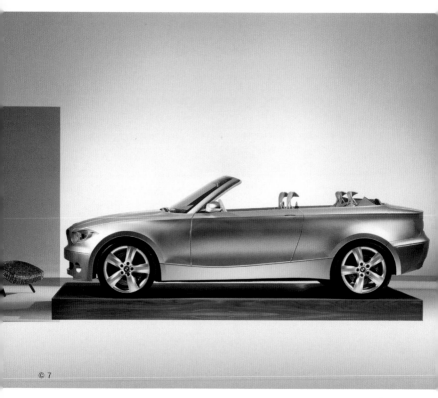

© 7

Turn of the century: the golden years of car design are back again.

Jahrtausendwende: Die goldenen Jahre des Automobildesigns sind wieder da.

Changement de millénaire : les années d'or du design automobile sont de retour.

El cambio de milenio: Los años dorados del diseño del automóvil han vuelto.

Nissan Primera

J 2002

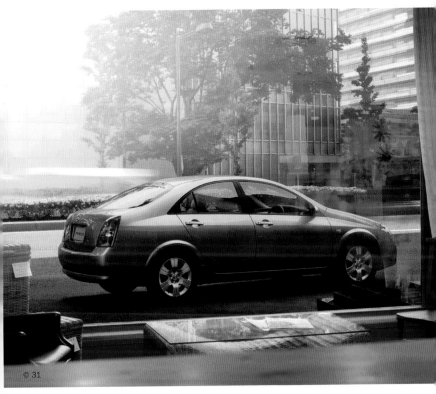

© 31

More design quality everywhere. Cars become bigger and fatter.

Mehr Designqualität überall. Die Autos werden aber immer größer und fetter.

Partout, plus de qualité dans le design. Mais les voitures deviennent toujours plus grandes et plus grosses.

Más calidad de diseño por todas partes. Pero los automóviles son cada vez más grandes y gruesos.

Maybach 62
D 2002

Pure New Classic design.

Pures New Classic Design.

Design New Classic pur.

Diseño New Classic puro.

Mazda RX-8
J 2003

342 **Carved design** with a surprise effect: concealed door for rear passengers.

Carved Design mit Aha-Effekt: versteckte Tür für Fondpassagiere.

Le design Carved fait tilt : une porte cachée pour le passager à l'arrière.

Diseño Carved con efecto sorpresa: una puerta escondida para los pasajeros de atrás.

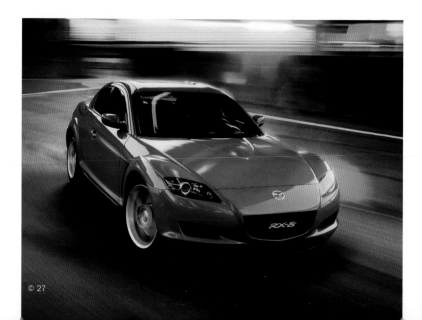

© 27

BMW X coupé
D 2001, concept

Carved design with a surprise effect: asymmetrical construction.

Carved Design mit Aha-Effekt: asymmetrische Konstruktion.

Le design Carved fait tilt : une construction asymétrique.

343

Diseño Carved con efecto sorpresa: una construcción asimétrica.

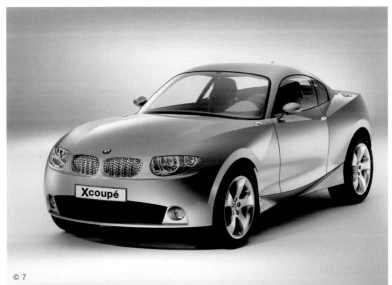

© 7

Toyota Will
J 2000

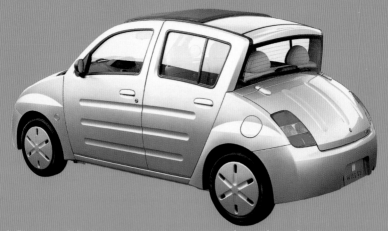

A Retro model of a special kind: the Japanese woman's car as part of an integrated brand concept.

Ein Retro der ganz besonderen Art: japanisches Frauenauto als Bestandteil eines integrierten Markenkonzeptes.

Une Rétro très spéciale : la voiture japonaise pour femme est un élément intégré au concept de marque.

Un Retro de una clase muy especial: el automóvil japonés para mujeres.

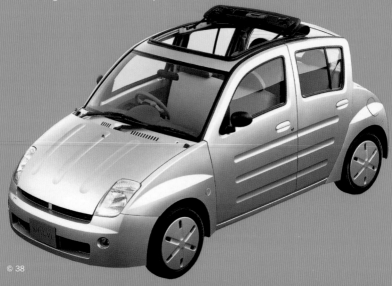

Nissan March
J 2003

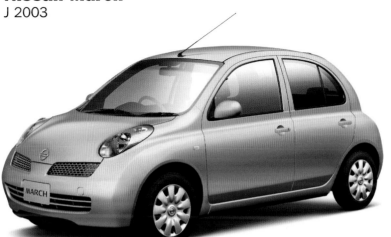

345

What sort of animal is that? Polymorphic design in the small Nissan.

Quel est cet animal ? Le polymorphisme de la petite Nissan.

Was ist das für ein Tier? Polymorphismus im kleinen Nissan.

¿Qué clase de animal es éste? El polimorfismo en el pequeño Nissan.

Sport Utility Vehicle

BMW X5
D 1999

Cadillac SRX
USA 2003

Crossover characteristics: the toy with the functional basis.

Crossover-Typologie als Spielzeug mit funktionaler Begründung.

Volvo XC 90
S 2001

Nissan Murano
J 2003

Typologie Crossover : un jouet à justification fonctionnelle.

Tipología Crossover: Un juguete con justificación funcional.

Lamborghini Murcielago
I 2001

© 4

Smooth Body with Edge details.

Smooth Body mit Edge Details.

Smooth Body avec détails Edge.

Smooth Body con detalles de Edge.

© 4

Opel Signum
D 2003

© 1

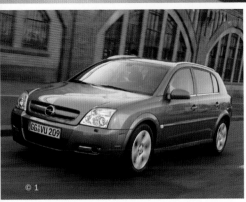

© 1

Edge Body with Smooth details.

Edge Body mit Smooth Details.

Smooth Body avec détails Edge.

Edge Body con detalles de Smooth.

Renault Espace
F 2003

Room with a view: large glass roof in the Renault Espace.

Room with a view: Glasdach im Renault Espace.

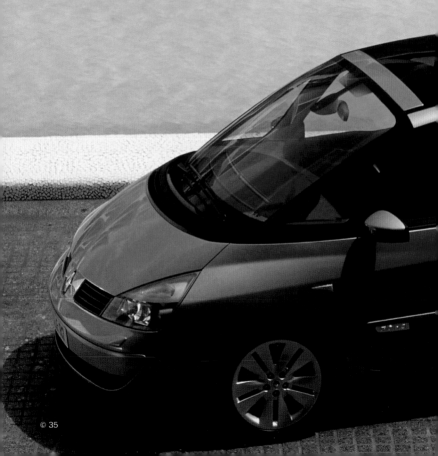

De l'espace avec vue : le toit en verre de la Renault Espace.

Room with a view: El techo de cristal en el Renault Espace.

Citroën Airlounge
F 2003, concept

352 **At last,** very Citroën once again.

Endlich wieder sehr Citroën.

Enfin très Citroën !

Por fin otra vez muy Citroën.

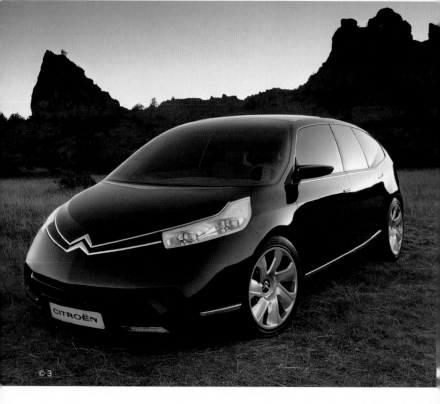

© 3

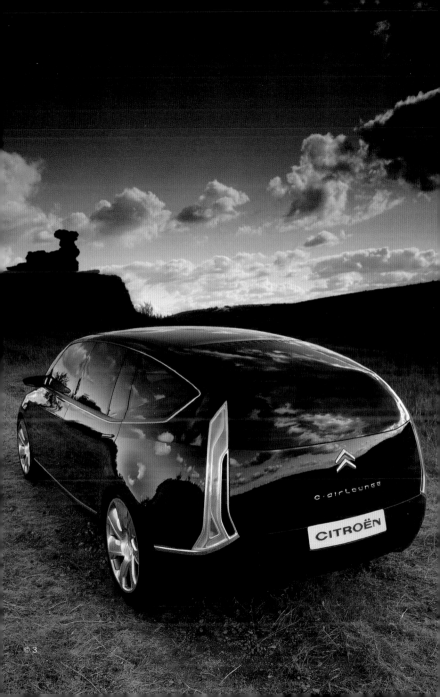

Citroën Pluriel
F 2003

354 **More courage:** a multifunctional vehicle with its own niche.

Mehr Mut: Multifunktionales Fahrzeug mit eigener Nische.

Beaucoup d'audace : un véhicule multifonctionnel ayant son propre créneau.

Más valentía: El vehículo multi-funcional con espacio separado propio.

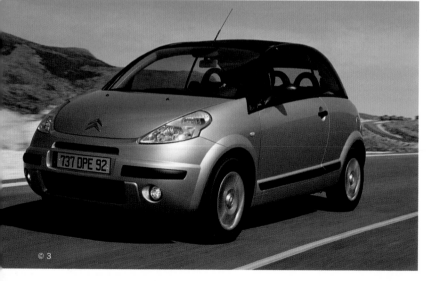

© 3

Renault Megane
F 2003

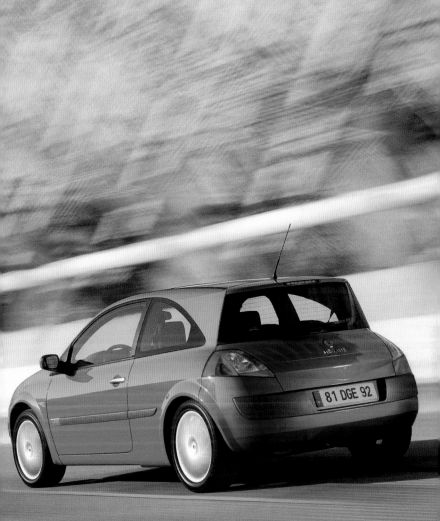

More courage: design revolution in the compact vehicle class.

Mehr Mut: Designrevolution in der Kompaktklasse.

Beaucoup d'audace : la révolution du design dans la classe compacte.

Más valentía: La revolución del diseño en la clase compacta.

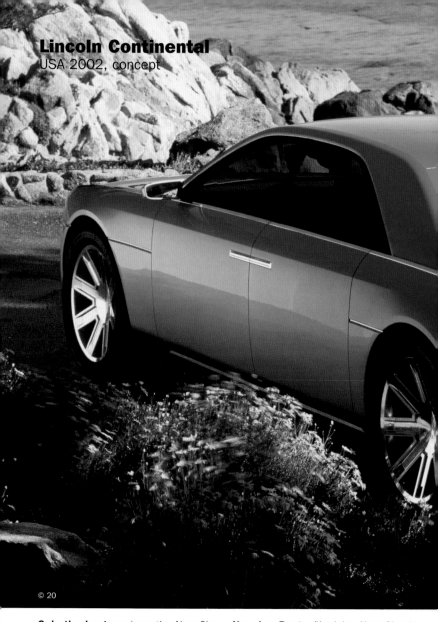

Lincoln Continental
USA 2002, concept

© 20

Only the best survives: the New Classic edition of the 1961 Continental.

Nur das Beste überlebt: New Classic Edition des 61er Continental.

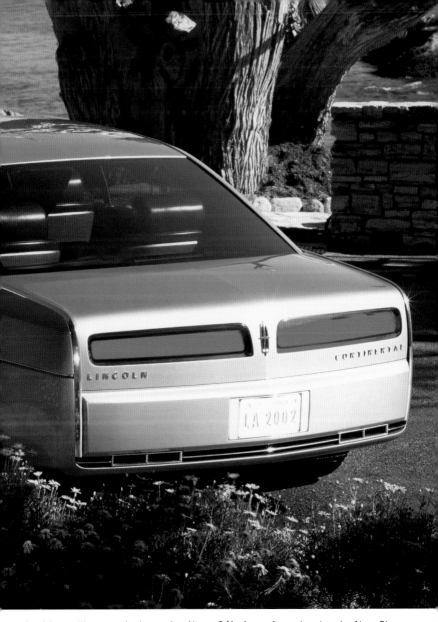

Seul le meilleur survit : la version New Classic de la Continental de 1961.

Sólo lo mejor sobrevive: La New Classic Edition del Continental del 61.

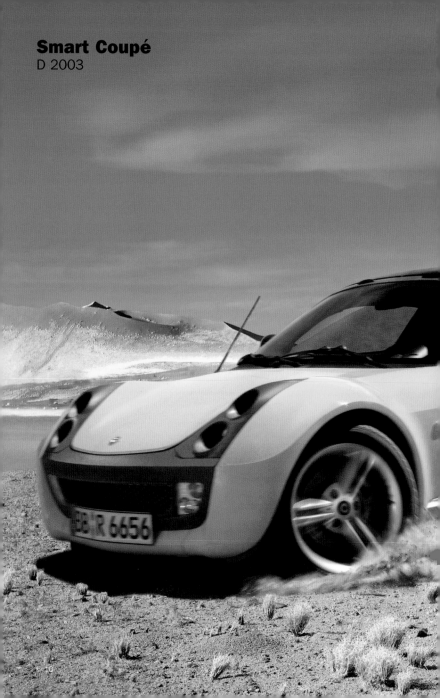

Smart Coupé
D 2003

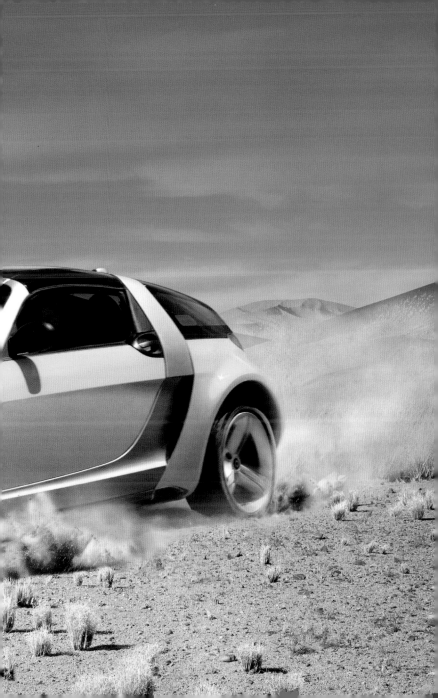

Porsche Cayenne
D 2003

© 13

BMW 5
D 2003

Design transformation between art and architecture: Chris Bangle's new Carved design for BMW.

Design im Wandel zwischen Kunst und Architektur: Bangles neues Carved Design für BMW.

Le design en mutation entre l'art et l'architecture : le nouveau design Carved de Chris Bangle pour BMW.

El diseño en la transición entre el arte y la arquitectura: El nuevo diseño Carved de Chris Bangle para BMW.

Ferrari 612 Scaglietti
I 2004
design: Pininfarina

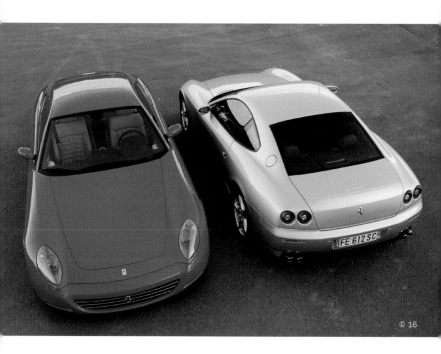

© 16

Reality: 1960s flair on the Ferrari in New Classic design.

La vérité : le charme des années 60 pour la Ferrari de design New Classic.

Wirklichkeit: 60er Flair des Ferrari im New Classic Design.

La realidad: El encanto del Ferrari de los 60 en diseño New Classic.

Cadillac Sixteen
USA 2003, concept

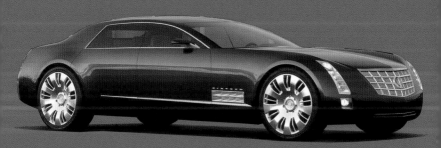

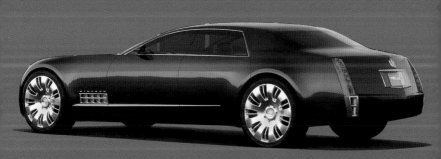

Dream: a remix of old Cadillac elements on the Sixteen.

Traum: Ein Remix alter Cadillac-Elemente im Sixteen.

Un rêve : le modèle Sixteen est un remixage de tous les éléments Cadillac.

Sueño: Un remix de viejos elementos del Cadillac en el Sixteen.

Aston Martin V12 Vanquish

GB 2003

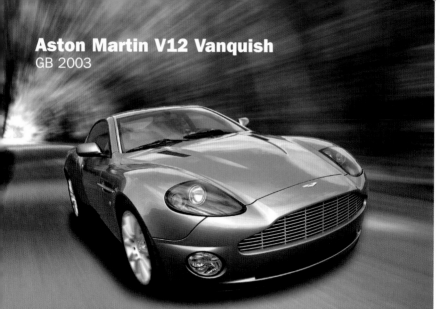

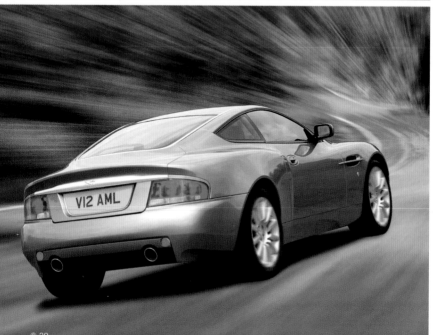

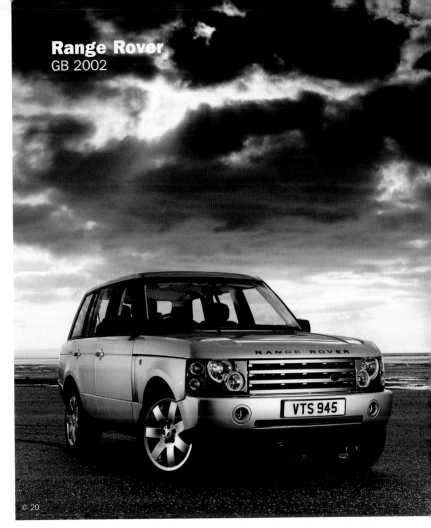

Range Rover
GB 2002

© 20

New car, classical image: Aston Martin and Range Rover return to the original design.

Nouvelle voiture, image classique : Aston Martin et Range Rover reviennent au design d'origine.

Neues Auto, klassisches Image: Aston Martin und Range Rover kehren zum Urdesign zurück.

Nuevo automóvil, imagen clásica: El Aston Martin y el Range Rover vuelven al diseño original.

Alfa Romeo GT
I 2004
design: Bertone

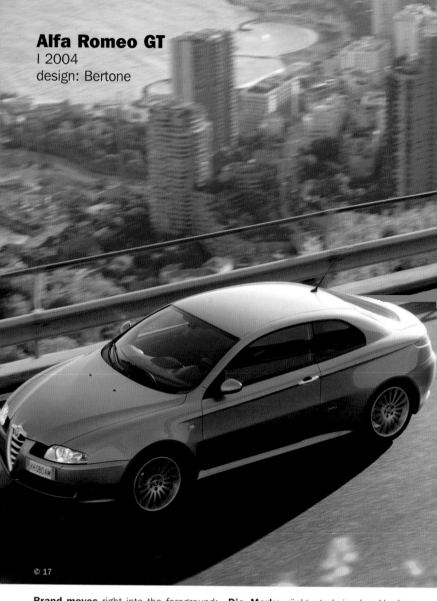

© 17

Brand moves right into the foreground: an oversized Alfa coat-of-arms on the GT, a marked, vertical grill inherited from racing cars on the Audi.

Die Marke rückt stark in den Vordergrund: überdimensioniertes Alfa-Wappen im GT, ein von den Rennwagen geerbter markanter, vertikaler Grill im Audi.

Audi A6
D 2004

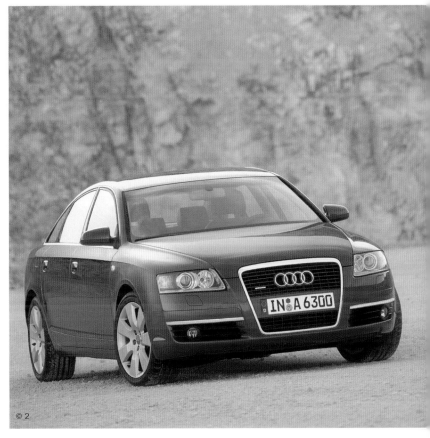

© 2

La marque passe en force au premier plan : un blason Alfa surdimensionné dans le modèle GT, une calandre verticale marquante héritée du sport automobile pour Audi.

La marca se pone fuertemente de relieve: El gigantesco escudo del Alfa en el GT, la marcada parrilla vertical heredada del deporte de carreras en el Audi.

Mercedes Benz CLS
D 2004

Hybrid and emotional: no notable advantages, the lifestyle society needs image.

Emotionaler Hybride: keine nennbaren Vorteile, sondern Image braucht die Lifestyle-Gesellschaft.

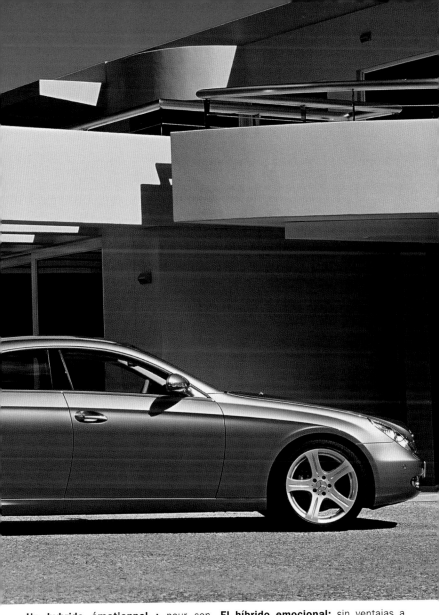

Un hybride émotionnel : pour son style de vie, la société ne recherche pas des avantages spécifiques mais elle a besoin d'une image.

El híbrido emocional: sin ventajas a mencionar sino que la sociedad del lifestyle necesita una imagen.

© 35
Renault design
F 1965

designer

Introduction

In 1963, Ford defined a car designer's job as follows: the "stylist" is a "catalyst between nature and technology". He must possess multi-faceted skills and know-how. "He is a textile designer, sculptor, glass and plastics designer, architect, interior designer, artist, production and installation designer"—nobody less than Leonardo da Vinci is introduced as the model version of such a stylist. In fact, the first generation of designers were primarily people with a wide range of skills, which emerged from their love and passion for the automobile: artists with a feel for mechanics, engineers with a sense of aesthetics, or simply craftsmen with universal talent. They were free thinkers with highly diverse profiles and biographies, who lived at a time when it was still possible single-handedly to define the way a car looked.

Body designers like Bertone, Ghia or Pininfarina were involved until the 1970s in training, research and cutting new trends—all at the same time. They determined how an automobile series was to develop, just like in any fashion house.
In the USA, in-house company design offices were already introduced before World War Two. Nevertheless, if they wanted to bring a special series onto the market that was not part of standard production, automobile manufacturers in the 1950s remained dependent on Italian body designers and their signatures. Similarly, the Italians were also influenced by the "American Way of Life", so that a combination of clean lines, taste and brand awareness finally formed the basis of a car design culture that had, in the meantime, gone global.
Since the mid-1980s, the concept of strategic design has become established in Europe and Japan. Much greater importance was attached to creative research; and accordingly, offices were opened and new and far-reaching skills were adopted. The companies now demanded special training in design, so that the theory and practice of the profession were precisely defined.

Nowadays, car design is the result of a long and complex process: the design department of a major company often employs well over 1,000 people, whose work has to be carefully coordinated. This is how the signature of an individual designer is replaced by a brand signature. In each case, however, it is a case of "mater semper certa, pater numquam". The mother—or the brand—is always known, but the father—that is, the designer—is in many cases disputed.

Einleitung

Ford erklärte 1963 die Arbeit eines Automobildesigners so: Der „Stylist" sei ein „Ka-375 talysator zwischen Natur und Technologie", der über ein vielfältiges Know-how verfügen muss. „Er ist Textildesigner, Bildhauer, Glas- und Kunststoffdesigner, Architekt, Interior Designer, Künstler, Produkt- und Einrichtungsdesigner" – kein geringerer als Leonardo da Vinci wird als der Prototyp eines solchen Stylisten vorgestellt. Tatsächlich handelte es sich bei den Designern der ersten Generation vornehmlich um Menschen, deren Vielseitigkeit sich aus ihrer Liebe und Leidenschaft zum Automobil ergab: Künstler mit Gefühl für Mechanik, Ingenieure mit Sinn für Ästhetik oder einfach nur sehr universell begabte Handwerker. Sie waren freie Denker mit höchst unterschiedlichen Profilen und biographischen Hintergründen, deren Epoche es ihnen noch ermöglichte, das Aussehen eines Autos allein bestimmen zu können.

Karosseriebauer wie Bertone, Ghia oder Pininfarina waren dabei bis in die 70er Jahre Schule, Forschungszentrum und Trendschmiede zugleich. Wie in einem Modehaus wurde dort festgelegt, wie sich die Automobillinie entwickeln sollte.
In den USA begann man bereits vor dem Zweiten Weltkrieg mit der Einführung firmeninterner Designbüros. Dennoch blieben die Hersteller in den 50er Jahren von den italienischen Karosseriebauern und ihren Handschriften abhängig, wenn sie eine besondere Serie abseits der Standardproduktion auf den Markt bringen wollten. Umgekehrt blieben auch die Italiener nicht unbeeinflusst vom „American Way of Life", so dass eine Kombination aus Geradlinigkeit, Geschmack und Markenbewusstsein schließlich die Grundlage einer mittlerweile globalen Automobildesignkultur bildete.
Seit Mitte der 80er hat sich in Europa und Japan das Konzept des strategischen Designs etablieren können. Der kreativen Forschung wurde weitaus größere Bedeutung beigemessen; entsprechend wurden Büros eröffnet und neue, weit reichende Kompetenzen integriert. Die Firmen förderten nun eine besondere Designausbildung, so dass Theorie und Praxis der Profession genau definiert wurden.

Heutzutage ist das Design eines Automobils das Resultat eines langwierigen, komplexen Prozesses: Die Designabteilung eines großen Konzerns beschäftigt oftmals weit über 1.000 Menschen, deren Arbeit sorgfältig koordiniert werden muss. So wird schließlich die Handschrift eines einzelnen Menschen durch die Handschrift der Marke ersetzt. Für beide gilt jedoch: „Mater semper certa, Pater numquam". Die Mutter – also die Marke – ist immer bekannt, der Vater hingegen – also der Designer – bleibt in vielen Fällen umstritten.

Introduction

En 1963, Ford expliquait le travail d'un concepteur automobile de la manière suivante : le « styliste » sert de « catalyseur entre la nature et la technologie », et il doit disposer d'un savoir-faire multiple. « Il est à la fois créateur en textile, designer du verre et du plastique, architecte, architecte d'intérieur, artiste, concepteur de produit et d'aménagement » – le prototype d'un tel styliste n'est pas moins talentueux que Léonard de Vinci. En effet, les concepteurs de la première génération étaient des gens dont les multiples facettes venaient de leur intérêt et de leur passion pour l'automobile : des artistes avec un don pour la mécanique, des ingénieurs ayant le sens de l'esthétique ou tout simplement des artisans talentueux dans tous les domaines. Ils étaient des penseurs libres aux profils et aux biographies extrêmement variés, vivant à une époque qui les autorisait à choisir l'esthétique d'une voiture.

Dans les années 70, les constructeurs de carrosserie comme Bertone, Ghia ou Pininfarina tenaient à la fois le rôle d'école, de centre de recherche et de forge des modes. La ligne d'une automobile était développée comme dans la Haute Couture. Aux Etats-Unis, on commença à fonder des bureaux internes de conception dans les sociétés avant la deuxième guerre mondiale. Cependant, les fabricants des années 50 restaient dépendants des carrossiers italiens et de leur signature lorsqu'ils voulaient lancer sur le marché une série spéciale en dehors de la production standard. Inversement, les Italiens n'étaient pas insensibles au « American Way of Life », de sorte qu'une combinaison de lignes droites, de bon goût et d'esprit de marque formait la base d'une culture de la création automobile devenue globale.
Depuis le milieu des années 80, le concept du design stratégique a pu également s'établir en Europe et au Japon. La recherche créative a pris une plus grande importance, et par la suite, des bureaux se sont ouverts et ont intégré de nouvelles compétences plus étendues. Les sociétés exigeaient une formation spécialisée en design, ce qui conduisit à définir exactement la théorie de la profession et sa mise en pratique.

De nos jours, le design d'une voiture est le résultat d'un processus long et complexe : le service conception d'un grand groupe compte souvent plus de 1000 personnes dont le travail doit être soigneusement coordonné. En conséquence, la signature d'une personne est remplacée par la signature de la marque. Pourtant dans les deux cas : « Mater semper certa, Pater numquam ». La mère – donc la marque – est toujours connue, le père – le créateur – est par contre souvent controversé.

Introducción

En 1963, Ford explicó el trabajo de un diseñador de automóviles de esta manera: El "estilista" sería un "catalizador entre la naturaleza y la tecnología" que debe disponer de conocimientos tecnológicos variados. "Es un diseñador textil, escultor, diseñador de vidrio y materiales sintéticos, arquitecto, diseñador de interiores, artista, diseñador de productos y de equipamientos" –el mismísimo Leonardo da Vinci es propuesto como el prototipo de tal estilista. De hecho, en el caso de los diseñadores de la primera generación, se trató principalmente de personas cuya versatilidad se produjo por su amor y pasión por el automóvil: Artistas con un sentido de la mecánica, ingenieros con un sentido de la estética o simplemente sólo artesanos muy dotados universalmente. Fueron pensadores libres con perfiles y trasfondos biográficos altamente distintos cuya época todavía les permitió poder determinar ellos solos la apariencia de un automóvil.

Hasta entrados los años 70, los constructores de carrocerías como Bertone, Ghia o Pininfarina fueron en esto escuela, centro de investigaciones y forjadores de tendencias al mismo tiempo. Como en una casa de modas, allí se determinó cómo debía desarrollarse la línea de automóviles.
Ya con anterioridad a la Segunda Guerra Mundial se empezaron a introducir en los EEUU oficinas de diseño internas dentro de las empresas. Sin embargo, en los años 50 los fabricantes continuaron dependiendo de los constructores italianos de carrocerías y sus sellos cuando querían introducir al mercado una serie especial fuera de la producción estándar. Al revés, los italianos no quedaron sin la influencia de la "American Way of Life", de manera que una combinación de las líneas rectas, el gusto y la conciencia de marca constituyó finalmente la base de una cultura del diseño del automóvil entretanto global.
Desde mediados de los 80 también pudo establecerse en Europa y Japón el concepto del diseño estratégico. Se otorgó una importancia mucho mayor a la investigación creativa; conforme a ello, se abrieron oficinas y se integraron nuevas competencias de gran alcance. Las empresas demandaron ahora una especial formación para el diseño de modo que la teoría y la práctica de la profesión fueron definidas con exactitud.

Actualmente, el diseño de un automóvil es el resultado de un proceso largo y complicado: El departamento de diseño de un gran consorcio emplea a menudo a muchas más de 1.000 personas cuyo trabajo debe ser coordinado cuidadosamente. Así, la firma de una persona individual es sustituida finalmente por la firma de la marca. No obstante, para ambos es válido aquello de: "Mater semper certa, Pater numquam". La madre –o sea, la marca– siempre es conocida, el padre, en cambio –o sea, el diseñador– en muchos casos permanece discutido.

B

Bahnsen, Uwe
D, 1930

As Ford Europe's Vice President for design from 1976 to 1986, he was responsible, among others, for the 1961 Taunus "Bath" and the 1984 Sierra. Although both these cars are as different from each other as the time in which they were created, they still have something in common: soft lines, functional aerodynamics, personality.

Als Vizepräsident für Design bei Ford Europe zwischen 1976 und 1986 zeichnete er u.a. für den 61er Taunus „Badewanne" und den 84er Sierra verantwortlich. Obwohl diese beiden Autos so unterschiedlich sind wie die Epochen aus denen sie stammen, haben sie doch einiges gemeinsam: weiche Linien, funktionale Aerodynamik, Persönlichkeit.

En tant que vice-président du design chez Ford Europe entre 1976 et 1986, il fut responsable, entre autres, de la Taunus de 1961 « baignoire » et de la Sierra de 1984. Bien que ces voitures soient aussi différentes que les époques où elles ont été conçues, elles ont beaucoup en commun : des lignes douces, une aérodynamique fonctionnelle, de la personnalité.

En calidad de vicepresidente de diseño de Ford Europe entre 1976 y 1986 fue responsable, entre otros, del Taunus "Bañera" del 61 y del Sierra del 84. Aunque estos dos automóviles son tan distintos como las épocas de las que surgieron, tienen algo en común: las líneas suaves, una aerodinámica funcional, personalidad.

Bangle, Chris
USA, 1956

© 7

Bangle climbed the hierarchy of design centers as an American in Europe. At first, he was at Fiat, then, from 1992, at BMW. In Munich, he broke with the past and was responsible for the first design revolution in German automobile history with the 2001 7 series. It was even a double break: not only do Bangle's BMW's look totally different to their predecessors, but they also very clearly differ from each other. Both changes were measures, for which many fans of this brand only gradually forgave him. The inspiration for his complex and controversial style, which takes some getting used to, is found less in car design than in cubism and deconstructionist architecture.

Als Amerikaner in Europa kletterte Bangle die Hierarchie der Designzentren hinauf. Zuerst bei Fiat und dann, ab 1992, bei BMW. In München brach er mit der Vergangenheit und zeichnete mit dem 7er von 2001 für die erste Designrevolution der deutschen Automobilgeschichte verantwortlich. Sogar eine doppelte: nicht nur sehen Bangles BMWs ganz anders aus als die Vorgänger, sondern unterscheiden sich auch untereinander sehr deutlich. Beide Veränderungen stellen Maßnahmen dar, die ihm viele Markenfans nur langsam verzeihen werden. Vorbilder für seinen komplexen, kontroversen und gewöhnungsbedürftigen Stil kann man weniger im Automobildesign als in der kubistischen Kunst und in der dekonstruktivistischen Architektur finden.

En tant qu'Américain en Europe, Bangle grimpait la hiérarchie des centres de design. D'abord chez Fiat puis, à partir de 1992, chez BMW. A

Munich, il rompit avec le passé et fut responsable de la série 7 de 2001, la première révolution dans l'histoire du design de l'automobile allemande. Et même une double révolution : non seulement les BMW de Bangle sont différentes des modèles antérieurs mais chaque modèle est particulier et différent des autres. Les fans de la marque ont mis beaucoup de temps à lui pardonner ces deux changements. Les sources de son style controversé et inhabituel sont plutôt présentes dans l'art cubiste et l'architecture déconstructiviste que dans le design automobile.

Como americano en Europa, Bangle escaló la jerarquía de los centros de diseño. Primero en Fiat y luego, a partir de 1992, en BMW. En Munich rompió con el pasado y, con el 7 de 2001, fue responsable de la primera revolución del diseño en la historia alemana del automóvil. Incluso de una doble: Los BMW de Bangle no solamente tienen otro aspecto totalmente diferente del de los predecesores, sino que se diferencian los unos de los otros muy claramente. Los dos cambios representan medidas que muchos fans de la marca sólo le perdonarán lentamente. Los modelos para su estilo complejo, controvertido y necesitado de costumbre pueden encontrarse menos en el diseño del automóvil que en el arte cubista y en la arquitectura deconstructivista.

Bertone, Nuccio
I, 1914–1997

© 37

Nuccio Bertone's eye for talent spotted Scaglione, Giugiaro and Gandini,—three of the most influential designers in the post-war era. Nobody was more radical and inno-

vative than the Carrozzeria Bertone. Bertone helped production of true milestones in automobile design. In addition to Franco Scaglione's BAT-Experiments, which were mainly to prove building competence, cars emerged like the classic Alfas, such as Guiletta Sprint, 2600 Sprint or the Montreal. For Fiat, Bertone produced what were then the most successful small roadsters of their time, the 850 Spider and X 1/9 and for Lancia, the Stratos, one of the best rally cars of all time. He gave the Lamborghini an identity and played a decisive role in the creation of the Lamborghini myth. Bertone was involved in the invention of Wedge Line, with the Alfa Carabo and Lancia Fulvia Stratos HF. His creations can be recognized mainly due to his love of the graphic handling of surfaces, from the Lamborghini Marzal to the Citroën BX and XM.

Nuccio Bertones Gespür für Talente entdeckte mit Scaglione, Giugiaro und Gandini drei der einflussreichsten Designer der Nachkriegszeit. Radikaler und innovativer als die Carrozzeria Bertone war niemand, und Bertone ließ wahre Meilensteine des Automobildesigns produzieren. Neben Franco Scagliones BAT-Experimenten, die vor allem Baukompetenz beweisen sollten, traten die mittlerweile klassischen Alfas wie der Giulietta Sprint, der 2600 Sprint oder der Montreal. Für Fiat produzierte er die bis dato erfolgreichsten Kleinroadster 850 Spider und X1/9, für Lancia mit dem Stratos eines der besten Rallyeautos aller Zeiten. Er gab Lamborghini ein Gesicht und trug so entscheidend zur Entstehung dieses Mythos bei. Mit dem Alfa Carabo und dem Lancia Fulvia Stratos HF war Bertone an der Erfindung der Wedge Line beteiligt. Vor allem an seiner Vorliebe für die graphische Behandlung der Oberflächen sind Bertones Schöpfungen zu erkennen, vom Lamborghini Marzal bis hin zum Citroën BX und XM.

Nuccio Bertone, avec son flair pour le talent, découvrit Scaglione, Giugiaro et Gandini, trois des créateurs les plus influents de l'après-guerre. Personne n'était plus radical et innovateur que la Carrozzeria Bertone qui fit produire des modèles qui furent des étapes déterminantes du design automobile. En plus des modèles expérimentaux BAT de Franco Scaglione prouvant sa compétence dans le domaine de la construction, furent lancées les Alfa, devenues maintenant des classiques, telles que la Giulietta Sprint, la 2600 Sprint et la Montreal. Il produisit pour Fiat les petits cabriolets 850 Spider et X1/9 les plus célèbres de l'époque, et pour Lancia, il créa la Strato, une des meilleures voitures de rallye de tous les temps. Il donna son visage à la Lamborghini et contribua à la création de ce mythe. Bertone participa à la création de la Wedge Line avec les modèles Alfa Carabo et Lancia Fulvia Strato HF. Les créations de Bertone se reconnaissent au soin apporté au traitement graphique des surfaces, depuis le modèle Lamborghini Marzal jusqu'aux Citroën BX et XM.

El olfato de Nuccio Bertone para los talentos descubrió con Scaglione, Giugiaro y Gandini a tres de los diseñadores más influyentes de la posguerra. Nadie fue más radical e innovador que la Carrozzeria Bertone, y Bertone hizo producir verdaderos hitos del diseño del automóvil. Junto a los experimentos BAT de Franco Scaglione, que debían demostrar sobre todo competencia en la construcción, aparecieron los Alfas, entretanto clásicos, como el Giulietta Sprint, el 2600 Sprint o el Montreal. Para Fiat produjo los pequeños Roadster 850 Spider y X1/9 de más éxito hasta la fecha, para Lancia, con el Stratos, uno de los mejores vehículos de rally de todos los tiempos. Dio una cara a Lamborghini contribuyendo así decisivamente al surgimiento de este mito. Con el Alfa Carabo y el Lancia Fulvia Stratos HF, Bertone participó en el invento de la Wedge Line. Las creaciones de Bertone pueden reconocerse sobre todo en su predilección por el tratamiento gráfico de las superficies, del Lamborghini Marzal hasta los Citroën BX y XM.

Bertoni, Flaminio
I-F, 1903–1964

The multi-talented Italian—he was an artist, sculptor and architect—only worked in automobile design for Citroën between 1934 and 1963. Basically, he created relatively few cars, but his brilliant designs were well ahead of their time, such as, the Traction Avant, the 2 CV and of course the DS. No other car received more attention and even excited great prestige outside of the world of automobiles. Never before was so much technical, conceptional and design innovation channelled into and produced in a series of vehicles. The French literary specialist, Roland Barthes, even compared "the Goddess" to a Gothic cathedral.

Das italienische Multitalent – er war Maler, Bildhauer und Architekt – arbeitete im Automobilbereich zwischen 1934 und 1963 nur für Citroën. Im Prinzip schuf er relativ wenige Autos, diese genialen Schöpfungen aber waren ihrer Zeit weit voraus, so z.B. der Traction Avant, der 2CV und natürlich die DS. Kein anderes Auto erhielt mehr Aufmerksamkeit und vermochte darüber hinaus auch jenseits der Automobilwelt so großes Aufsehen zu erregen. Nie zuvor wurde so viel technische, konzeptionelle und gestalterische Innovation in Form eines Serienfahrzeuges umgesetzt. Der französische Literaturwissenschaftler Roland Barthes verglich „die Göttin" sogar mit einer gotischen Kathedrale.

Cet italien aux talents multiples qui était peintre, sculpteur et architecte, travaillait dans le domaine automobile entre 1934 et 1963, mais seulement pour Citroën. Il créa relativement peu de voitures mais ces inventions géniales étaient de beaucoup en avance sur leur époque, par exemple, la Traction Avant, la 2 CV et naturellement la DS. Aucune autre voiture n'obtint autant d'attention et n'éveilla autant d'intérêt, même en dehors du monde automobile. Jamais par le passé ne fut apportée autant d'innovation technique, conceptionnelle et créatrice dans un véhicule de série. L'écrivain Roland Barthes va jusqu'à comparer la « déesse » à une cathédrale gothique.

El polifacético italiano – fue pintor, escultor y arquitecto – trabajó en el ámbito del automóvil entre 1934 y 1963 sólo para Citroën. En principio, creó relativamente pocos automóviles, pero estas creaciones geniales se adelantaron mucho a su tiempo, así por ejemplo el Traction Avant, el 2CV y naturalmente el DS. Ningún otro automóvil recibió más atención ni pudo causar, además, tanta sensación también más allá del mundo automovilístico. Nunca antes se había colocado tanta innovación técnica, conceptual y creativa en forma de un vehículo en serie. El científico francés de la literatura, Roland Barthes, comparó "la Diosa" incluso con una catedral gótica.

Boano, Mario Felice
I 1903– n. a.

Boano's cars are better known than his name. The Lancia Aurelia GT and the Karmann Ghia are masterpieces by his hand. Until 1953, he was co-owner of Ghia, when he always cultivated contact with Virgil Exner of Chrysler and Franco Scaglione of Bertone. From 1954 to 1957, he ran his own body shop, producing fantastic special pieces—one of them was even for Henry Ford Jr. In 1957, together with his son, Gian Paolo, he founded the first styling office at Fiat, which they continued to co-direct.

Boanos Autos sind bekannter als sein Name. Von seiner Hand stammen Meisterwerke wie der Lancia Aurelia GT und der Karmann Ghia. Bis 1953 war er Mitinhaber von Ghia, wobei er stets den Kontakt zu Virgil Exner von Chrysler und Franco Scaglione von Bertone pflegte. Zwischen 1954 und 1957 betrieb er eine eigene Karosseriefirma, mit der er wunderschöne Sonderanfertigungen realisierte – eine davon sogar für Henry Ford Jr. 1957 gründete er mit seinem Sohn Gian Paolo das erste Styling Office von Fiat, das sie fortan auch gemeinsam leiteten.

Les voitures de Boano sont plus connues que son nom. Il donna le jour à des chefs d'œuvre tels que le Lancia Aurelia GT et la Karmann Ghia. Jusqu'en 1953, il était copropriétaire de Ghia et entretenait simultanément des contacts réguliers avec Virgil Exner de Chrysler et Franco Scaglione de Bertone. Entre 1954 et 1957, il exploita sa propre usine de carrosserie où il fabriqua de merveilleux modèles hors série, dont une voiture pour Henry Ford Jr. En 1957, il fonda le premier bureau de conception (Styling Office) chez Fiat avec son fils Gian Paolo. Ensuite, ils en assumèrent ensemble la direction.

Los automóviles de Boano son más conocidos que su nombre. De su mano surgieron obras maestras como el Lancia Aurelia GT y el Karmann Ghia. Hasta 1953 fue copropietario de Ghia, a lo cual mantuvo siempre el contacto con Virgil Exner de Chrysler y Franco Scaglione de Bertone. Entre 1954 y 1957 regentó una empresa propia de carrocerías con la que realizó modelos especiales bellísimos –uno de ellos incluso para Henry Ford Jr. En 1957 fundó con su hijo Gian Paolo la primera Styling Office de Fiat que, en adelante, también dirigieron juntos.

Bracq, Paul
F, 1933

The French artist and sculptor heavily influenced German car design. As the head of Advance Design at Mercedes from 1957 to 1967, he was involved in the development of the 220 S Coupé, the 230SL "Pagode" and the 600. As the design director at BMW from 1970 to 1974, he became known as the father of the first 3, 5, 6 and 7 series. At the same time, he designed the French high-speed TGV train. Afterwards, he went to Peugeot. He is now mainly working as a freelance artist.

Der französische Maler und Bildhauer hat Deutschlands Automobildesign stark beeinflusst. Als Chef von Advance Design bei Mercedes zwischen 1957 und 1967 nahm er an der Entwicklung des 220 S Coupé, der 230SL „Pagode" und des 600 teil. Als Design Director von BMW zwischen 1970 und 1974 wurde er als Vater der ersten 3er, 5er, 6er und 7er Serie bekannt. Zur gleichen Zeit gestaltete er außerdem den französischen Hochgeschwindigkeitszug TGV; danach ging er zu Peugeot. Mittlerweile arbeitet er vor allem als freier Künstler.

Le peintre et sculpteur français a fortement influencé le design automobile. En tant que chef de « Advance Design » chez Mercedes entre 1957 et 1967, il participa à la création du coupé 220 S, du modèle 230 SL « Pagode », et du modèle 600. En tant que directeur de la conception chez BMW entre 1970 et 1974, il fut connu comme le créateur des premières séries 3, 5, 6 et 7. A la même époque, il travailla à la conception du TGV puis il choisit Peugeot. Il travaille à présent comme artiste indépendant.

El pintor y escultor francés ha influido fuertemente en el diseño automovilístico de Alemania. Como jefe de Advance Design en Mercedes entre 1957 y 1967, participó en el desarrollo del 220 S Coupé, del 230 SL "Pagode" y del 600. Como director de diseño de BMW entre 1970 y 1974, fue conocido como el padre de las primeras Serie 3, 5, 6 y 7. Además configuró al mismo tiempo el tren francés de alta velocidad TGV; después se fue a Peugeot. Entretanto, trabaja sobre todo como artista libre.

Brovarone, Aldo
I 1926

The talented Aldo Brovarone is not a well-known designer, because officially he did not sign any of his projects—Dino GT, Peugeot 504 Lancia Gamma. Nevertheless, after a lifetime working for Pininfarina, he is, as they say, a myth. Anyone who knows about the car industry respects this man and that is why he is worth a mention.

Der talentierte Aldo Brovarone signierte offiziell keines seiner Projekte – Dino GT, Peugeot 504 Lancia Gamma. Trotzdem ist er nach seiner lebenslangen Karriere bei Pininfarina, wie man so schön sagt, ein Mythos, den alle Branchenkenner respektieren – und insofern eine erwähnenswerte Persönlichkeit.

Le talentueux **Aldo Brovarone** n'est pas un concepteur connu car il n'a jamais officiellement signé ses projets – Dino GT, Peugeot 504 Lancia Gamma. Malgré tout, après une longue carrière chez Pininfarina, on peut dire qu'il est devenu un mythe, que tous les connaisseurs de la branche respectent, et une personnalité digne d'être citée.

El dotado Aldo Brovarone no es un diseñador conocido, pues oficialmente no firmó ninguno de sus proyectos –Dino GT, Peugeot 504 Lancia Gamma. Sin embargo, tras una carrera de toda la vida con Pininfarina es, como suele decirse, un mito que todos los conocedores del ramo respetan y, en la medida de ello, una personalidad digna de mención.

Chapman, Colin
GB, 1928–1982

The pilot and construction specialist founded the Lotus company in the 1950s as a works for racing cars. Chapman actually revolutionized Formula One racing and the concept of a sports car with his middle-engine vehicles. His cars in the 1950s and 1960s—Elite, Elan, Europa—were characterzied in terms of their concept and construction by a clever reduction to the bare essentials. The resulting style was unmistakable and timeless.

Der Pilot und Konstrukteur gründete in den 50er Jahren die Firma Lotus als Schmiede für Rennfahrzeuge. Tatsächlich revolutionierte Chapman mit seinen Mittelmotorfahrzeugen sowohl die Formel 1 als auch das Konzept des Sportwagens überhaupt. Seine Autos der 50er und 60er – Elite, Elan, Europa – waren von ihrem Konzept und ihrer Konstruktion her geprägt von einer cleveren Reduktion auf das Wesentliche. Der Stil, der daraus resultierte, war unverwechselbar und zeitlos.

Le pilote et constructeur fonda la société Lotus comme forge de voitures de course dans les années 50. En effet, Chapman révolutionna la Formule 1 et le concept de la voiture de sport avec ses véhicules au moteur central. Ses voitures de 1950 et 1960 – Elite, Elan, Europa – étaient marquées du point de vue du concept et de la construction par la réduction à l'essentiel. Le style qui en résulte est unique et intemporel.

El piloto y constructor fundó en los años 50 la empresa Lotus como forjadora de vehículos de carreras. De hecho, Chapman revolucionó con sus automóviles de motor central tanto la fórmula 1 como el concepto del vehículo deportivo en general. Sus automóviles de los años 50 y 60 –Elite, Elan, Europa– estuvieron marcados en su concepción y construcción por una inteligente reducción a lo esencial. El estilo que resultó de ello fue inconfundible y atemporal.

Cherry, Wayne
USA, 1938

From 1992 to 2004, he was Vice President of Design for General Motors, for whom he worked for thirty years, first in England and then in Germany. Some of his Opel models were design leaders in their market category: the Corsa, the Vectra and the Calibra. His leaving present was the relaunch of the Cadillac brand, crowned with the Show Car Sixteen, a hommage to the golden age of Harley Earl and Bill Mitchell.

Zwischen 1992 und 2004 war er Vice President für Design bei General Motors, für die er insgesamt über 30 Jahre lang gearbeitet hat, zuerst in England und in Deutschland. Einige seiner Opel waren die Designführer in ihrem Segment: der Corsa, der Vectra und der Calibra. Sein Abschiedsgeschenk war die Wiedergeburt der Marke Cadillac, gekrönt durch das Show Car Sixteen, eine Hommage an die goldenen Zeiten von Harley Earl und Bill Mitchell.

Entre 1992 et 2004, il a été vice-président du design chez General Motors, pour qui il a travaillé pendant 30 ans, d'abord en Angleterre puis en Allemagne. Certaines de ses Opel furent des modèles de design dans leur segment : la Corsa, la Vectra et la Calibra. Son cadeau d'adieu fut la renaissance de la marque Cadillac, couronnée par le Show Car Sixteen, un hommage à l'âge d'or de Harley Earl et de Bill Mitchell.

Entre 1992 y 2004 fue vicepresidente de diseño en General Motors para la que ha trabajado durante más de 30 años en total, primero en Inglaterra y Alemania. Algunos de sus Opel fueron los líderes del diseño en su segmento: el Corsa, el Vectra y el Calibra. Su regalo de despedida fue el renacimiento de la marca Cadillac, coronada por el Show Car Sixteen, un homenaje a la época dorada de Harley Earl y Bill Mitchell.

De Silva, Walter
I, 1951

What Walter de Silva likes most of all about cars is the "scent of the brand". As Alfa Romeo's design chief, he helped the firm rise to new heights from 1986 to 1999 with models like the 156. His creations mix dynamic forms with eye-catching lines and at the same time, they are classic, without falling back into retro design.

After a short period working for Seat, in 2002, he was appointed as head of design for the Audi group.

Was Walter de Silva vor allem an Autos mag, ist ihr „Markenduft". Als Designchef von Alfa Romeo verhalf er der Firma zwischen 1986 und 1999 mit Modellen wie dem 156 zu neuem Glanz. Seine Schöpfungen mischen dynamische Formen mit markanten Linien und sind dabei klassisch, ohne aber in ein Retrodesign zu verfallen. Nach einer kurzen Station bei Seat wurde er 2002 zum Designdirektor der Audi Brand Group ernannt.

Ce que Walter de Silva aime avant tout dans une automobile, c'est le « parfum de la marque ». En tant que responsable de la conception chez Alfa Romeo entre 1986 et 1999, il contribua à redonner à la société un nouvel éclat avec des modèles comme la 156. Ses créations mélangeaient des formes dynamiques et des lignes marquantes tout en restant classiques, sans tomber dans un design Retro. Après un court séjour chez Seat, il fut nommé directeur de la conception en 2002 chez Audi Brand Group.

Lo que a Walter de Silva le gusta especialmente de los automóviles es su "aroma de marca". Como diseñador jefe de Alfa Romeo consiguió un nuevo esplendor para la empresa entre 1986 y 1999 con modelos como el 156. Sus creaciones mezclan las formas dinámicas con las líneas marcadas, siendo clásicas pero sin caer en un diseño Retro. Tras una corta estancia en SEAT, en 2002 fue nombrado director de diseño del Audi Brand Group.

Earl, Harley
USA, 1893–1969

© 22

In 1927, Earl joined General Motors, where he was meant to design for the new Cadillac brand Lasalle. GM's director, Alfred P. Sloan, let him found the Art & Color Department that very same year. This department is today seen as the first car design office of all time. Earl is regarded as the first to discover design dynamics as an instrument of brand leadership. As a Hollywood figure, he had the idea of developing show cars to grab the attention of media and popular opinion. The first of these show cars was the 1938 Buick Y-Job. Earl was strongly influenced by contemporary aircraft design: the already round, flowing forms of his designs were liberally decorated with fins and other chrome ornaments—a prototype of this style was the 1951 Le Sabre. He loved colors and continually worked on their development. Many design features of the fifties are Earl's invention, such as pastel colors, the hard-top roof and the panoramic windshield. The temperamental autocrat, Earl, revolutionized car design by introducing clay modeling and he is considered the father of this innovation.

Earl kam 1927 zu General Motors, wo er für die neue Cadillac-Marke Lasalle gestalten sollte. GMs Chef Alfred P. Sloan ließ ihn im selben Jahr das Art & Color Department gründen, jene Abteilung, die heute als das erste Automobildesignbüro überhaupt angesehen wird. Er gilt als der Entdecker der Designdynamik als Instrument der Marken-

führung. Als Hollywood-Mensch kam er auf die Idee, Show Cars zu entwickeln, mit denen die Aufmerksamkeit von Medien und Massen angezogen werden sollten. Das erste dieser Show Cars war der 1938er Buick Y-Job. Earl war stark vom zeitgenössischen Flugzeugdesign beeinflusst: die ohnehin schon runden, fließenden Formen seiner Schöpfungen wurden mit Flossen und anderen verchromten Ornamenten reichlich dekoriert – als Prototyp dieses Stils gilt der 1951er Le Sabre. Er liebte Farben und arbeitete ständig an deren Weiterentwicklung. Viele Designmerkmale der 50er Jahre sind eine Erfindung Earls, so z. B. die Pastellfarben, das Hardtopdach und die Panoramascheibe. Der cholerische Autokrat Earl revolutionierte durch die Einführung der Clay-Modellierung das Automobildesign, als dessen Vater er gilt.

Earl commença en 1927 chez General Motors, où il conçut la Lasalle pour la marque Cadillac. Alfred P. Sloan, le chef de GM l'encouragea la même année à fonder le département Art & Color qui, aujourd'hui, est considéré comme le meilleur bureau de design automobile. Il est considéré comme l'inventeur de la dynamique du design utilisée comme instrument-guide de la marque. Issu de Hollywood, il eut l'idée d'offrir des Show Cars (spectacles de voiture) pour attirer l'attention des médias et du public. Le premier Show Car fut consacré à la Buick Y-Job de 1938. Earl était fortement influencé par le design aéronautique : les formes déjà rondes et fluides de ses créations furent munies d'ailettes et d'autres ornements chromés. Le prototype de ce style est représenté par Le Sabre de 1951. Il aimait les couleurs et travaillait constamment à leur amélioration. De nombreuses caractéristiques de design des années 50 lui sont redevables, telles que les couleurs pastel, le toit rigide (hard top) et la vitre panoramique. L'autocrate colérique Earl révolutionna le design automobile avec le modelage à l'argile dont il est l'inventeur présumé.

Earl llegó a General Motors en 1927 donde había de diseñar para Lasalle, la nueva marca de Cadillac. El

382

mismo año, el jefe de GM, Alfred P. Sloan, le hizo fundar el Art & Color Department, aquel departamento que hoy es visto como el primer despacho de diseño automovilístico en realidad. Está considerado como el descubridor de la dinámica del diseño como instrumento de gestión de la marca. Siendo una persona de Hollywood, tuvo la idea de desarrollar Show Cars con los que había de atraerse la atención de los medios de comunicación y de las masas. El primero de estos Show Cars fue el Buick Y-Job de 1938. Earl estuvo fuertemente influido por el diseño de aviones de la época: Las formas de sus creaciones, que de todos modos ya eran redondas y fluidas, fueron decoradas en abundancia con estabilizadores y otros ornamentos cromados –el Le Sabre de 1951 está considerado como el prototipo de este estilo. Amaba los colores y trabajaba constantemente en su desarrollo. Muchas características del diseño de los años 50 son un invento de Earl, así, por ejemplo, los colores pastel, el techo hardtop y la luna panorámica. El colérico autócrata Earl revolucionó el diseño automovilístico mediante la introducción del modelado Clay del que está considerado el padre.

Engle, Elwood
USA, n. a.

He loved chiselled forms with clear, folding lines and he is regarded as among the inventors of Flow and Edge Line Design in the sixties. He designed the '61 Lincoln Continental for Ford. This was his best design and one of the most beautiful cars to emerge from the USA. In the same year, he transferred to Chrysler, where he first abolished fins, which were preferred by Virgil Exner. The '62 and '63 models suffered a lot because of the compromise. His design language then became more obvious with the 1964 Imperial and the 1965 Chrysler. He rounded off his career with the Muscle Cars Dodge Charger and Plymouth Barracuda.

Er liebte gemeißelte Formen mit klaren Faltlinien und zählt zu den Erfindern des Flow und Edge Line Design der 60er Jahre. Bei Ford gestaltete er den 61er Lincoln Continental, sein bestes Design und eines der schönsten Autos aus den USA. Im selben Jahr wechselte er zu Chrysler, wo er zunächst die von Virgil Exner bevorzugten Flossen abschaffte – worunter die 62er und 63er Kompromissmodelle sehr zu leiden hatten. Mit dem Imperial von 1964 und dem Chrysler von 1965 kam seine Designsprache dann eindeutig zum Vorschein. Er schloss seine Karriere mit den Muscle Cars Dodge Charger und Plymouth Barracuda ab.

Il aimait les formes sculptées aux lignes de pli claires. Il compte parmi les fondateurs du design Flow et Edge Line. Pour Ford il créa la Lincoln Continental de 1961, le meilleur de son design et l'une des plus belles voitures des Etats-Unis. La même année, il changea pour Chrysler où il supprima d'abord les ailettes favorisées par Virgil Exner – ce qui porta un coup aux modèles de 1962 et 1963 qui étaient des compromis. Son langage du design fit ses preuves avec l'Imperial de 1964 et la Chrysler de 1965. Il termina sa carrière avec les modèles Muscle Cars Dodge Charger et Plymouth Barracuda.

Le gustaban las formas esculpidas con claras líneas plisadas y cuenta entre los inventores del diseño Flow y Edge Line de los años 60. En Ford configuró el Lincoln Continental del 61, su mejor diseño y uno de los automóviles más bellos de los EEUU. El mismo año se pasó a Chrysler donde primero eliminó los estabilizadores preferidos por Virgil Exner –bajo los que los modelos de compromiso del 62 y el 63 tenían que sufrir mucho. Su lenguaje de diseño se manifestó entonces claramente con el Imperial de 1964 y el Chrysler de 1965. Terminó su carrera con los Muscle Cars Dodge Charger y Plymouth Barracuda.

Exner, Virgil
USA, 1909–1973

Before the war, Exner was design chief of Pontiac and Studebaker. After the war, he introduced the "For-

ward Look" with the '54 Chrysler and he became co-founder of New Line Design. His preference for tail-fins is explained by his encounter with the 1947 Cisitalia Aerodinamica Savonuzzi; Exner believed that the fins improved the aerodynamics of this vehicle. The Gilda, a joint project with Ghia, was the first model to introduce this preference in public. However, it was immediately obvious that the fins were anything but functional. The Gunsight tail lights were also part of this trend, they were an eccentric ornament, which was to remain the most characteristic feature of the Chrysler Imperial for an entire decade.

Vor dem Krieg war Exner Designchef von Pontiac und Studebaker, nach dem Krieg wurde er mit dem „Forward Look", den er mit dem 54er Chrysler einführte, zum Miterfinder des New Line Designs. Seine Vorliebe für Heckflossen erklärt sich aus seiner Begegnung mit dem 1947 Cisitalia Aerodinamica Savonuzzi; Exner war der Meinung, dass sie die Aerodynamik des Fahrzeuges verbesserten. Der Gilda, gemeinsam mit Ghia realisiert, brachte diese Vorliebe zum ersten Mal ans Licht der Öffentlichkeit, womit aber gleichfalls deutlich wurde, dass die Flossen alles andere als funktional waren. Zu diesem Trend gehörten gleichfalls die Gunsight Rückleuchten, ein skurriles Ornament, das für 10 Jahre das charakteristischste Merkmal des Chrysler Imperial blieb.

Avant la guerre, Exner était responsable de la conception chez Pontiac et Studebaker ; après la guerre il coopéra à la création du design New Line grâce au Forward Look qu'il introduisit avec la Chrysler de 1954. Sa préférence pour les ailettes s'explique par sa rencontre avec la Cisitalia Aerodinamica Savonuzzi de 1947 ; Exner pensait que les ailettes améliorait l'aérodynamique du véhicule. Le modèle Gilda réalisé en commun avec Ghia révéla au public cette préférence et démontra simultanément que les ailettes arrière n'étaient pas vraiment fonctionnelles. Les feux arrière Gunsight faisaient également partie de cette mode ; c'était un ornement bizarre qui resta la caractéristique typique de Chrysler Imperial.

Antes de la guerra, Exner fue jefe de diseño de Pontiac y Studebaker, después de la guerra se convirtió en el coinventor del diseño New Line con el "Forward Look", que introdujo con el Chrysler del 54. Su predilección por los estabilizadores traseros se explica por su encuentro con el Cisitalia Aerodinamica Savonuzzi de 1947; Exner era de la opinión que aquéllos mejoraban la aerodinámica del vehículo. El Gilda, realizado conjuntamente con Ghia, llevó esta predilección por primera vez a la luz pública con lo que, sin embargo, al mismo tiempo quedó claro que los estabilizadores lo eran todo menos funcionales. A esta tendencia pertenecen igualmente las luces traseras Gunsight, un ornamento extravagante que permaneció 10 años como la marca más característica del Chrysler Imperial.

Fioravanti, Leonardo
I, 1938

From 1964 to 1984, Fioravanti worked for Pininfarina, where he was the director of the research center from 1972. He developed the flowtail sedan with the BMC 1800, a totally new type of automobile, which posted great successes in the seventies and eighties. The details on this car also had an inspirational influence: the full profile headlight cover was also used on the Citroën SM, the tail lights with rimmed profile were later to become a trademark of Mercedes. Flowing lines and respectable, classical elegance are features of his designs, which include many desirable Ferraris like the Daytona and the 308 GTB.

Zwischen 1964 und 1984 war er bei Pininfarina, wo er ab 1972 als Direktor des Forschungszentrums arbeitete. Mit dem BMC 1800 konzipierte er mit der Fließhecklimousine eine völlig neuen Automobiltypologie, die in den 70er und 80er Jahren große Erfolge feierte. Auch die Details dieses Wagens übten inspirierenden Einfluss aus: Die vollseitige Scheinwerferabdeckung kam beim Citroën SM zum Einsatz, die

Rückleuchten mit dem gerillten Profil wurden später zum Markenzeichen von Mercedes. Fließende Linien und dezente, klassische Eleganz sind die Merkmale seiner Schöpfungen, zu denen auch viele begehrte Ferraris gehören, wie etwa der Daytona und der 308 GTB.

Entre 1964 et 1984, il était employé chez Pininfarina où il devint directeur du centre de recherche en 1972. Il conçut la BMC 1800, une berline à l'arrière fluide, une toute nouvelle typologie de voiture qui eut beaucoup de succès dans les années 70 et 80. Les détails de cette voiture eurent également une influence : sa couverture complète de phare fut utilisée par Citroën SM, les feux arrière au profil rainuré de-vinrent plus tard une griffe de Mercedes. Les lignes fluides et décentes ainsi que l'élégance classique sont les caractéristiques de ses créations, dont font partie les Ferrari très recherchées, telles que la Daytona et la 308 GTB.

Entre 1964 y 1984 estuvo con Pininfarina donde trabajo a partir de 1972 en calidad de director del centro de investigaciones. Con el BMC 1800 concibió, con la limusina de portón trasero alargado, una tipología del automóvil completamente nueva que celebró grandes éxitos en los años 70 y 80. También los detalles de este vehículo ejercieron una influencia inspiradora: El completo cubrimiento de los faros en el lado se introdujo en el Citroën SM, las luces traseras con el perfil estriado se convirtieron más tarde en la marca característica de Mercedes. Las líneas fluidas y una elegancia discreta y clásica son las características de sus creaciones a las que también pertenecen muchos Ferraris deseados, como por ejemplo el Daytona y el 308 GTB.

Frua, Pietro
I, 1913-1983

Aged 22 years, this trained technical drawer became the chief designer for Pininfarina and in 1939 he founded his own workshop. In 1957, he sold it to Ghia, with whom he was to continue to cooperate for years,

before finally becoming self-employed again. It is difficult to identify a clear, personal style, because his creative ideas carried him in very different directions. Among Frua's best known works are the Volvo P1800, the Renault Floride, the Maserati Mistral and the first Quattroporte.

Der gelernte technische Zeichner wurde mit 22 Jahren Chefdesigner von Pininfarina und gründete 1939 seine eigene Werkstatt. 1957 verkaufte er diese an Ghia, mit dem er in der Folgezeit jahrelang kooperierte, um sich dann anschließend aber wieder selbständig zu machen. Ein eindeutiger, eigener Stil lässt sich bei ihm schwer ausmachen, da seine kreativen Ideen ihn in sehr unterschiedliche Richtungen führten. Zu den am meisten bekannten Werken von Frua zählen der Volvo P1800, der Renault Floride, der Maserati Mistral und der erste Quattroporte.

Ce dessinateur technique professionnel devint responsable de la conception chez Pininfarina à 22 ans et fonda son propre atelier en 1939. En 1957, il le vendit à Ghia avec lequel il coopéra ensuite pendant des années, pour finalement se remettre à son compte. Chez lui, il est difficile de définir un style marquant et personnel car ses idées créatives se dirigeaient dans diverses directions. La Volvo P1800, la Renault Floride, la Maserati Mistral et la première Quattroporte comptent parmi les œuvres les plus connues de Frua.

Especializado en dibujo técnico, se convirtió con 22 años en jefe de diseño de Pininfarina y fundó en 1939 su propio taller. En 1957 lo vendió a Ghia con quien cooperó en el período siguiente durante muchos años para, no obstante, volver a independizarse a continuación. En él resulta difícil distinguir un claro estilo propio pues sus ideas creativas lo llevaron en muchas direcciones distintas. Entre las obras más conocidas de Frua cuentan el Volvo P1800, el Renault Floride, el Maserati Mistral y el primer Quattroporte.

Gandini, Marcello

I, 1938

Gandini started his career as an interior designer and he still works today as a freelance designer. His first project for the Carrozzeria Bertone, where in 1965 he was successor to the head designer Giorgio Giugiaro, was the futuristic sports car, the Miura. Gandini is presumed as the inventor of Wedge Line, which he translated into the staight lines of his often radical creations. His car series combine geometric clarity with dynamic aggression; graphic elements are supported with glaring colors. The Lamborghini Countach, Fiat X1/9 and Lancia Stratos best show his distinctive signature, which is rich in contrasts.

Gandini startete seine Karriere als Interior Designer und arbeitet noch heute als Freelancer. Sein erstes Projekt für die Carrozzeria Bertone, wo er 1965 Giorgio Giugiaro als Chefdesigner ablöste, war der zukunftsweisende Sportwagen Miura. Gandini gilt als mutmaßlicher Erfinder der Wedge Line, die er in seinen oft radikalen Schöpfungen geradlinig umsetzte. Seine Serienautos verbinden geometrische Klarheit mit dynamischer Aggressivität; graphische Elemente werden durch schrille Farben unterstützt. Lamborghini Countach, Fiat X1/9 und Lancia Stratos repräsentieren seine markante, kontrastreiche Handschrift am Besten.

Gandini démarra sa carrière en tant qu'architecte d'intérieur et travaille encore à son compte. Il remplaça Giorgio Giugiaro comme chef de conception à la Carrozzeria Bertone en 1965 et son prêmier projet fut la voiture de sport Miura, tournée vers l'avenir. Gandini est l'inventeur supposé de la Wedge Line qu'il dessina en lignes droites dans ses créations souvent extrêmes. Ses voitures de série associent une clarté géométrique à une agressivité dynamique ; les éléments graphiques sont soulignés par des couleurs vives. Les Lamborghini Countach, Fiat X1/9 et Lancia Strato illustrent le mieux sa signature marquante et riche en contrastes.

Gandini comenzó su carrera como diseñador de interiores y hoy trabaja todavía como free lance. Su primer proyecto para las Carrozzeria Bertone, donde en 1965 reemplazó a Giorgio Giugiaro como diseñador jefe, fue el progresista vehículo deportivo Miura. Gandini está considerado como el supuesto inventor de la Wedge Line que en sus creaciones, a menudo radicales, realizó en líneas rectas. Sus automóviles en serie unen la claridad geométrica con la agresividad dinámica; los elementos gráficos son favorecidos por los colores estridentes. El Lamborghini Countach, el Fiat X1/9 y el Lancia Stratos son los que mejor representan su sello destacado y rico en contrastes.

Giacosa, Dante

I, 1905–1996

The engineer, Giacosa, joined Fiat in 1927 and the most famous prewar models were developed by him. He was also responsible for product development at the Turin manufacturer after the war until 1970. His special passion for small cars was first evident with the 1936 Topolino. His cars put the whole of Italy on the road and in the sixties they finally made Fiat into Europe's biggest car manufacturer.

Der Ingenieur Giacosa ging 1927 zu Fiat, deren berühmteste Modelle der Vorkriegszeit von ihm entwickelt wurden. Auch nach dem Krieg, bis 1970, war er verantwortlich für die Produktentwicklung des Turiner Herstellers. Seine besondere Leidenschaft für Kleinautos zeigte sich das erste Mal mit dem Topolino von 1936. Seine Autos motorisierten ganz Italien und machten Fiat in den 60er Jahren schließlich zum größten Automobilhersteller in ganz Europa.

L'ingénieur Giacosa commença chez Fiat en 1927 où il développa les modèles les plus célèbres de l'avant-guerre. Après la guerre et jusqu'en 1970, il était responsable du développement des produits pour le fabricant de Turin. Sa passion pour les petites voitures s'illustra la première fois avec la Topolino de 1936. Ses voitures se vendirent dans toute l'Italie et firent de Fiat le plus grand fabricant automobile européen des années 60.

El ingeniero Giacosa se fue en 1927 a Fiat cuyos modelos más famosos de la época de la preguerra fueron desarrollados por él. También después de la guerra, hasta 1970, fue responsable del desarrollo de la producción del fabricante turinés. Su especial pasión por los automóviles pequeños se mostró por primera vez en el Topolino de 1936. Sus automóviles motorizaron a toda Italia y finalmente hicieron de Fiat en los años 60 uno de los fabricantes de automóviles en toda Europa. 385

Albrecht Goertz

US-D, 1914

© 7

At first, Goertz started tuning Ford models in a garage. He was then discovered by Raymond Loewy and obtained a job as designer for Studebaker. But his masterpiece is a BMW,—the 507.

Goertz fing zunächst in einer Garage an, Modelle von Ford zu tunen. Er wurde dann von Raymond Loewy entdeckt und bekam eine Stelle als Designer bei Studebaker. Sein Meisterwerk ist allerdings ein BMW, und zwar der 507.

Goertz commença d'abord dans un garage comme « Tuner » pour Ford. Il fut ensuite découvert par Raymond Loewy et obtint un poste de créateur chez Studebaker. Son chef d'œuvre est pourtant une BMW, le modèle 507.

Goertz comenzó primero en un garaje trucando modelos de Ford. Más tarde fue descubierto por Raymond Loewy y obtuvo un puesto como diseñador en Studebaker. Su obra maestra es por cierto un BMW y concretamente el 507.

Issigonis, Alec

GB 1906–1988

The father of the Mini was not a designer, but an engineer and construction specialist with design ambitions. His first car was the 1948 Morris Minor. Although he enjoyed being advised by Pininfarina on matters of style, he designed the Mini himself and managed to influence the concept of a modern, small car. The most innovative small vehicles of all time offered the best relations of external mass and interior space and was thought through to every last detail. The Mini stayed in production for over forty years and became a design icon. Two anecdotes are memorable: firstly, his instruction to cut in half and widen the finished prototype model of the Morris Minor, which had become too narrow and vertical. Secondly, he was content with the uncomfortable seating position in the Mini, because the driver could never be in danger of falling asleep.

Der Vater des Mini war kein Designer, sondern ein Ingenieur und Konstrukteur mit Designambitionen. Sein erstes Auto war der 48er Morris Minor. Obwohl er sich in Sachen Stil gerne von Pininfarina beraten ließ, hat er den Mini selbst entworfen und prägte so das Konzept des modernen Kleinautos. Das innovativste Kleinfahrzeug aller Zeiten bot das beste Verhältnis zwischen Außenmassen und Innenraum und war bis ins Detail durchdacht. Er blieb über 40 Jahre in Produktion und wurde zur Designikone. Zwei Anekdoten bleiben in Erinnerung: zum einen seine Anweisung, den fertigen Prototyp des Minors zu halbieren und zu verbreitern, da dieser zu eng und vertikal geraten war, zum anderen seine Zufriedenheit mit der unbe-

quemen Sitzposition im Mini, weil so der Fahrer angeblich niemals hätte einschlafen könne.

Le père de la Mini n'était pas un designer mais un ingénieur et constructeur ayant des ambitions de design. Sa première voiture fut la Morris Minor de 1948. Bien qu'il se fit volontiers conseiller par Pininfarina, il conçut lui-même la Mini et influença ainsi le concept de la petite voiture moderne. Le plus innovateur des petits véhicules offrait le meilleur rapport entre les dimensions extérieures et l'habitacle, et chaque détail était parfaitement pensé. Il fut produit pendant 40 ans et devint un mythe du design. Deux anecdotes sont restées : d'abord, l'ordre de diminuer de moitié le prototype de la Minor et de l'élargir car il était trop étroit et trop vertical ; ensuite, la satisfaction pour la position assise inconfortable de la Mini, ainsi le conducteur ne risquait pas de s'endormir.

El padre del Mini no fue un diseñador, sino un ingeniero y constructor con ambiciones en el diseño. Su primer automóvil fue el Morris Minor del 48. Aunque en materia de estilo le gustaba dejarse asesorar por Pininfarina, él mismo proyectó el Mini acuñando así el concepto del pequeño automóvil moderno. El vehículo pequeño más innovador de todos los tiempos ofrecía la mejor relación entre las medidas exteriores y el espacio interior y estaba pensado hasta en el detalle. Permaneció en la producción durante más de 40 años y se convirtió en un icono del diseño. Dos anécdotas quedan en el recuerdo: Por un lado, su indicación de partir por la mitad y ensanchar el prototipo acabado del Minor, ya que había salido demasiado estrecho y vertical, por otro lado, su insatisfacción con la incómoda posición del asiento en el Mini porque así el conductor supuestamente nunca habría podido dormir.

Komenda, Erwin
A, 1904–1966

© 13

From 1931 to 1966, the Austrian was director of body development for Porsche. He is considered as the creator of milestones in car design, such as the VW Beetle and the first generation of Porsche models. His trademarks: round, soft lines in Organic Flow Design, a consistent reduction of all design elements and the introduction of a tail engine.

Der Österreicher leitete zwischen 1931 und 1966 die Karosserieentwicklung bei Porsche und gilt als Schöpfer automobiler Meilensteine wie dem VW Käfer und den Porsche-Modellen der ersten Generation. Sein Markenzeichen: runde, weiche Linien im Organic Flow Design, konsequente Reduktion aller Designelemente sowie die Einführung des Heckmotors.

Cet autrichien dirigeait le développement de la carrosserie chez Porsche entre 1931 et 1966. Il est le créateur de modèles qui furent des étapes décisives du design automobile comme la coccinelle VW et les modèles de Porsche de la première génération. Sa griffe caractéristique : les lignes rondes et douces en design Organic Flow, la réduction radicale de tous les éléments de design ainsi que le moteur à l'arrière.

El austriaco dirigió entre 1931 y 1966 el desarrollo de carrocerías en Porsche y está considerado como el creador de hitos automovilísticos como el Escarabajo (VW Käfer) y los modelos Porsche de la primera generación. Su marca característica:

líneas redondas y suaves en diseño Organic Flow, una reducción consecuente de todos los elementos de diseño así como la introducción del motor trasero.

L

le Quement, Patrick
F, 1945

© 35

Patrick le Quement breathed new life into car design in the 1990s. Since 1987, he has been responsible for design at Renault. As a promoter of visionary creativity, he not only brought in new car designers in to his studios, but he also let other designers experiment with new design processes. The Twingo and Megane Scenic series were the first design innovations to emerge in a long time in the small- and two-door vehicle categories. The Avantime was an attempt to do something similar for higher category vehicles. Le Quement's polyhedral, sculptural and expressive design language for Renault continued to introduce design innovations, which were a risk every time for mass produced vehicles.

Patrick le Quement, seit 1987 verantwortlich für das Design bei Renault, hauchte dem Automobildesign in den 90er Jahren neues Leben ein. Als Förderer visionärer Kreativität holte er nicht nur Automobildesigner in seine Studios, sondern ließ auch andere Gestalter mit neuen Designprozessen experimentieren. Der Twingo und der Megane Scenic waren die ersten Designinnovationen im Segment der Klein- und Kompaktwagen seit langem; ähnliches versuchte auch der Avantime in der höheren Klasse zu leisten. Le

Quements polyedrische, skulpturalexpressive Designsprache für Renault führte stets gestalterische Neuerungen ein, was für die Massenproduktion jedes Mal ein Risiko darstellte.

Patrick le Quement, responsable du design chez Renault depuis 1987 a influé une nouvelle vie au design automobile des années 90. Favorisant la créativité visionnaire, il recruta non seulement des concepteurs automobiles dans ses studios mais permit à d'autres créateurs d'expérimenter de nouveaux processus de design. La Twingo et la Mégane Scénic étaient les premières innovations en terme de design dans le segment des petites voitures compactes ; l'Avantime également mais dans la classe au-dessus. Le langage polyédrique, sculptural et expressif de Quement pour Renault a donné constamment le jour à des nouveautés de conception, qui apportaient chaque fois un nouveau risque pour la production en masse.

Patrick le Quement, responsable de diseño en Renault desde 1987, dio nueva vida al diseño del automóvil en los años 90. Como impulsor de una creatividad visionaria, no sólo llevó a sus estudios a diseñadores de automóviles sino que también hizo que otros diseñadores experimentaran con nuevos procesos del diseño. El Twingo y el Megane Scenic fueron las primeras innovaciones del diseño en el segmento de los vehículos pequeños y compactos desde hacía mucho tiempo; El Avantime intentó realizar algo similar en la clase superior. El lenguaje de diseño de Le Quements para Renault, poliédrico y escultural-expresivo, introdujo constantemente innovaciones creadoras que representaban cada vez un riesgo para la producción en masa.

Loewy, Raymond
USA, 1893–1986

© 34

Loewy is possibly the most famous designer of all time and certainly one of the most talented. Besides, he had a great head for business. Along with cigarette packets and trains, he also worked on cars for the firm Studebaker, for whom he was a consultant for many years. His designs were always innovative, and freely developed according to his motto MAYA: "most advanced yet acceptable". Above all, the Avanti, one of his last creations for Studebaker, was a very progressive car by American standards. However, attractiveness was a well-known bone of contention; and that is why his European colleagues criticized his eccentric cars, which Loewy designed for himself, like for example, the Lancia Flamina Loraymo.

Loewy ist möglicherweise der berühmteste Designer aller Zeiten, auf jeden Fall aber einer der talentiertesten, der außerdem ein großes Gespür fürs Geschäft hatte. Zwischen Zigarettenpackungen und Lokomotiven beschäftigte er sich auch mit den Autos der Firma Studebaker, für die er als langjähriger Berater tätig war. Seine Entwürfe waren stets innovativ, frei nach seinem Motto MAYA: „Most advanced yet acceptable". Vor allem der Avanti, seine letzte Schöpfung für Studebaker, war ein für amerikanische Verhältnisse sehr fortschrittliches Auto. Über Schönheit lässt sich aber bekanntlich streiten; so kritisierten seine europäischen Kollegen die Skurrilität der Autos, die Loewy für sich selbst entwarf, wie z. B. den Lancia Flaminia Loraymo.

Loewy est peut-être le concepteur le plus célèbre de tous les temps et certainement le plus talentueux. En outre, c'était quelqu'un qui avait un grand sens des affaires. Entre les paquets de cigarettes et les locomotives, il s'occupa des voitures de la société Studebaker, pour laquelle il fut longtemps conseiller. Ses créations étaient toujours innovatrices, selon sa devise MAYA : « Most advanced yet acceptable ». En particulier l'Avanti, sa dernière création pour Studebaker, était une voiture très avancée pour les Américains. La beauté peut engendrer des controverses. Ainsi les collègues européens de Loewy critiquèrent la bizarrerie des voitures qu'il conçut pour lui-même, par exemple la Lancia Flaminia Loraymo.

388

Loewy es posiblemente el diseñador más famoso de todos los tiempos, en todo caso uno de los más dotados y que además poseía un gran sentido para el negocio. Entre paquetes de cigarros y locomotoras se dedicó a los automóviles de la empresa Studebaker para la que trabajó como asesor durante muchos años. Sus proyectos fueron siempre innovadores, libres según su lema MAYA: "Most advanced yet acceptable". Especialmente el Avanti, su última creación para Studebaker, fue un automóvil muy progresista teniendo en cuenta las circunstancias en América. Pero como es sabido, sobre la belleza puede discutirse; así, sus colegas europeos criticaron la extravagancia de los automóviles que Loewy proyectó para sí mismo, como por ejemplo el Lancia Flaminia Loraymo.

Luthe, Claus
D, 1932

As chief designer of NUS, Luthe developed the milestone Ro80 at the end of the 1960s. This car anticipated the form language of the nineties: rounded form, high tail, rising trim. From 1976 to 1992, he worked for BMW and one of his last creations—the 5 series of the E39—counts as one of the most attractive sedans that were ever produced.

Als Chefdesigner von NSU entwickelte Luthe Ende der 60er den Meilenstein Ro80, der die Formensprache der 90er Jahre antizipierte: abgerundete Form, hohes Heck, steigende Gürtellinie. Zwischen 1976 und 1992 war er bei BMW, und eine seiner letzten Schöpfungen – die Serie 5 der Reihe E39 – zählt zu den schönsten Limousinen, die je produziert wurden.

En tant que responsable de la conception pour NSU, Luthe développa le modèle Ro80, étape déterminante du design automobile à la fin des années 60, avec un langage des formes en anticipation des années 90 : formes arrondies, arrière élevé, ligne de ceinture ascendante. Entre 1976 et 1992, il travailla chez BMW ; la série 5 E39, une de ses dernières créations, compte parmi les plus belles berlines jamais produites.

En calidad de jefe de diseño de NSU, Luthe desarrolló a fines de los 60 el hito Ro80 que anticipó el lenguaje de formas de los años 90: formas redondeadas, parte trasera alta, guardabarros ascendiente. Entre 1976 y 1992 estuvo en BMW y una de sus últimas creaciones –la Serie 5 de la línea E39– se cuenta entre las limusinas más bellas que se han producido nunca.

Lyons, William
GB, 1901–1985

The founder and company chief of Jaguar had the last word on the look of every model. He was absolutely sure of style and obsessed with detail. The body of a Jaguar was above all to be low and was meant to fascinate with its sensuality and dynamics. The classic MK2 was the first ever sports sedan. The 1968 XV remained unchanged in terms of its basic design and proportions for over 30 years and it was undoubtedly the most elegant sedan on the market.

Als Gründer und Firmenchef von Jaguar hatte er das letzte Wort über das Aussehen eines jeden Modells. Dabei war er absolut stilsicher und detailbesessen. Vor allem niedrig

sollte die Karosserie eines Jaguar sein und durch Sensualität und Dynamik faszinieren. Der klassische MK2 war die erste Sportlimousine überhaupt. In seinem Grundkonzept und den Proportionen blieb der 68er XV über 30 Jahre lang unverändert und zweifellos die eleganteste Limousine auf dem Markt.

En tant que fondateur et chef de Jaguar, il avait toujours le dernier mot sur l'apparence de chaque modèle. Il était un maître du style et était également possédé par les détails. La carrosserie d'un Jaguar devait être basse et fasciner par sa sensualité et sa dynamique. La classique MK2 était la toute première berline de sport. La XV 68 resta identique à son concept de base et à ses proportions pendant 30 ans et demeura aussi, sans aucun doute, la plus élégante berline sur le marché.

Como fundador y jefe de empresa tenía la última palabra en Jaguar acerca de la apariencia de un modelo. En esto era absolutamente seguro del estilo y estaba obsesionado con los detalles. La carrocería de un Jaguar había de estar sobre todo colocada baja y fascinar por su sensualidad y su dinámica. El clásico MK2 fue realmente la primera limusina deportiva. En su concepto básico y en sus proporciones, la XV del 68 permaneció inalterada durante 30 años e indudablemente la limusina más elegante en el mercado.

Matano, Tom
J, 1947

Tom Matano designed the Mazda Miata, the car which signalled the return of emotion at the end of the 1980s and introduced the subsequent wave of retro design.

Tom Matano hat den Mazda Miata entworfen, jenes Auto, das Ende der 80er Jahre die Rückkehr zur Emotion und die folgende Retrowelle einleitete.

Tom Matano a conçu la Mazda Miata, une voiture qui a permis le retour à l'émotion et a introduit la vague Retro.

Tom Matano diseñó el Mazda Miata, aquel automóvil que a finales de los 80 inició el regreso a la emoción y la siguiente oleada Retro.

Mays, J
USA, 1954

© 20

The graduate of Pasadena Art Center College worked for various European firms—Audi, BMW, Volkswagen —before he became Vice President of Design at the Ford Motor Company in 1997. That meant he was in control of design for a total of seven different brands in the Ford group. Mays, who names Ludwig Mies van der Rohe and Walt Disney as his inspirations, surprised the world in 1994 with the VW Prototype Concept One. As the New Beetle, this car heralded an era of retro-remakes. Nobody knows better than Mays how to spot the essence of a car, how to retain it and still to freshen it up with new lines and proportions.

Der Absolvent des Art Center College, Pasadena arbeitete für verschiedene Firmen in Europa – Audi, BMW, Volkswagen – bevor er 1997 Vizepräsident für Design bei der Ford Motor Company und somit der Herr über die Gestaltung von insgesamt sieben Marken der Gruppe wurde. Mays, der als seine Vorbilder Ludwig Mies van der Rohe und Walt Disney nennt, überraschte die Welt 1994 mit dem VW Prototyp Concept One, der als New Beetle die Ära des Retro-Remakes eröffnete. Niemand versteht es besser als Mays die Essenz eines Autos zu erkennen, zu

bewahren und dabei doch mit neuen Linien und Proportionen aufzufrischen.

Le diplômé du Art Center College à Pasadena travaillait pour diverses sociétés en Europe – Audi, BMW, Volkswagen – avant de prendre le titre de vice-président pour le design chez Ford Motor Company en 1997, et devenir ainsi le maître de la conception pour sept marques du groupe. Mays qui cite en exemple Ludwig Mies van der Rohe et Walt Disney surprit le monde, en 1994, avec le prototype VW Concept One, qui en tant que New Beetle ouvrit l'ère du Retro-Remake. Personne d'autre que Mays n'est capable de reconnaître l'essentiel d'une voiture, de le préserver et de le rajeunir avec des lignes et des proportions nouvelles.

El graduado del Art Center College, Pasadena, trabajó para diferentes empresas en Europa –Audi, BMW, Volkswagen– antes de convertirse en 1997 en vicepresidente de diseño de Ford Motor Company y con ello en el señor de la creación de, en total, siete marcas del grupo. Mays, quien cita como sus modelos a Ludwig Mies van der Rohe y Walt Disney, sorprendió al mundo en 1994 con el VW Prototyp Concept One que, como New Beetle, abrió la nueva era del Retro-Remake. Nadie mejor que Mays sabe reconocer y mantener la esencia de un automóvil y refrescarla

McRae, Duncan
USA, n.a.

The former designer for Ford became chief designer for Studebaker in 1955, where he cooperated with Raymond Loewy. His no-nonsense philosophy can be seen mainly on the '59 Lark: a simple, carefree design at a time that was otherwise dominated by Baroque Design.

Der ehemalige Ford-Designer wurde 1955 Chefdesigner von Studebaker, wo er mit Raymond Loewy kooperierte. Seine No-Nonsense-Philosophie lässt sich vor allem am 59er Lark erkennen: schlichtes, sorgloses Design in einer Ära, in der andernorts noch das Baroque Design dominierte.

L'ex-concepteur de Ford devint responsable de la conception chez Studebaker en 1955, où il travailla en coopération avec Raymond Loewy. Sa philosophie du raisonnable se reconnaît surtout dans le modèle Lark de 1959 : design simple et sans souci à une époque où dominait ailleurs le style Baroque.

El antiguo diseñador de Ford se convirtió en 1955 en diseñador jefe de Studebaker donde cooperó con Raymond Loewy. Su filosofía No-Nonsense puede reconocerse sobre todo en el Lark del 59: Un diseño sencillo y despreocupado en una era en la que en otras partes todavía dominaba el diseño Baroque.

Michelotti, Giovanni
I, 1921–1980

© 29

Michelotti has produced over 1,200 cars,—no wonder then, that at the 1954 Turin Salon, for instance, 40 of his creations already caused a stir. He worked as a freelance designer with all Italian body builders. For that reason, his name is less well known than his creations. The designs for the Carrozzeria Vignale are unforgettable, and many early 1950's Ferraris are among them. At the end of the fifties, he designed the Renault Alpine. In the sixties, Michelotti worked 'incognito' as advisor for many car manufacturers. This is how he influenced, among others, the look of modern BMWs, because from 1959 to 1975, he designed everything that the Bavarians produced. In this way, he defined the elegant, dynamic line of this brand with its typical front, distinguished by a negative incline, double head lights and kidney shape. He played a similar role in the 1960s for Triumph and Daf.

Michelotti hat über 1200 Autos realisiert – kein Wunder also, dass z. B. beim Turiner Salon von 1954 von ihm allein schon 40 Schöpfungen zu bestaunen waren. Als freier Designer arbeitete er mit allen italienischen Karosseriebauern, weswegen sein Name weit weniger bekannt ist als seine Kreationen. Unvergesslich sind vor allem jene für die Carrozzeria Vignale, unter denen sich viele Ferrari der frühen 50er Jahre befinden. Ende der 50er entwarf er den Renault Alpine. In den 60er Jahren war Michelotti – inkognito – als Berater für viele Hersteller tätig. So hat er u. a. das Gesicht der modernen BMWs geprägt, denn zwischen 1959 und 1975 designte er alles, was die Bayern produzierten und definierte so die elegante, dynamische Linienführung der Marke mit ihrer typischen Front, die sich durch negative Neigung, Doppelscheinwerfer und Nieren auszeichnet. Eine ähnliche Rolle spielte er in den 60er Jahren bei Triumph und Daf.

390

Michelotti a conçu plus de 1200 voitures – ce n'est pas étonnant que 40 de ses créations aient été exposées au salon de Turin en 1954, par exemple. Comme designer indépendant, il a travaillé avec tous les carrossiers italiens, c'est pourquoi son nom est moins connu que ses créations. Les plus inoubliables sont celles de la Carrozzeria Vignale, qui comptent de nombreuses Ferrari du début des années 50. A la fin des années 50, il conçut la Renault Alpine. Dans les années 60, Michelotti était – incognito – le conseiller auprès de nombreux fabricants. Il a influencé le visage des BMW modernes. En effet, entre 1959 et 1975, il a créé tout ce que la Bavière a produit et il a défini la ligne élégante et dynamique de la marque avec son avant typique, qui se caractérise par son aspect incliné en négatif, ses phares doubles et ses reins. Il a joué un rôle identique dans les années 60 chez Triumph et Daf.

Michelotti realizó más de 1200 automóviles –o sea, que no es un milagro que por ejemplo, en el Salón de Turín de 1954, ya pudieran admirarse sólo de él 40 creaciones. En calidad de diseñador libre trabajó con todos los constructores italianos de carrocerías por lo que su nombre es mucho menos conocido que sus creaciones. Inolvidables son sobre todo aquéllas para las Carrozzeria Vignale, entre las cuales se encuentran muchos Ferrari de los tempranos años 50. A finales de los 50 proyectó el Renault Alpine. En los años 60, Michelotti trabajó –de incógnito– como asesor para muchos fabricantes. Así marcó, entre otras, la cara de los BMW modernos, pues entre 1959 y 1975 diseñó todo lo que los bávaros produjeron definiendo así el trazado de líneas elegante y dinámico de la marca con su típica parte frontal caracterizada por la inclinación negativa, los faros dobles y los riñones. En los años 60 desempeñó un papel similar en Triumph y Daf.

Mitchell, Bill
USA, 1912–1988

© 22

The talented advertising illustrator was discovered in 1935 by Harley Earl and in 1958 he became Earl's successor as Vice President of GM Design. Under Earl's directorship as the design chief of Cadillac, he had been responsible for working with brightest chrome and excessive fins, once he took office himself, he immediately got rid of them. From then onwards and well into the 1970s, he counted on a new form language that he called "sheer look": compact and angular, yet often expressive and almost baroque. The Corvette Stingray, the '63 Buick Riviera and the '67 Cadillac Eldorado are his masterpieces.

Der talentierte Werbeillustrator wurde 1935 von Harley Earl entdeckt und trat 1958 dessen Nachfolge als Vizepräsident von GM Design an. Obwohl er selbst noch unter Earl, als Designchef von Cadillac, für die buntesten Chrom- und Flossenexzesse verantwortlich gewesen war, schaffte er diese nach seinem Amtsantritt sofort ab. Von da an setzte er bis in die 70er Jahre hinein auf eine neue Formensprache, die er „sheer look“ nannte: kompakt und kantig, oft allerdings expressiv und nahezu baroque. Die Corvette Stingray, der 63er Buick Riviera und der 67er Cadillac Eldorado sind seine Meisterwerke.

Ce talentueux illustrateur publicitaire a été découvert par Harley Earl en 1935 et prit sa succession comme vice-président de GM Design en 1958. Bien qu'il ait été responsable du chrome extrêmement coloré et de l'excès d'ailettes en tant que directeur de la conception chez Cadillac sous la direction de Earl, il supprima ces deux tendances immédiatement après son entrée en fonctions. Dès lors et jusque dans les années 70, il misa sur un nouveau langage des formes qu'il appela « sheer look » : compact, à arêtes, souvent expressif et presque baroque. La Corvette Stingray, la Buick Riviera de 1963 et la Cadillac Eldorado de 1967 font partie de ses chefs d'œuvre.

El dotado ilustrador publicitario fue descubierto en 1935 por Harley Earl y se incorporó en 1958 para sucederle como vicepresidente de GM Design. Aunque él mismo, todavía bajo Earl y como diseñador jefe de Cadillac, había sido responsable de los excesos más variados de cromo y estabilizadores, los eliminó inmediatamente tras tomar posesión de su cargo. Desde ese momento hasta entrados los años 70, apostó por un nuevo lenguaje de formas que llamó "sheer look": compacto y anguloso, ciertamente a menudo expresivo y casi barroco. El Corvette Stingray, el Buick Riviera de 63 y el Cadillac Eldorado de 67 son sus obras maestras.

Opron, Robert

F, 1932

In 1962, Opron was recruited to Citroën by Flaminio Bertoni. In 1964, he became Bertoni's successor as design chief. His first trademark was the clad, double revolving headlights for the DS. The harmonious and flowing Fastback lines of the GS and CX—admittedly, inspired by Pininfarina—were an innovation at the start of the 1970s. The avantgarde SM remains a masterpiece. His creations often polarized design elements: individuality and the avantgarde also characterize the Fuego and the R25, which he later developed for Renault.

Opron wurde 1962 von Flaminio Bertoni zu Citroën geholt und trat 1964 dessen Nachfolge als Designchef an. Sein erstes Markenzeichen wurden die verkleideten doppelten Drehscheinwerfer für den DS. Die harmonisch fließenden Fastback-Linien des GS, CX – freilich durch Pininfarina inspiriert – waren Anfang der 70er Jahre eine Innovation. Ein Meisterwerk bleibt der avantgardistische SM. Seine Kreationen waren oft polarisierend: Individualität und Avantgarde kennzeichnen auch den Fuego und den R25, die er später bei Renault entwarf.

Opron fut recruté par Flaminio Bertoni et entra chez Citroën en 1962 puis il prit sa succession comme responsable de la conception en 1964. La première expression de sa griffe fut les phares doubles pivotants avec couverture de la DS. Le Fastback de la GS et CX à la ligne fluide – inspiré probablement de Pininfarina – était une innovation au début des années 70. La SM est un chef d'œuvre d'avant-garde. Ses créations étaient souvent polarisantes : l'individualité et l'avant-garde caractérisent la Fuego et la R25 qu'il créa ensuite pour Renault.

Flaminio Bertoni se llevó a Opron a Citroën en 1962 quien le sucedió en 1964 en su puesto de diseñador jefe. Su primera marca característica fueron los faros dobles giratorios revestidos para el DS. Las líneas fastback del GS, CX fluyendo armoniosamente –claramente inspiradas por Pininfarina– fueron a principios de los 70 una innovación. El vanguardista SM permanece una obra maestra. Sus creaciones a menudo polarizaron: La individualidad y la vanguardia caracterizan también al Fuego y al R25 que proyectó más tarde para Renault.

Pininfarina, Battista

I, 1893–1966

© 33

Battista "Pinin" Farina first worked with his brother, Giovanni. But he soon founded his own firm, which was a factory, research center and talent promoter all in one. It quickly became the most famous address for automobile design. In the 1960s, when the President of the Republic of Italy changed the family name to Pininfarina, it was already an established brand. Battista was heavily influenced by a trip to America and after that, he began to see his own firm as an industry. As a result, he often worked as a partner to big concerns—in the fifties and sixties, Lancia, Fiat, Alfa Romeo and Cadillac all had their special series models produced by Pininfarina. It is remarkable that Pininfarina was already researching into aerodynamics before the war, the material always interested him. Consequently, he did the right thing in 1972 when he built the first wind tunnel for research purposes. Pininfarina designed and built for almost every manufacturer, the most faithful were Ferrari and Peugeot. His classical trademark is the preference of a line that is both innovative and elegant at the same time.

Battista „Pinin" Farina arbeitete zunächst bei seinem Bruder Giovanni, gründete aber relativ bald seine eigene Firma, die eine Fabrik, ein Forschungszentrum und eine Talentschmiede zugleich war und schnell zur berühmtesten Adresse für Automobildesign wurde. Als in den 60ern der Präsident der italienischen Republik den Familiennamen in Pininfarina änderte, war dieser bereits eine etablierte Marke. Battista war von einer Reise nach Amerika sehr geprägt worden und begann daraufhin die eigene Firma als eine Industrie zu sehen, so dass er häufig als Partner von Großkonzernen arbeitete – in den 50er und 60er Jahren ließen Lancia, Fiat, Alfa Romeo und Cadillac ihre Sondermodelle bei Pininfarina produzieren. Bemerkenswert ist, dass Pininfarina bereits vor dem Krieg auf dem Gebiet der Aerodynamik forschte, eine Materie, die ihn stets interessierte; folgerichtig baute er 1972 einen der ersten Windtunnels zu Forschungszwecken. Pininfarina entwarf und baute für fast jeden Hersteller, zu den treuesten zählen jedoch Ferrari und Peugeot. Sein klassisches Markenzeichen ist die Vorliebe für eine Linie, die innovativ und elegant zugleich ist.

Battista « Pinin » Farina travailla d'abord chez son frère Giovanni puis fonda rapidement sa propre société, qui fut à la fois une usine, un centre de recherche et une forge des talents, et devint rapidement une adresse réputée pour le design automobile. Dans les années 60, lorsque le président de la république italienne modifia le nom de famille qui devint Pininfarina, c'était déjà une marque établie. Battista avait été très influencé par un voyage en Amérique. Il commença à considérer sa société comme une industrie et travailla souvent comme partenaire de grands groupes – dans les années 50 et 60, Lancia, Fiat, Alfa Romeo et Cadillac firent produire leurs modèles spéciaux par Pininfarina. Avant la guerre Pininfarina explorait déjà le domaine de l'aérodynamique, un sujet qui l'a toujours intéressé ; e 1972, il construisit l'un des

premiers tunnels aérodynamiques pour effectuer ses recherches. Pininfarina créa et construisit pour presque tous les fabricants, dont les plus fidèles sont Ferrari et Peugeot. Sa griffe classique est une ligne à la fois innovatrice et élégante.

Battista "Pinin" Farina trabajó primero con su hermano Giovanni, pero relativamente pronto fundó su propia empresa que fue al mismo tiempo una fábrica, un centro de investigaciones y una forja de talentos y se convirtió rápidamente en la dirección más famosa para el diseño del automóvil. Cuando en los 60 el Presidente de la República italiana cambió el apellido por el de Pininfarina, ésta ya era una marca establecida. Battista había quedado muy marcado por un viaje a América y, en vista de ello, comenzó a ver la propia empresa como una industria, de manera que a menudo trabajó como socio de grandes consorcios; En los años 50 y 60, Lancia, Fiat, Alfa Romeo y Cadillac hicieron producir sus modelos especiales con Pininfarina. Digno de destacar es que, ya antes de la guerra, Pininfarina investigado en el terreno de la aerodinámica, una materia que siempre le interesó. Consecuentemente, en 1972 construyó uno de los primeros túneles de viento con fines de investigación. Pininfarina proyectó y construyó para casi todos los fabricantes pero entre los más fieles se cuentan Ferrari y Peugeot. Su marca característica clásica es la predilección por una línea que al mismo tiempo es innovadora y elegante.

Porsche, F. A. "Butzi"
A, 1935

© 13

"A good product must be respectable. Design is not fashion." The eldest son of Ferdinand "Ferry" Porsche stamped his words in metal. His design for the Porsche 911 more or less emerged as the classic car that it was to remain decades later. This typical product of German design has never given up its original characteristics.

„Ein gutes Produkt muss dezent sein. Design ist keine Mode". Der älteste Sohn von Ferdinand „Ferry" Porsche hat seine Worte in Blech gestanzt. Der von ihm entworfene Porsche 911 kam gewissermaßen als der Klassiker zur Welt, der er die folgenden Jahrzehnte über geblieben ist. Seine ursprüngliche Charakteristik hat dieses typische Produkt deutschen Designs nie aufgegeben.

« Un bon produit doit être décent. Le design n'est pas une mode ». Le fils aîné de Ferdinand « Ferry » Porsche a gravé ses mots dans le métal. La Porsche 911 qu'il a conçue vint au monde en tant que classique et le resta au cours des années. Ce produit typique du design allemand n'a jamais perdu ses caractéristiques d'origine.

"Un buen producto debe ser discreto. El diseño no es una moda". El hijo mayor de Ferdinand "Ferry" Porsche estampó sus palabras en chapa. El Porsche 911, diseñado por él, vino al mundo, por así decirlo, como el clásico que continuó siendo durante los años posteriores. Este producto típico del diseño alemán no ha abandonado nunca su característica original.

Sacco, Bruno
I-D, 1933

© 10

When Sacco said goodbye to his office in Sindelfingen in 1999, he had been the design chief at Mercedes for 24 years. In 1958, he had begun his career with this company and he had turned into a design legend. Nobody knew better than he did how to combine continuity with innovation and elegance with modernity: his design certainty is unequalled and the beauty of his cars is the logical and undisputed consistency of the design. The result are cars that never age and even today clearly represent the essence of the Mercedes brand, as for instance the 1979 S-Class.

Als Sacco 1999 Abschied von seinem Büro in Sindelfingen nahm, war er 24 Jahre lang der Designchef von Mercedes, wo er auch 1958 seine Karriere begann, gewesen – und eine Designlegende dazu. Niemand hat es besser als er verstanden, Kontinuität mit Innovation und Eleganz mit Modernität zu verbinden: seine gestalterische Sicherheit ist unübertroffen und die Schönheit seiner Autos die logische Konsequenz der unbestrittenen Konsistenz des Designs. Das Resultat sind Autos, die nie altern und noch heute die Substanz der Marke Mercedes eindeutig repräsentieren, so etwa die 79er S-Klasse.

Quand il quitta son bureau de Sindelfingen en 1999 après avoir été le responsable de la conception chez Mercedes pendant 24 ans, Sacco était devenu un mythe du design. Il y avait commencé sa carrière en 1958. Personne d'autre que lui n'a compris comment combiner la continuité et l'innovation, l'élégance et la modernité : l'assurance

de sa conception est unique et la beauté de ses voitures est la conséquence logique de la consistance controversée du design. Le résultat sont des voitures qui ne vieillissent pas et qui assurent aujourd'hui le caractère de la marque Mercedes, comme par exemple la classe S 79.

Cuando Sacco se despidió de su oficina en Sindelfingen en 1999, había sido durante 24 años jefe de diseño en Mercedes –donde también había comenzado su carrera en 1958– y, además, una leyenda del diseño. Nadie mejor que él ha sabido unir la continuidad con la innovación y la elegancia con la modernidad: Su seguridad en la creación no tiene igual y la belleza de sus automóviles es la consecuencia lógica de la indiscutida consistencia del diseño. El resultado son automóviles que nunca envejecen y que todavía hoy representan claramente la sustancia de la marca Mercedes como, por ejemplo, los de la Clase-S del 79.

Sason, Sixten
S, 1912–1967

The Swede, Sason, was an industrial designer with many interests. This is how he came to design household goods for Electrolux, cameras for Hasselblad and also cars for SAAB. The 1946 model 92 actually influenced SAAB's brand image, which is distinguished by a combination of aerodynamics and functionality. The 1967 model 99 introduced a design concept with its typically concave fast-back line, which SAAB still produce today.

Der Schwede Sason war ein Industriedesigner mit vielen Interessen. So entwarf er z. B. Haushaltswaren für Electrolux, Fotokameras für Hasselblad und auch Autos für SAAB. Tatsächlich hat das Modell 92 von 1946 sogar deren Markencharakter geprägt, der sich durch eine Kombination von Aerodynamik und Funktionalität auszeichnet. Der 99 von 1967 führte mit seiner typischen konkaven Fastbacklinie ein

Designkonzept ein, das bis heute bei Saab erhalten geblieben ist.

Le Suédois Sason était un designer industriel qui avait de nombreux intérêts. Il créa, entre autres, des articles ménagers pour Electrolux, des appareils-photos pour Hasselblad et également des voitures pour SAAB. Il est évident que le modèle 92 de 1946 a influencé le caractère de la marque par sa combinaison d'aérodynamique et de fonctionalité. Avec la ligne concave typique de son Fastback, le modèle 99 de 1967 introduisait un concept de design que Saab a conservé jusqu'à aujourd'hui.

El sueco Sason fue un diseñador industrial con muchos intereses. Así, proyectó por ejemplo productos domésticos para Electrolux, cámaras fotográficas para Hasselblad y también automóviles para SAAB. De hecho, el modelo 92 de 1946 acuñó incluso su carácter de marca caracterizada por una combinación de la aerodinámica y la funcionalidad. El 99 de 1967 introdujo, con su típica línea cóncava fastback, un concepto del diseño que se ha mantenido en Saab hasta hoy.

Sayer, Malcolm
GB, n.a.

In the post-war era, Sayer worked at Jaguar as an expert in aerodynamics. He was mainly working on racing cars like the C-Type. The experience he gained was the basis for his masterpiece: the 1961 Jaguar XK-E-Type.

Als Aerodynamikexperte arbeitete er in der Nachkriegszeit bei Jaguar, wo er sich vor allem mit Rennfahrzeugen wie dem C-Type beschäftigte. Diese Erfahrungen waren die Grundlage für sein Meisterwerk: den Jaguar XK-E-Type von 1961.

Après la guerre, il travailla en tant qu'expert de l'aérodynamique chez Jaguar où il s'occupa avant tout de véhicules de course tels que le C-Type. Cette expérience fut la base de son chef d'œuvre : la Jaguar XK-E-Type de 1961.

Durante la posguerra trabajó como experto en aerodinámica en Jaguar donde se dedicó especialmente a los vehículos de carreras como el C-Type. Estas experiencias constituyeron la base de su obra maestra: el Jaguar XK-E-Type de 1961.

Scaglione, Franco
I, 1917– n.a.

Scaglione gave up his engineering studies because of the war and he started to design cars—at first for Pininfarina, then with Bertone, for whom he worked as design chief until 1959. The winged BAT-mobiles for Alfa Romeo demonstrate his visionary creativity; his 1954 Giulietta Sprint was one of the most elegant and beautiful sports cars in the post-war period. Unfortunately, nobody knows what became of him.

Er unterbrach wegen des Krieges sein Studium der Ingenieurswissenschaft und begann Autos zu gestalten – zuerst bei Pininfarina, dann bei Bertone, dessen Designchef er bis 1959 war. Die geflügelten BAT-mobile für Alfa Romeo demonstrieren seine visionäre Kreativität; sein Giulietta Sprint von 1954 war eines der elegantesten und schönsten Sportautos der Nachkriegszeit. Leider weiß niemand, was aus ihm geworden ist.

Il interrompit ses études d'ingénieur à cause de la guerre et commença à créer des voitures – d'abord chez Pininfarina, puis chez Bertone où il devint responsable de la conception jusqu'en 1959. Les BAT-mobiles à ailettes conçues pour Alfa Romeo démontrent sa créativité visionnaire ; la Giulietta Sprint de 1954 était une des voitures de sport les plus belles et les plus élégantes de l'après-guerre. Malheureusement, personne ne sait ce qu'il est devenu.

Interrumpió su carrera de ingeniería debido a la guerra y comenzó a crear automóviles –primero con Pininfarina y luego con Bertone de quien fue jefe de diseño hasta 1959. Los automóviles BAT con alerones para Alfa Romeo demuestran su creatividad visionaria; su Giulietta Sprint de 1954 fue uno de los auto-

móviles deportivos más elegantes y bellos de la posguerra. Por desgracia, nadie sabe que fue de él.

Schreyer, Peter
D, 1953

© 39

After graduating from the Royal College of Art in London, in 1980, he went to Audi and finally ended up in 2002 as design chief for Volkswagen. He helped to create the unmistakable design language of the new Audis: clear geometry of forms, dynamic lines, respectable perfection in design detail.

Nach dem Studium am Royal College of Art in London ging er 1980 zu Audi und landete schließlich 2002 als Designchef bei Volkswagen. Er schuf die unverwechselbare Designsprache der neueren Audis mit: eine klare Geometrie der Formen, dynamische Linien, dezente Perfektion im Detail.

Après ses études au Royal College of Art à Londres, il commença chez Audi en 1980 et passa chez Volkswagen en 2002, en tant que responsable de la conception. Il participa à la création du langage de design unique des nouvelles Audi : une géométrie claire des formes, des lignes dynamiques, une décente perfection des détails.

Después de estudiar en el Royal College of Art en Londres se fue en 1980 a Audi llegando finalmente en 2002 a Volkswagen como diseñador jefe. Ayudó a crear el inconfundible lenguaje de diseño de los nuevos Audis: una clara geometría de formas, unas líneas dinámicas, una perfección discreta en el detalle.

Segre, Luigi
I, 1921–1963

At first, Segre was partner to Felice Mario Boano, then from 1953, he was the sole director and also design chief of the Carrozzeria Ghia.

Zuerst war Segre der Partner von Felice Mario Boano, ab 1953 dann alleiniger Geschäftsführer und somit auch Designchef der Carrozzeria Ghia.

Il fut d'abord le partenaire de Felice Mario Boano, et à partir de 1953, il devint le seul chef d'entreprise et également le responsable de la conception chez Carrozzeria Ghia.

Primero fue el socio de Felice Mario Boano, a partir de 1953 gerente único y con ello también diseñador jefe de Carrozzeria Ghia.

Spada, Ercole
I, 1938

In 1960, Spada started to work with Zagato as a designer. He was avantgarde and partly controversial in his design language and in 1969, together with Alfa Romeo's Junior Zagato, he modernized the look of the Italian sports car.

Spada fing 1960 an bei Zagato als Designer zu arbeiten. Avantgardistisch und teils kontrovers in seiner Designsprache, modernisierte er 1969 mit dem Alfa Romeo Junior Zagato den Look des italienischen Sportwagens.

Spada commença à travailler comme concepteur chez Zagato en 1960. À l'avant-garde et parfois controversé dans son langage du design, il modernisa l'allure de la voiture de sport italienne avec Alfa Romeo Junior Zagato en 1969.

Spada comenzó a trabajar como diseñador con Zagato en 1960. Vanguardista y en parte controvertido en su lenguaje de diseño, modernizó el look del automóvil deportivo italiano en 1969 con el Alfa Romeo Junior Zagato.

T

Tjaarda, Tom
US-I, 1934

Tjaarda's father, John, already designed the 1935 Lincoln Zephyr. Tom was discovered by Ghia and tempted to move to Turin where he also worked for Pininfarina and OSI. In 1967, he returned as design chief to Ghia. The De Tomaso Pantera is regarded as his most attractive design.

Tjaardas Vater John entwarf bereits den 35er Lincoln Zephyr. Toms Talent wurde von Ghia entdeckt, so dass es ihn nach Turin zog, wo er außerdem bei Pininfarina und OSI arbeitete. 1967 kam er zu Ghia als Designchef zurück. Der De Tomaso Pantera gilt als sein schönster Entwurf.

John, le père de Tjaarda créa la Lincoln Zephyr de 1935. Le talent de Tom fut découvert par Ghia, ce qui l'amena à s'installer à Turin où il travailla également pour Pininfarina et OSI. En 1967, il revient chez Ghia comme responsable de la conception. La De Tomaso Pantera a la réputation d'être sa plus belle création.

El padre de Tjaardas, John, ya proyectó el Lincoln Zephyr del 35. El talento de Tom fue descubierto por Ghia, de manera que ello lo llevó a Turín donde además trabajó para Pininfarina y OSI. En 1967 regresó a Ghia como diseñador jefe. El De Tomaso Pantera está considerado como su diseño más bello.

W

Wilsgaard, Jan
S, 1930

Wilsgaard worked for Volvo since 1950 and he was design chief for years. The 145 became an icon of the European station wagon. Wilsgaard's intuition that it was possible to integrate big, rubber-sealed bumpers as a standard design feature made the Swedish brand synony-

mous with robustness and safety. He remained faithful to Edge Box Design and combined American and European style elements in the 760-740 series to make one of the most interesting vehicles of the 1980s.

Wilsgaard ist seit 1950 bei Volvo, wo er jahrelang als Designchef arbeitete. Der 145 wurde zur Ikone des europäischen Station-Wagon. Wilsgaards Intuition, große, mit Gummi bezogene Stoßstangen als Standardausstattung in das Design zu integrieren, machte die schwedische Marke zum Synonym für Robustheit und Sicherheit. In konsequenter Treue zum Edge Box Design kombinierte er mit der 760-740 Serie amerikanische und europäische Stilelemente in einem der interessantesten Fahrzeuge der 80er Jahre.

Wilsgaard est chez Volvo depuis 1950 et il y a travaillé pendant des années comme responsable de la conception. Le modèle 145 devint une icône du station-wagon européen. L'intuition de Wilsgaard d'intégrer des pare-chocs recouverts de caoutchouc comme équipement standard faisant partie du design a rendu la marque suédoise synonyme de robustesse et de sécurité. Restant fidèle au design Edge Box, il combina dans la série 760-740 des éléments de style américains et européens pour aboutir à l'un des plus intéressants véhicules des années 80.

Wilsgaard está en Volvo desde 1950 donde ha trabajado durante años como diseñador jefe. El 145 se convirtió en el icono del Station-Wagon europeo. La gran intuición de Wilsgaard de integrar en el diseño grandes parachoques revestidos de goma como equipamiento estándar hizo de la marca sueca un sinónimo de robustez y seguridad. Con una consecuente fidelidad al diseño Edge Box, combinó con la Serie 760-740 elementos de estilo americanos y europeos en uno de los vehículos más interesantes de los años 80.

Z

Zagato, Ugo
I, 1890–1968

Ugo Zagato, together with his sons Elio and Gianno, almost exclusively built sports cars from the 1920s to the 1960s. The cars were a success on ordinary roads as well as on the race track. No other body shop knew better how to combine performance with style: Zagato's designs were always measured by their efficiency and that is why they were never overloaded with ornaments. In spite of this, they were expressive, often controversial, but never banal. Functionality governed every design detail; for instance, the wide glass surfaces ensured better visibilty of the road and the curved roof gave more space for the racing driver's helmet.

Von den 20ern bis in die 60er baute Ugo Zagato – zusammen mit seinen Söhnen Elio und Gianni – fast ausschließlich Sportautos, die sowohl auf der Straße als auch auf der Rennstrecke erfolgreich waren. Keine andere Carrozzeria wusste besser, wie man Leistung mit Stil kombiniert: Zagatos Schöpfungen wurden immer an ihrer Effizienz gemessen und deswegen nie mit Ornamenten überladen. Trotzdem waren sie expressiv, oft kontrovers, niemals banal. Funktionalität bestimmte jedes gestalterische Detail; so sorgten etwa die großen Glasflächen für eine bessere Sicht nach außen und die Dachbuckel für mehr Helmfreiheit.

Des années 1920 à 1960, Ugo Zagato a construit – avec ses fils Elio et Gianni – presque uniquement des voitures de sport qui furent une réussite aussi bien dans la rue que sur un circuit de course. Aucune autre usine de carrosserie ne savait mieux combiner la puissance et le style : les créations de Zagato étaient basées sur l'efficacité et donc jamais surchargées d'ornements. Elles étaient cependant expressives, souvent controversées et jamais banales. La fonctionalité déterminait chaque détail de la conception, par

exemple les grandes vitres permettaient une meilleure vision extérieure et le toit bombé fournissait plus d'espace pour le casque.

Desde los 20 hasta entrados los 60, Ugo Zagato –juntamente con sus hijos Elio y Gianni– construyó casi exclusivamente automóviles deportivos que fueron famosos tanto en la carretera como también en el circuito de carreras. Ninguna otra Carrozzeria supo mejor cómo combinar el rendimiento con el estilo: Las creaciones de Zagato se midieron siempre por su eficiencia y por eso nunca fueron sobrecargadas con ornamentos. Sin embargo, fueron expresivas, a menudo controvertidas, nunca banales. La funcionalidad determinó todos los detalles del diseño; así, por ejemplo las grandes superficies de cristal proporcionaron una mejor visibilidad hacia el exterior y el abombamiento del techo más libertad para el casco.

PORSCHE

INTERMECCANICA

OPEL

© 13
Porsche Trade Show
1970s

Paolo Tumminelli

...studied architecture and design direction in Milan. Today, he is the chief executive officer of the consulting company goodbrands® and Professor for Design Concepts at the Köln International School of Design. Tumminelli has worked as a design critic since 1992 and he now writes for the magazine Form and the business newspaper Handelsblatt.

...studierte Architektur und Design Direction in Mailand. Heute ist er gesellschaftlicher Geschäftsführer des Beratungsunternehmens goodbrands® und Professor für Design Konzepte an der Köln International School of Design. Seit 1992 als Designkritiker tätig, schreibt Tumminelli unter anderem für das Magazin Form und die Wirtschaftszeitung Handelsblatt.

...a étudié l'architecture et la Direction Design á Milan. Il est actuellement PDG social de l'entreprise conseil goodbrands® et professeur pour concepts de design à la Köln International School of Design. Tumminelli est critique de design depuis 1992, il écrit, entre autres, pour le magazine Form et le journal économique Handelsblatt.

...estudió Arquitectura y Design Direction en Milán. Actualmente es gerente social de la empresa consultora goodbrands® y profesor de Conceptos de Diseño en la Köln International School of Design. Tumminelli es crítico de diseño desde 1992 y escribe, entre otros, para la revista Form y el periódico de economía Handelsblatt.

thanx

The **selection of models** shown here is dependent on the availability and qua-lity of the pictures. Should you miss an important reference, this is probably due to lost or uncooperative sources. This book still makes it possible to gain a com-prehensive overview of all important design trends. The quality of the publication could not have been achieved without the support of all companies and indivdu-als who made their own photographical material available. Thank you!

Die Auswahl der hier gezeigten Modelle orientiert sich an Verfügbarkeit und Qualität der Bilder. Sollte man eine wichtige Referenz vermissen, ist dies zumeist auf fehlende oder unkooperative Quellen zurückzuführen. Das Buch ermöglicht trotzdem einen umfassenden Überblick über alle bedeutenden Designrichtungen. Diese Qualität wäre nicht ohne die Unterstützung aller Unternehmen und Personen, die eigenes Fotomaterial zur Verfügung gestellt haben, denkbar gewe-sen. Vielen Dank!

La sélection des modèles présentés s'oriente sur la disponibilité et la qualité des images. L'absence éventuelle d'une référence importante est due, la plupart du temps, à une source non existante ou non coopérante. Ce livre offre malgré tout une vue d'ensemble complète des directions de design les plus importan-tes. Cette qualité n'aurait pu être atteinte sans l'assistance des entreprises et des personnes qui ont fourni le matériel photographique. Tous nos remercie-ments !

La elección de los modelos aquí presentados se orienta a la disponibilidad y calidad de las imágenes. En caso de echar de menos una referencia importan-te, ello ha de atribuirse la mayoría de las veces a fuentes no existentes o no cooperativas. El libro hace posible, sin embargo, una amplia visión de todos los estilos del diseño importantes. Esta calidad no habría sido posible sin el apoyo de todas las empresas y las personas que han puesto a disposición material fotográfico propio. ¡Muchas gracias!

Special thanks to/ein besonders herzlicher Dank an/nos remerciements particu-lières à/un cordial agradecimiento especial a:

Archivio Quattroruote, **Donatella Biffignandi** (Museo dell'Automobile di Torino), **Massimo Castagnola** (Archivio Storico Fiat), **Elisabetta Farmeschi** (Stile Bertone), **Lothar Franz** (Archiv Audi Tradition), **Regine Fuchs-Reinhardt**, (Archiv Motorpresse Stuttgart), **Malte Jürgens** (Editor in Chief, Motor Klassik), **Helmut Kern** (Opel Design), **Christian Labonte** (Audi Design), **Prof. Harald Leschke** (DaimlerChrysler Sindel-fingen), **Klaus Parr** (Porsche Historisches Archiv), **Ing. Roberto Piatti** (Stile Bertone), **Elvira Ruocco** (Archivio Storico Alfa Romeo), **Horst Sass + Axel Schwalm** (Ford Werke Köln), **Norman Winkler** (Fiat Auto), **Martin Zimmermann** (Renault Nissan Deutschland)

copyright info

Every picture is credited in as precise detail as possible. If anything has been overlooked, the author apologizes and is grateful for your notification. The details can then be updated for future editions.

Für jede Bildquelle wurden möglichst präzise Angaben gemacht. Sollte etwas übersehen worden sein, so wird um Entschuldigung und um Bescheid gebeten. Die Angaben können dann bei den nächsten Auflagen aktualisiert werden.

Pour chaque photographie, nous avons essayé de donner les indications les plus précises possibles. Si une information devait manquer, nous nous en excusons et vous prions de nous en informer. Une mise à jour sera faite à la prochaine édition.

Para todas las fuentes gráficas se han dado datos lo más precisos posibles. En caso de que algo haya sido pasado por alto, rogamos nos disculpen y nos lo hagan saber. De esta manera, los datos podrán ser actualizados en las siguientes ediciones.

1 Adam Opel AG
2 Archiv Audi Tradition
3 Automobiles Citroën
4 Automobili Lamborghini Holding S.p.A.
5 Bentley Motors Ltd.
6 Blue Sky/Wolfgang Drehsen
7 BMW AG
8 BMW AG, Historisches Archiv
9 Citroën Kommunikation
10 DaimlerChrysler Communication
11 DaimlerChrysler Corp. Auburn Hills
12 DaimlerChrysler, Mercedes Benz Historisches Archiv
13 Dr. Ing h.c. F. Porsche Aktiengesellschaft, Historisches Archiv
14 Editoriale Domus S.p.A.,
15 Excerpt from original marketing collateral, author unknown
16 Ferrari S.p.A.
17 Fiat Auto S.p.A.
18 Fiat Auto, archivio storico Fiat
19 Fiat Auto, archivio storico Alfa Romeo
20 Ford Motor Company from http://media.ford.com and related sites

21 Ford Werke, Köln
22 General Motors and Wieck Media services, Inc. from http://media.gm.com and related sites
23 General Motors
24 Goodbrands GmbH
25 Italdesign – Giugiaro S.p.A.
26 Maserati S.p.A.
27 Mazda Motors
28 MG Rover Group Ltd.
29 Michelotti Edgardo, courtesy of
30 Museo dell'Automobile di Torino
31 Nissan Motor Co. Ltd.
32 Peugeot Deutschland GmbH
33 Pininfarina S.p.A.
34 Raymond Loewy Foundation, courtesy of Laurence Loewy
35 Renault
36 Renault Nissan Deutschland AG and Autodrom Publikationen
37 Stile Bertone
38 Toyota Motor Corporation
39 Volkswagen AG
40 Volkswagen AG, Historische Kommunikation
41 Wilhelm Karmann GmbH, Historisches Archiv

copyright info

Every picture is credited in as precise detail as possible. If anything has been over-looked, the author apologizes and is grateful for your notification. The details can then be updated for future editions.

Für jede Bildquelle wurden möglichst präzise Angaben gemacht. Sollte etwas übersehen worden sein, so wird um Entschuldigung und um Bescheid gebeten. Die Angaben können dann bei den nächsten Auflagen aktualisiert werden.

Pour chaque photographie, nous avons essayé de donner les indications les plus précises possibles. Si une information devait manquer, nous nous en excusons et vous prions de nous en informer. Une mise à jour sera faite à la prochaine édition.

Para todas las fuentes gráficas se han dado datos lo más precisos posibles. En caso de que algo haya sido pasado por alto, rogamos nos disculpen y nos lo hagan saber. De esta manera, los datos podrán ser actualizados en las siguientes ediciones.

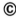

1 Adam Opel AG
2 Archiv Audi Tradition
3 Automobiles Citroën
4 Automobili Lamborghini Holding S.p.A.
5 Bentley Motors Ltd.
6 Blue Sky/Wolfgang Drehsen
7 BMW AG
8 BMW AG, Historisches Archiv
9 Citroën Kommunikation
10 DaimlerChrysler Communication
11 DaimlerChrysler Corp. Auburn Hills
12 DaimlerChrysler, Mercedes Benz
 Historisches Archiv
13 Dr. Ing h.c. F. Porsche Aktiengesell-
 schaft, Historisches Archiv
14 Editoriale Domus S.p.A.,
15 Excerpt from original marketing
 collateral, author unknown
16 Ferrari S.p.A.
17 Fiat Auto S.p.A.
18 Fiat Auto, archivio storico Fiat
19 Fiat Auto, archivio storico Alfa Romeo
20 Ford Motor Company from
 http://media.ford.com and related sites

21 Ford Werke, Köln
22 General Motors and Wieck Media services, Inc.
 from http://media.gm.com and related sites
23 General Motors
24 Goodbrands GmbH
25 Italdesign – Giugiaro S.p.A.
26 Maserati S.p.A.
27 Mazda Motors
28 MG Rover Group Ltd.
29 Michelotti Edgardo, courtesy of
30 Museo dell'Automobile di Torino
31 Nissan Motor Co. Ltd.
32 Peugeot Deutschland GmbH
33 Pininfarina S.p.A.
34 Raymond Loewy Foundation,
 courtesy of Laurence Loewy
35 Renault
36 Renault Nissan Deutschland AG and
 Autodrom Publikationen
37 Stile Bertone
38 Toyota Motor Corporation
39 Volkswagen AG
40 Volkswagen AG, Historische Kommunikation
41 Wilhelm Karmann GmbH, Historisches Archiv

Other Designpocket titles by teNeues

African Interior Design 3-8238-4563-2
Asian Interior Design 3-8238-4527-6
Avant-Garde Page Design 3-8238-4554-3
Bathroom Design 3-8238-4523-3
Beach Hotels 3-8238-4566-7
Berlin Apartments 3-8238-5596-4
Cafés & Restaurants 3-8238-5478-X
Cool Hotels 3-8238-5556-5
Cool Hotels America 3-8238-4565-9
Cosmopolitan Hotels 3-8238-4546-2
Country Hotels 3-8238-5574-3
Exhibition Design 3-8238-5548-4
Furniture Design 3-8238-5575-1
Garden Design 3-8238-4524-1
Italian Interior Design 3-8238-5495-X
Kitchen Design 3-8238-4522-5
London Apartments 3-8238-5558-1
Los Angeles Houses 3-8238-5594-8
Miami Houses 3-8238-4545-4
New York Apartments 3-8238-5557-3
Office Design 3-8238-5578-6
Paris Apartments 3-8238-5571-9
Pool Design 3-8238-4531-4
Product Design 3-8238-5597-2
Rome Houses 3-8238-4564-0
San Francisco Houses 3-8238-4526-8
Showrooms 3-8238-5496-8
Ski Hotels 3-8238-4543-8
Spa & Wellness Hotels 3-8238-5595-6
Sport Design 3-8238-4562-4
Staircases 3-8238-5572-7
Sydney Houses 3-8238-4525-X
Tokyo Houses 3-8238-5573-5
Tropical Houses 3-8238-4544-6

Each volume:

12.5 x 18.5 cm
400 pages
c. 400 color illustrations